Bruce Boucher,
Reader in the History of Art
at University College, London, was born in Birmingham,
Alabama in 1948. He studied at Harvard University, at
Oxford University (where he was a Rhodes Scholar), and at
the Courtauld Institute, London. He subsequently obtained
a fellowship at the Villa I Tatti, Florence, and later an
Alexander von Humboldt Fellowship at the University of
and the Technisches Universität, Berlin. He is
author of *The Sculpture of Jacopo Sansovino* (1991),
ea *Palladio: The Architect in his Time* (1994) and
co-editor of *Piero di Cosimo de' Medici:*
Art in the Service of the Medici (1993).

below.

W

rang

Printed in Italy

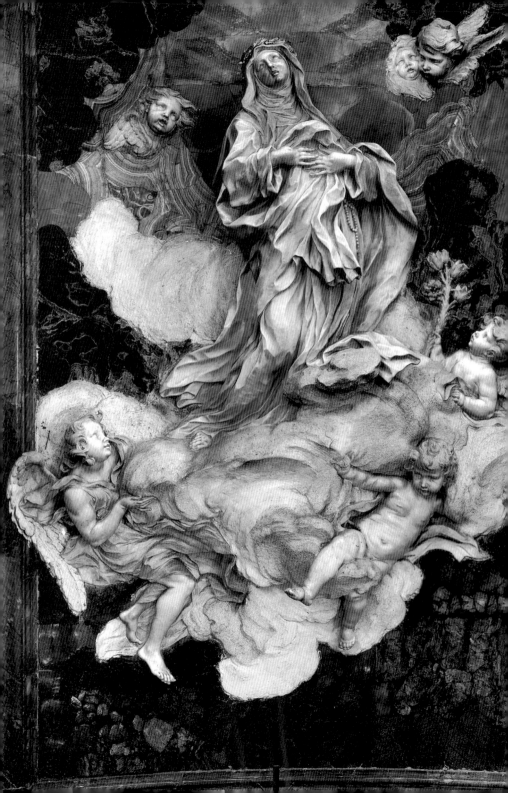

BRUCE BOUCHER

Italian Baroque Sculpture

185 illustrations, 34 in colour

THAMES AND HUDSON

for John Fleming and Hugh Honour

Frontispiece: Melchiorre Cafà, *Ecstasy of St Catherine of Siena*.
Santa Caterina da Siena a Magnanapoli, Rome, 1667.
White marble on coloured marble background.

British Library Cataloguing-in-Publication Data
A catalogue record for this book is available from the British Library

ISBN 0-500-20307-5

Printed and bound in Italy by Conti Tipocolor

Contents

Preface

The study of Italian Baroque sculpture has undergone a sea change in recent years, thanks to the major scholarly contributions of Irving Lavin, Jennifer Montagu and Rudolf Preimesberger. This renewed interest is part of a broader transformation that has affected all aspects of the study of Italian art of the period; yet sculpture still remains something of a Cinderella in comparison with her sister arts, painting and architecture, especially outside Rome. While monographic studies now exist on many of the major protagonists of the period, general coverage is patchy. Rudolf Wittkower's magisterial *Art and Architecture in Italy, 1600–1750*, has long been indispensable, but its pages devoted to sculptors other than Bernini, Algardi and their immediate followers are highly compressed, especially for anyone coming to the subject for the first time.

Although I have on occasion regretted my impetuosity, I was attracted to the challenge to write this book because it enabled me to address a wide range of artefacts not generally discussed together. In assembling the chapters of my text, I have opted for a thematic treatment of topics ranging from tombs to the *bel composto* as opposed to the chronological and biographical approach found in the most recent major survey of the subject by Anna Nava Cellini. Inevitably, Rome looms large in any book about Italian sculpture of the seventeenth and eighteenth centuries, but I have tried to balance essential coverage of Bernini and his world with important developments elsewhere on the Italian peninsula. Bearing in mind that Italy was more a geographical than a political entity during this period, I have given more space to native Italian sculptors than to foreign sculptors; architecture and ephemeral creations have also received attention in order to illustrate the diversity of forms employed by sculptors and designers of the period. Another concern has been the overlap between late Baroque and Neoclassicism which constitutes a recurring theme across several chapters.

Writing a work of this kind entails many debts, the majority of which are indicated in the Further Reading section of the book.

I would like to acknowledge help from the following colleagues: Maria Giulia Barberini, Gerhard Bissell, Giancarlo Gentilini, Corinna Giudici, Tobias Kämpf, Jutta Kappel, Luca Leoncini, Henry A. Millon, John Pinto and Anthony Radcliffe. Jennifer Montagu was especially generous in finding the time to answer many questions and in helping with photographs. Diane Michaels offered constant assistance in typing and checking the manuscript and was a tactful reader of early drafts.

Finally, I must thank John Fleming and Hugh Honour for sharing with me their vast knowledge of the period reviewed in these pages. In the early stages of preparing my text, I found their pioneering articles written for *The Connoisseur* during the 1950s and early 1960s a mine of information, reflecting that enviable combination of archival knowledge and response to the artefact which is the hallmark of their subsequent books. Beyond that, I wish to acknowledge their friendship and counsel over two decades: this book is dedicated to them in admiration and with great affection.

B. B.
London, July 1997

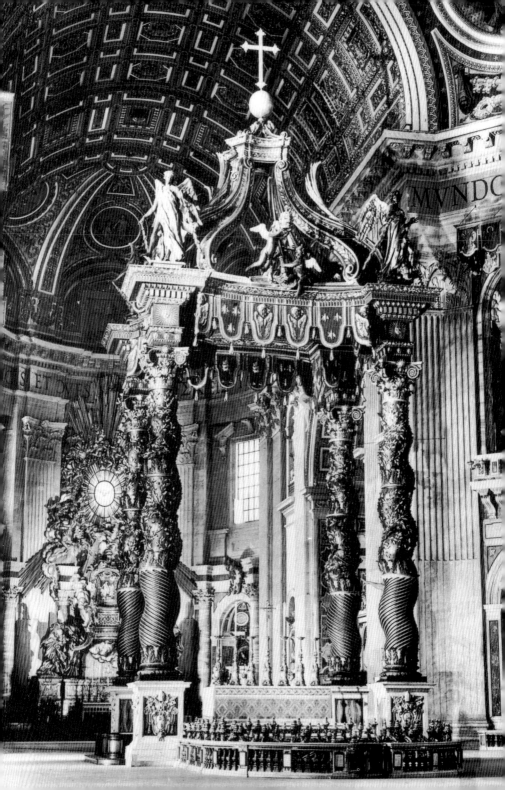

In Search of the Baroque

'Borromini in architecture, Bernini in sculpture, Pietro da Cortona in painting . . . are a plague on taste, a plague which has infected a great number of artists.' These words, written by Francesco Milizia, a Neoclassical critic, sum up the hostility felt by later generations towards the artistic phenomenon we now call the Baroque. Rhetorical poses, undulating buildings and more than a whiff of theatricality still come to mind when the Baroque is mentioned. The negative reaction that began with Johann Joachim Winckelmann, the pioneering German writer on art and archaeology, in the 1750s still held sway well into the twentieth century; few writers on the subject since have been wholly immune to this prejudice. Even as perceptive a student of Italian art as Jacob Burckhardt could recognize the supreme talents of Gianlorenzo Bernini (1598–1680) while at the same time lamenting his deviation from the Classical style. 'How Bernini,' he reflected, 'in Rome, in the presence of the most beautiful . . . statues of antiquity, went so astray remains a riddle.' It was not until the publication of Rudolf Wittkower's monograph on Bernini in 1955 that the English-speaking world could read a sympathetic account of one of the greatest figures in Baroque art. And even Wittkower found it necessary to plead with his readers to take Baroque sculpture seriously.

The situation is rather different today, and few would endorse John Ruskin's opinion that Bernini's sculpture is not only bad, but also morally corrupt. At the same time, Baroque sculpture cannot simply be taken literally (a misunderstanding of many antagonistic critics of the nineteenth century), or the result would certainly be disappointment verging on incredulity. The scientific and industrial revolutions of the modern period have put such a gap between our world and that of the Baroque that a considerable feat of the imagination is required to bridge it. In many ways, the Baroque seems even more distant than the Renaissance, for it relies overtly on illusionism and the supernatural, and on strong subjective appeal and opulent decor – all tastes that have not yet returned to fashion. Like Gothic

1 Gianlorenzo Bernini, Baldacchino, 1624–33. St Peter's, Rome. Gilt bronze. H. 25.9 m.

art, the art of the Baroque was meant to appeal more to the inner eye of the imagination than to the stricter laws of rationality. Even the very word 'Baroque' was inherently negative, long before it was associated with the arts. If we bear in mind its original meanings of either a forced argument or a misshapen pearl, the term must have conveyed a sense of the bizarre and defective which has been applied liberally to the art and architecture of the seventeenth and early eighteenth centuries.

Although it has suffered an often hostile press, the age of the Baroque witnessed one of the greatest flowerings of the arts in Italy, with hosts of native and foreign artists drawn to Rome and other major centres – Italian sculpture of this period occupied a dominant position which it would never enjoy again. It may be easier to describe the Baroque in negative terms, but a visit to St Peter's in Rome conveys the aims of Baroque sculpture more vividly than any extended verbal commentary. As we proceed down the nave and aisles, we take in the coloured marbles and gilding, the outsized holy water stoops, the reliefs of angels bearing medallions of the popes, the papal and other tombs, the statues of the founders of the religious orders, and finally the great set piece of the Baldacchino framing the explosive radiance of Bernini's *Cathedra Petri*. Today's world may be saturated with visual imagery, but the experience of St Peter's can still overwhelm, by virtue of its vast scale and the cumulative effect of so many sculptural witnesses encouraging our submission to an otherworldly experience.

Bernini's biographer, Filippo Baldinucci, touched on this fundamental aspect of the Baroque when he wrote of the Baldacchino: 'What appears to the spectator is something completely new, something he had never dreamt of seeing . . . There is no one, no matter how judicious or expert he may be, whose spirit is sufficiently satisfied by the first sight of it to form any concept other than that of complete wonderment.' A sense of wonder is rarely absent in the Baroque, and Baldinucci's words could as well apply to spectacular fireworks created for special occasions or, indeed, a stuccoed interior by Giacomo Serpotta (1656–1732). Qualities of immediacy and mimicry, and the unexpected and the surprising were all prized by Baroque artists and their public; such themes will recur frequently in the following chapters.

Whether at a technical or visceral level, Baroque sculpture was a rhetorical art form *par excellence*. Like all the arts, sculpture became a weapon in the armoury of the Catholic Church as it attacked its

2 Melchiorre Cafà, *St Rose of Lima*, 1665. Saõ Domengo, Lima. Marble. Life-size.

Protestant critics at the turn of the seventeenth century. The weight of tradition had always been felt within the Church, and this lent emphasis to the cult of relics, the lives of early martyrs and the examples of newer saints, as well as to the fundamental mysteries of the mass. François Duquesnoy's *St Susanna* and Melchiorre Cafà's *St Rose of Lima* illustrate complementary aspects of Baroque piety. Susanna was an obscure saint, beheaded in the persecutions of the Christians under the Roman Emperor Diocletian, while Rose of Lima was the first saint canonized from the Americas in 1671. Both works were produced in Rome, some sixty years apart. Duquesnoy (1597–1643), a Fleming, fashioned an image of the rarely depicted St Susanna as a Roman vestal, turning towards the spectator but also pointing towards the altar in acceptance of her martyrdom and ultimate salvation through Christ. Cafà (1635–1667) shows an angel comforting the dying St Rose, who wore a spiked, metal crown and suffered privations in imitation of the medieval Dominican, St Catherine of Siena. A highly emotive work, *St Rose of Lima* is notable because, as Baldinucci observed, it was the first work to depict a saint dying, and undoubtedly influenced subsequent works like Bernini's *Blessed Ludovica Albertoni*, the *Death of St Francis Xavier* by

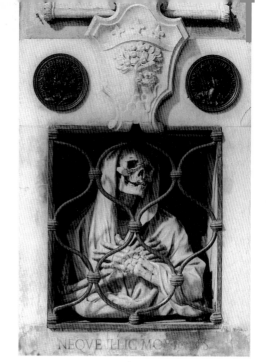

3 (*left*) François Duquesnoy,
St Susanna, 1629–33. Santa Maria
di Loreto, Rome. Marble.
Life-size.

4 Tomb of Giovanni Battista
Gisleni, 1672. Detail. Santa
Maria del Popolo, Rome.
Coloured marble and bronze
grille.

Massimiliano Soldani (1656–1740), or analogous paintings by Carlo
Maratti (1625–1713) and others. Even Duquesnoy's more overtly
classicizing *St Susanna* has an undercurrent of emotion that distin-
guishes it from the passivity to be found in most Classical sculpture.
The great upsurge of religious feeling in the Catholic Church during
this period provided scope for artistic commemoration of recently
canonized saints, such as St Philip Neri and St Aloysius Gonzaga, as
well as the challenge of creating images of visionary experiences, as in
Bernini's celebrated *Ecstasy of St Teresa*. At the same time, images of
the Virgin of the Immaculate Conception and medieval saints such as
Francis of Assisi or Bruno, the founder of the Carthusian order,
emphasized the preoccupations of the contemporary Church with
sin, transience and the need for repentance. Such themes were never
far from the minds of Baroque sculptors or their patrons, whether in
altarpieces such as that for the Venetian church of Santa Maria della
Salute by Josse de Corte (1627–1678), or the design for his own tomb
by the architect Giovanni Battista Gisleni (1600–1672) in the Roman
church of Santa Maria del Popolo, in which the sculptor's image is
contrasted with one of Death, the portrait bearing the inscription
'neither here alive' and the skeleton 'nor there dead'.

Gianlorenzo Bernini has already been mentioned several times in these pages; his artistic personality dominated the sculptural world of his day even more than Michelangelo's had done in the High Renaissance. Bernini's vision was so compelling, his knowledge of spiritual questions so profound and his technique so dazzling that he transformed every art form with which he engaged. Indeed, much of the difference between Duquesnoy's *St Susanna* and Cafà's *St Rose of Lima* can be explained by the impact of Bernini's work on his contemporaries. A child prodigy, the talented young Bernini was harnessed early by successive popes, and this put him in an unassailable position of influence and patronage. Even his major rival Alessandro Algardi (1598–1654) felt the influence of Bernini's more dynamic style. It would be only a slight exaggeration to call Baroque sculpture Bernini's invention and thus attribute to him the extraordinary consolidation of the Baroque style which Rome witnessed during the first decades of the seventeenth century. Rome and Bernini must feature prominently in any account of Italian Baroque sculpture because the scale and prestige of Bernini's commissions set a standard which could not be ignored; the number of sculptors passing through Bernini's studio ensured the widest possible dissemination of his art throughout Italy and beyond. Ironically, it was also in Rome that a departure from the High Baroque first manifested itself: the anticipation of Neoclassicism during the early eighteenth century began with projects in the basilica of St John Lateran such as the *Apostles* by Rusconi, Monnot and Legros, among others, and the Corsini Chapel by Galilei.

The Baroque has sometimes been called a re-enactment of the High Renaissance, but at a higher pitch. This is a valid way of stressing a continuity between two periods which would at first seem poles apart. By the early 1620s, informed amateurs articulated a generally held perception that art had declined after the death of Raphael in 1520. As they saw it, much of the art produced in the later sixteenth century had been characterized by rather artifical, self-conscious quotations from Michelangelo and Raphael, as well as by a preoccupation with form over subject matter; this highly stylized current in sixteenth-century art is now generally referred to as Mannerism. The principal figures of Roman art around 1600 began to turn away from an exclusive preoccupation with *maniera* in favour of an art grounded in the ideals of the early 1500s. It was the achievement of Annibale Carracci (1560–1609) and Michelangelo Merisi, called Caravaggio (1571–1610), amongst others to create a new style, based partly upon

14

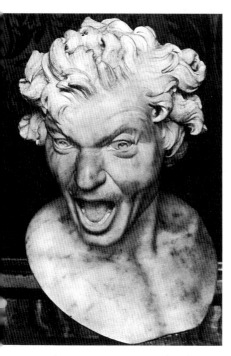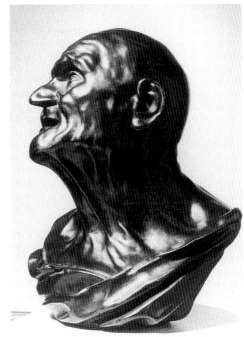

5 Gianlorenzo Bernini, *Damned Soul*, c. 1619. Spanish Embassy to the Holy See, Rome. Marble. Life-size.

6 After Guido Reni, *Seneca*. Made while Reni was in Rome, 1601–14. Private collection, London. Bronze. H. c. 34 cm.

a reformulation of High Renaissance principles and partly upon a new naturalism derived from the study of life models.

The foundation of this new movement in painting was largely laid by the time of the deaths of Carracci and Caravaggio, but a sculptural equivalent only emerged with Bernini's early works during the second decade of the new century. His youthful self-portrait as a *Damned Soul* has been frequently compared to Caravaggio's *Boy Bitten by a Lizard*, a genre piece, especially for its concern with fleeting expressions of emotion, the *affetti* which Leonardo da Vinci had deemed the proper sphere of art. Like Caravaggio, Bernini strove for verisimilitude – with enough idealization to guard against too close a brush with reality – not found in the conventional artistic canon. Before Bernini, no sculptor had attempted to render this kind of sketch as a finished work in marble, but it is interesting to note that even such a fastidious artist as Guido Reni (1575–1642) made similar studies. His

15

6 so-called *Seneca* only survives in plaster and bronze copies, but, rather than being taken from a Classical prototype, it was based on a Dalmatian porter whom Reni had observed in Rome. As with Bernini's *Damned Soul*, Reni's *Seneca* is more emphatic than a comparable production by a Renaissance artist; this stress upon actions and expressions as the principal goals of art would later be encouraged by theoreticians of Seicento art such as Giovan Pietro Bellori. Like the High Renaissance, the Baroque derived its vitality from a direct transcription of physical and emotional states; artists such as Reni and Bernini clearly felt that they were following the precepts of nature and the antique.

 For Baroque artists, nature and the antique were virtually synonymous, but their sense of Classical decorum was less exacting than that of their Neoclassical successors. They admired Hellenistic sculptures like the *Laocoön* or the more recently excavated *Niobids*, with their emphasis upon pathos and movement, for offering new departures for compositions. When Bernini addressed the French Academy in Paris in 1665, he stressed the importance of the study of Classical sculpture over study from the life; he further volunteered that 'when I was in difficulties with my first statue, I turned to the *Antinous* as an

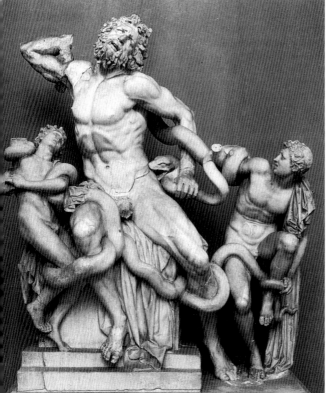

7 *Laocoön*, first century AD. Cortile Belvedere, Vatican Museums. Marble. H. 2.42 m.

(*opposite*)

8 François Perrier, engraving, *c.* 1638, of *Niobids* in the gardens of the Villa Medici, Rome.

9 Engraving of the Belvedere *Antinous* (reversed), from Bellori's *Lives of the Modern Painters, Sculptors and Architects*, 1672.

10 François Duquesnoy, *Rondanini Faun*, antique statue, restored *c.* 1625–30. Victoria and Albert Museum, London, on loan from the British Museum. Marble. H. 1.75 m. (without plinth).

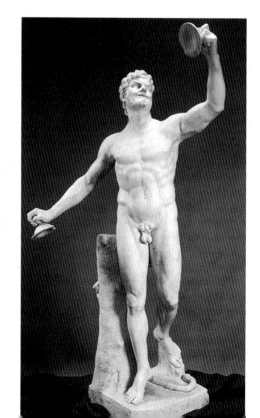

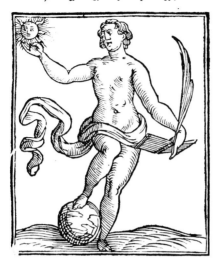

VERITA.

11 Cesare Ripa, Truth, from *Iconologia*, 1603.

12 (*right*) Gianlorenzo Bernini, *Truth Unveiled*, 1646–52. Galleria Borghese, Rome. Marble. H. 2.8 m.

oracle'. In his address, Bernini voiced common opinions which more classically minded artists like Duquesnoy or Algardi would have endorsed. According to Baroque theory, Classical sculpture presented an ideal form of the body, removed from the accidental imperfections found in ordinary human beings; thus it presented a sounder basis for training in the chief task of an artist, namely the representation of the human form. What appears remarkable to us today is how far from the Classical ideal most of Bernini's sculpture seems. Initial sketches show that the *Angel with the Superscription* for the Ponte Sant'Angelo in Rome began with a pose reminiscent of the *Antinous*, yet quickly evolved into something more ethereal and ecstatic, far removed in proportions and subjectivity from its model. Even contemporary restorations of Classical sculpture were not free of Baroque amplification. Duquesnoy's completion of Classical statuary was hailed by his contemporaries as 'absolutely perfect', but his famous *Rondanini Faun* is rejected as a Classical composition by modern archaeologists because its broad movement and open gesture were based upon the aesthetic preconceptions of seventeenth-century art. Likewise, the same sculptor's small bronze *Mercury* approaches Classical bronzes through the example of his Renaissance predecessors, with a sinuosity of movement inconceivable without the example of Giambologna (1529–1608).

One of the greatest gulfs between our world and that of the Baroque stems from the decline of allegory as a literary and artistic

10

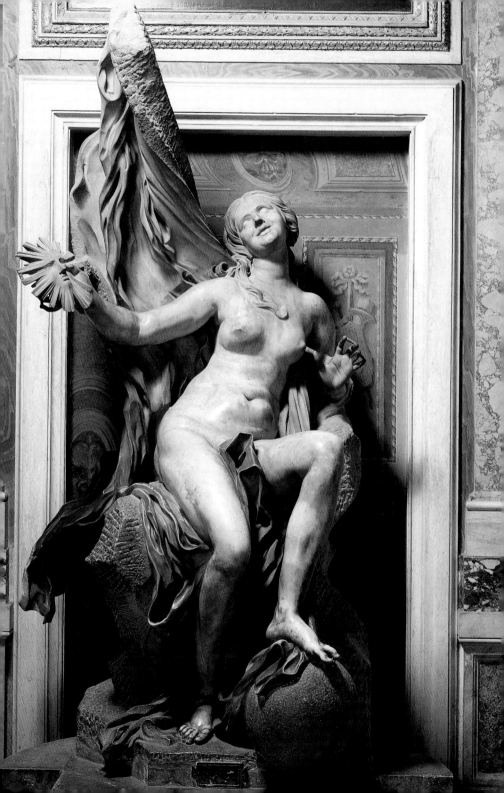

form. Allegory is the technique of describing one sequence of events by alluding to another, chiefly through the medium of narrative. The Greeks and Romans interpreted myths and fables in this manner, and allegorical commentaries on Ovid's *Metamorphoses* and Virgil's *Aeneid* formed staple parts of a Classical education until the nineteenth century. Similarly, Christians were encouraged by the Gospels and St Paul to read the Old Testament as a symbolic precursor of the New. Such habits of mind persisted well into the eighteenth century, colouring the expectations of patrons and artists alike. When Nicolas Poussin (1594–1665) wrote to his friend Chantelou about a painting of the Israelites gathering manna, he encouraged him to 'lisez l'histoire et le tableau', by which he meant to read the painting symbolically as well as literally. Such habits needed little prompting as they were engrained by sermons and didactic literature. It was in this spirit that Cardinal Maffeo Barberini composed an inscription to Bernini's *Apollo and Daphne*, drawing a moralistic conclusion about the pursuit of illusory pleasures leading to the fruit of disillusionment.

Such ideas are not uppermost in our minds as we marvel at the sculptor's *tour de force*, but for a contemporary audience such associations were rarely far from the surface. Indeed, allegory was understood as a way of penetrating the mysteries of the natural world which antiquity had enveloped in myth. Thus Nicola Salvi (1697–1751) explained the programme of his Trevi Fountain as an allegory of water being the animating principle of nature; as he argued, 'the ancient deities have always symbolized useful lessons in moral philosophy or have contained hidden explanations of natural phenomena'.

The popularity of allegory in this period is attested by numerous compilations of mythology; the single most influential volume was, undoubtedly, Cesare Ripa's *Iconologia*. First published in 1593 and again in an illustrated edition ten years later, Ripa's book furnished 11 handy descriptions of personifications – virtues, vices, even continents – which could be embodied in the visual arts. Ripa assembled his text, and later the illustrations, from Classical authors, statuary and Roman coins, and advocated his book's utility for poets and artists alike. Its popularity is attested by the numerous reprintings and foreign editions which appeared until the latter part of the eighteenth century; thereafter it fell out of fashion and remained so until its rediscovery earlier this century.

12 When Bernini carved *Truth Unveiled* in the late 1640s, he took the design directly from the pages of Ripa. Thus, he represented Truth as

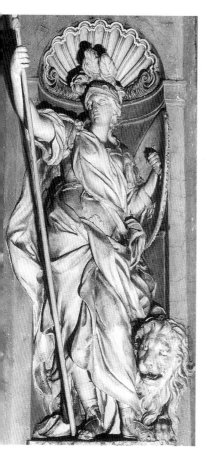

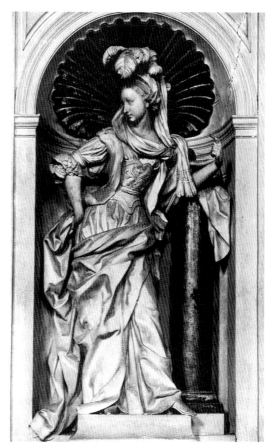

13 Camillo Rusconi, *Fortitude*, 1685–6. Ludovisi Chapel, Sant'Ignazio, Rome. Stucco.

14 Giacomo Serpotta, *Fortitude*, 1710–17. Oratorio del Rosario di San Domenico, Palermo. White stucco and gilding.

female – most abstract qualities are of the feminine gender in Latin – and nude because, as Ripa has it, 'her nature is simplicity'. She springs from the earth, which is represented by the globe at her feet, and holds an image of the sun in her right hand because she loves the light and is light herself. The statue had a deeply personal meaning for the sculptor, because he carved it when he was out of papal favour; it is striking that he chose to give vent to his feelings in such an indirect way. But this indirectness was typical of the contemporary demand for allegorical subjects on tombs, altars and in gardens. Even

21

as late as 1759, when Pietro Bracci (1700–1773) planned his monument to Pope Benedict XIV in St Peter's, he turned to Ripa for his representation of the rare and unusual virtue of Disinterestedness, shown as a woman refusing money.

Even though most sculptors plundered Ripa for ideas, the results differed considerably. When Camillo Rusconi (1658–1728) and Giacomo Serpotta created statues of *Fortitude*, both were female. Serpotta's was given a column as her attribute, while Rusconi's is a more conventional, Minerva-like figure in armour. Apart from a rather dainty breastplate, the emphasis of Serpotta's statue is unexpectedly contemporary, from her plumed hat to her high-heeled shoes. In part, this reflected the difference in ambience between Serpotta's native Palermo and Rome, as well as his bravura as a stuccoist, yet it also reflected another aspect of allegory, namely, as Ripa observed, that 'every virtue is a species of the true, beautiful, and desirable' and should consequently be rendered as such to delight the intellect.

Ripa did not explain everything about Baroque allegory, but his book provided new ways of conveying abstract ideas in concrete terms. No instance in Italian sculpture of this period is more extreme than the Sansevero Chapel in Naples, which was transformed into a sculptural pantheon by Raimondo di Sangro, Prince of Sansevero, in the 1750s. By importing Antonio Corradini (1688–1752) from Venice and Francesco Queirolo (1704–1762) from Genoa, the Prince of Sansevero evolved an elaborate programme of monuments and medallions to celebrate generations of his family, each in the light of a guiding virtue. The subjects of the tombs included Sincerity, Religious Zeal and Liberality, but the most remarkable works are Corradini's *Modesty* and Queirolo's *Release from Deception*. Paired in the chapel's presbytery, they were conceived as monuments to the patron's mother and father respectively. Like the other memorials there, the two works can be traced back to images in Ripa, but the sculptors' virtuosity transcends the rather crude woodcuts of the *Iconologia*. As with a painting by Rubens or Poussin, the sculptures have to be 'read' as well as seen. Corradini's *Modesty* brilliantly exploits the contradiction between the properties of marble and the transparency of the veil that both obscures and reveals the figure. The broken tablet at Modesty's side refers to the premature death of the patron's mother while the theme of purity is underscored by the relief on the pedestal which shows Christ appearing to the Magdalen after the Resurrection. Queirolo's *Release from Deception* inverts this theme

15 Antonio Corradini, *Modesty*, 1745–52. Sansevero Chapel, Santa Maria Pietà dei Sangro, Naples. Marble. H. 1.95 m.

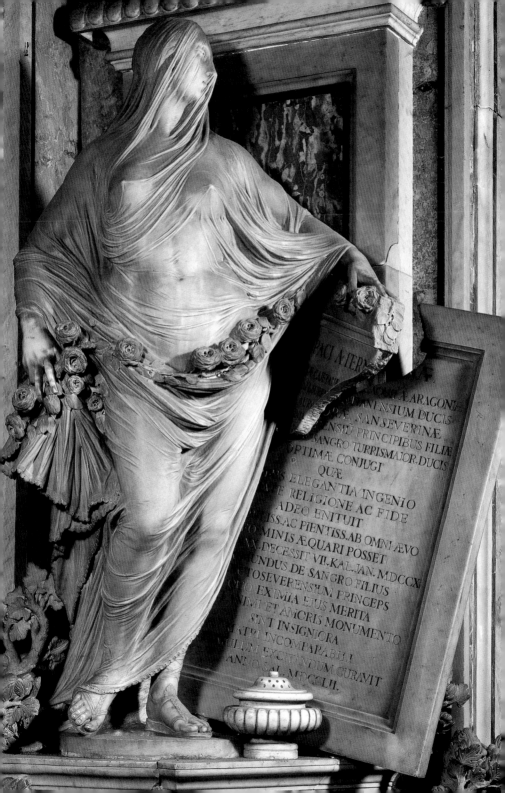

of veiling to show a man's emergence from the snares of error. It is, in fact, a self-portrait of the sculptor, as he is being helped from a net of cords by his own intellect, shown in the guise of a winged boy; the intellect points at the world, the source of deception, with a sceptre, while beneath a relief shows Christ healing a blind man.

Contemporaries praised the sculptures of the Sansevero Chapel as surpassing Classical art in conception and accomplishment. But three generations later, the Neoclassical critic Leopoldo Cicognara condemned the work of Corradini and Queirolo as 'puerile and mechanical', their technical bravura misspent in an idle show. The repudiation of allegory had made the Baroque seem shoddy and unnatural by the early nineteenth century, a stigma from which works like the Sansevero Chapel still suffer.

Hand in hand with allegory went a fusion of the didactic and illusionistic in Baroque art. Illusionism runs through virtually all manifestations of Baroque sculpture, bridging the gap between the spectator and the work of art. At its most elemental, this can be appreciated in portrait busts, where hair, flesh and costume are contrasted by degrees of polish and shading, but it also encompassed still-life, ephemera and interiors such as the *salone* in the Venetian Palazzo Albrizzi by Abbondio Stazio (1675–1757). Galileo neatly defined this artistic challenge when he wrote that 'imitation is all the more admirable when the means of imitation are far removed from the object to be imitated'. In Baroque art, such mimicry formed the basis of illusionism which often employed the natural world as a metaphor for the supernatural. Bernini's technical virtuosity led him again and again to efface the boundaries between painting and sculpture, as he did to such effect in his brilliant mythological groups, and ultimately to fuse painting, sculpture and architecture into a single entity or *bel composto*, as he did in his masterpiece, the Cornaro Chapel, in Santa Maria della Vittoria in Rome. Though embraced more vigorously outside Italy than within, the example of Bernini's *bel composto* demonstrated that sculpture could assume roles which had previously been solely within the domain of painting. In didactic terms, the *bel composto* became the ideal vehicle for Baroque art since it drew upon a visual sleight of hand coupled with the general tendencies for sculpture to acquire pictorial values and for architecture to assume the plastic quality of sculpture. In the Cornaro Chapel, the architecture directs the onlooker towards the altar tableau, the *Ecstasy of St Teresa*, which seems to exist somewhere beyond the walls of the church itself; moreover, the central image presents us with the uncanny

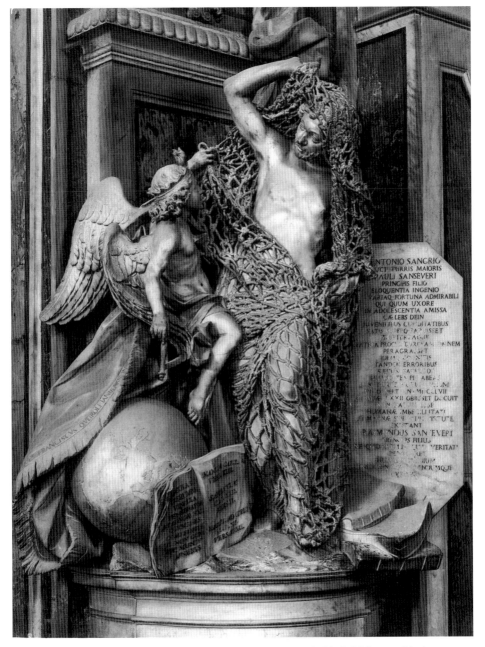

16 Francesco Queirolo, *Release from Deception*, 1752–9. Santa Maria Pietà dei Sangro, Naples. Marble. H. *c.* 1.95 m.

spectacle of marble figures hovering in the air, bathed in a golden light that has assumed palpable form as gilded rays.

It is testament to the many differences between our outlook and his that Bernini could represent an ecstatic state in such obviously physical terms, and indeed the debased coinage of words such as 'ecstasy' scandalized eighteenth- and nineteenth-century commentators. The famous quip of Charles de Brosses in 1739, 'if this is divine love, I have experienced it', is one of the earliest in a series of misunderstandings of Bernini's audacious work; the saint and her angel were even transformed into Venus and Cupid for a tapestry designed by François Boucher. Aldous Huxley expressed the characteristic modern reaction when he confessed to feeling as if he had opened a bedroom door 'at the most inopportune moment' while viewing the Cornaro Chapel and the Altieri Chapel which contains the *Blessed Ludovica Albertoni*. But the intertwining of death and sexual union would have been understood rather differently by Bernini's contemporaries, for they recognized, as did St Teresa, that the body was like a musical instrument of a given range on which different melodies overlapped: the physical signs of ecstasy could be a metaphor for spiritual ecstasy. Thus, Baroque art differed little from the medieval Franciscan emphasis upon the physical nature of Christ as a means of understanding the mystery of the Incarnation. The concept of a ladder of ascent from the physical to the spiritual world was an idea, revived by figures such as St Ignatius Loyola and St Teresa, which enjoyed great vogue in the seventeenth and eighteenth centuries.

Baroque art has been damned for dealing in a sham world and distracting the spectator from its inherent spiritual poverty with dazzling technical displays. For its most gifted exponents, Baroque art addressed serious questions about the nature of art and reality. By striving to transcend the limitations of individual media, it conveyed a multi-sensory experience in a manner comprehensible to lay people. Thus far, we have broached some of the salient features of Italian Baroque sculpture. Characteristic forms, such as tombs, fountains and portraiture, will be examined in more detail in subsequent chapters, but to understand how the mature expression of Italian Baroque sculpture evolved, we should first trace its origins to Rome at the turn of the seventeenth century.

17 The Pauline Chapel in Santa Maria Maggiore, Rome, 1603–15, designed by Flaminio Ponzio, showing the monument to Pope Paul V.

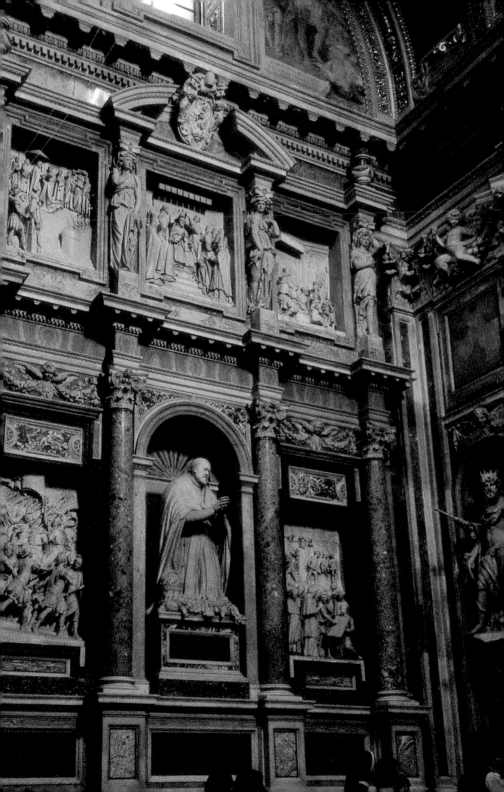

The Origins of Italian Baroque Sculpture

We began with Milizia's diatribe against Bernini, Borromini and Cortona as the originators of the 'plague' of Baroque art. Purged of its negative associations, the observation points to the fact that all three great artists were active in Rome during the first third of the seventeenth century when the Baroque emerged as a dominant style in all three arts. But they did not arrive unheralded. Rather, they built upon movements that were already underway around the turn of the century, due largely to the revitalization of the papal state by Pope Sixtus V, who reigned from 1585 to 1590.

Pragmatic and pious, Sixtus rose through the Roman Curia and proved himself an able administrator by reforming the papal bureaucracy and bequeathing a rich treasury to his successors. Clearly, he understood economics, observing that 'poor princes and . . . poor popes come to be despised, even by children, particularly in this age when one can do anything with money'. As a patron of the arts, Sixtus was prolific but undiscriminating: he built new palaces at the Lateran and the Vatican, restored the old Aqua Alexandrina and laid out new streets, fountains and piazzas with obelisks. Sixtus was not innovative, but the scale of his achievement was unprecedented and established a benchmark for his successors. Most of his urban interventions centred on the old basilica of Santa Maria Maggiore where he constructed a large chapel with monuments to himself and his early patron, Pope Pius V. Again, it was not the quality of workmanship but the scale of the tombs, the sumptuousness of the coloured marbles and the profusion of reliefs and statuary which foreshadowed the major characteristics of Baroque art.

17

Sixtus established a highly centralized rule as pontiff, but, in an age before an impartial civil service, each pope needed a trustworthy confidant to share the burdens of office, hence the custom of making a nephew or close relation a cardinal with the powers of a secretary of state. Such nepotism was expedient, and meant that each new papal family felt the need to consolidate power, expressing its status through new or enlarged palaces, villas, family chapels and elaborate tombs.

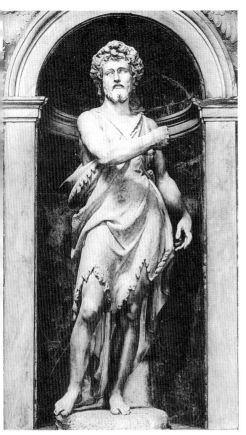 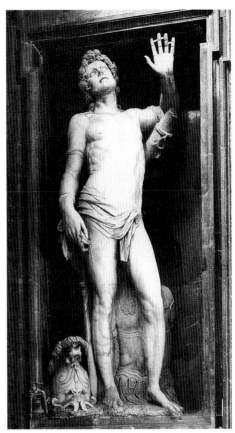

18 Ambrogio Bonvicino, *St John the Baptist*, 1602–3. Chapel of St Sebastian,
Santa Maria sopra Minerva, Rome. Marble.

19 Nicolas Cordier, *St Sebastian*, 1604. Aldobrandini Chapel, Santa Maria sopra
Minerva, Rome. Marble. H. 1.99 m.

Although this proved harmful to the papal economy in the long term,
it made Rome a dynamic centre for the arts in a way that it had not
been since the early sixteenth century. Two long papal reigns cover
the evolution of the Roman Baroque, those of Paul V (1605–1621)
and Urban VIII (1623–1644) with the brief interlude of Gregory XV
in between. Paul V saw himself as a second Sixtus V, a restorer of aque-
ducts and a prominent patron of the arts. He it was who ended the
debate on the final form of St Peter's by agreeing to add a nave to
Michelangelo's centrally planned church, thereby sanctioning its
transformation into a Baroque showcase. His cardinal-nephew,

Scipione Borghese, was a rapacious collector of ancient and modern art, who resorted to theft when bribery would not work. His villa outside the Pincian gate boasted works by Raphael, Domenichino (1581–1641) and, towards the end of his uncle's reign, the first major works of Gianlorenzo Bernini.

Art in Rome between 1590 and 1640 was highly fluid. The rigorous distinctions between Caravaggio, as arch-naturalist, and Annibale Carracci, as champion of a neo-Renaissance, were a later imposition that blurred the dialogue between artists of all persuasions. The city was large enough to support a great variety of artists, all of whom could ascend the ladder of patronage which encompassed minor clerics, nobles, the greater ecclesiastic and aristocratic magnates, and reached its apex in the papal family. The state of the arts in Rome around 1613 can be gauged by the recently completed Pauline Chapel, which Paul V created as a pendant to Sixtus's chapel on the opposite side of Santa Maria Maggiore. Here Italian and foreign artists collaborated on the elaborate papal tombs and frescoes. Although the result is overwhelming in its opulence and anticipates High Baroque art in its mixture of media, its sum is less than its parts; what is lacking is a dominant artistic will to fuse the components into a unified composition. This problem is also apparent in the work of fashionable sculptors like Ambrogio Bonvicino (c. 1552–1622) and the Frenchman Nicolas Cordier (1567–1612), who produced bland and often facile works for papal families such as the Aldobrandini, Borghese and Barberini.

There were, however, stirrings of a new style in the works of Stefano Maderno (1576–1636) and Francesco Mochi (1580–1654),

20 Stefano Maderno, *St Cecilia*, 1600. Santa Cecilia in Trastevere, Rome. Marble. Life-size.

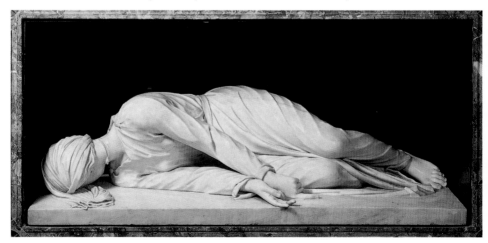

21, 22 Francesco Mochi. (*Left*) *Virgin Annunciate*, 1608–9. (*Right*) *Angel of the Annunciation*, 1603–5. Museo dell'Opera, Orvieto. Marble.

two sculptors who made a name for themselves at the turn of the century. Maderno's *St Cecilia*, dating from 1600, commemorates the discovery of the body of this early Christian martyr in her Roman basilica. The sculptor presents her as she was found, her severed head turned away from the spectator, her right hand pointing towards her feet. The understatement heightens the work's impact while the subject matter is typical of the Catholic Church in the decades following

the Council of Trent. Though he continued working into the 1630s, Maderno was never to produce an absolute masterpiece like the *St Cecilia* again.

More tantalizing, in many ways, was the brief Roman career of Camillo Mariani (*c.* 1565–1611). Born in Vicenza, Mariani trained in the school of Alessandro Vittoria (1525–1608) and late sixteenth-century Venetian sculpture, where the emphasis lay in formal elegance allied to direct and simple gestures. These features emerge notably in his large stucco figures for the Roman church of San Bernardo alle Terme, works which have rightly been compared to late Veronese as well as Vittoria. Had Mariani lived longer, he might have established himself as the major presence in Roman sculpture; his influence did, however, linger in the works of the Tuscan sculptor Francesco Mochi, who collaborated with him at San Bernardo alle Terme and worked in both Orvieto and Rome during the first decade of the century. Far more idiosyncratic than Mariani as a sculptor, Mochi first achieved 22 fame with his *Angel of the Annunciation* of 1603–5 for Orvieto Cathedral, a work whose vigour and directness reflect the artist's earnestness in reformulating a conventional theme. Three years lie 21 between the *Angel of the Annunciation* and the *Virgin Annunciate* which completed the composition. Here Mochi evoked reminiscences of Rome, in particular the suavity of Mariani and the more active type of Classical statuary, but added his own flair for dramatic gestures by showing the Virgin starting from her chair. Mochi's work has sometimes been explained as a response to Caravaggio, yet it is better understood as part of a general concern with conveying emotions through external expressions, something manifest in the work of Carracci and Reni, as well as that of Caravaggio. Interestingly enough, the forcefulness of Mochi's *Virgin Annunciate* was not to the liking of the Bishop of Orvieto, who opposed its placement in the cathedral for three years. Despite this setback, Mochi obtained a major commission in Rome from Cardinal Maffeo Barberini, the future Pope Urban VIII, for a *St Martha* for his family chapel in Sant'Andrea della Valle. The Barberini Chapel was a showcase for the most talented Roman sculptors in the era of Bernini's emergence, and Mochi competed there with the likes of Bonvicino and Gianlorenzo's father, Pietro Bernini (1562–1629). A brief comparison between 24, 25 Mochi's *St Martha* and Pietro Bernini's *St John the Baptist* reveals the distance between the two sculptors. Mochi's figure is tense and probably overly motivated for the narrow confines of the niche, yet it has a vigour absent from Pietro Bernini's boneless and enervated figure.

32

23 Camillo Mariani, *St Catherine of Alexandria*, 1599–1600. San Bernardo alle Terme, Rome. Stucco.

Pietro Bernini's gifts lay more in the field of decorative sculpture; Mochi's work often displays an idiosyncratic, at times obstinately individualistic, flair which made him stand out among a mediocre range of competitors. But Mochi failed to consolidate his reputation in Rome, and his employment by the Farnese family meant that he passed many of the years between 1612 and 1629 in their fiefdom of Piacenza. When he returned to Rome in 1629, Mochi was effectively marginalized by Pietro Bernini's son.

The elder Bernini enjoyed a peripatetic career in Florence and Naples before moving to Rome in 1605, where he produced a number of sculptures of uneven quality and a decidedly archaic flavour. But he knew the works of Giambologna at first hand and collaborated with one of Giambologna's pupils, Giovanni Caccini (1556–*c*. 1612);

33

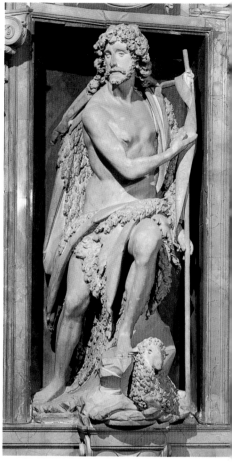

24 Francesco Mochi, *St Martha*, c. 1609–21. Sant'Andrea della Valle, Rome. Marble. H. 2.4 m.

25 Pietro Bernini, *St John the Baptist*, 1612–15. Sant'Andrea della Valle, Rome. Marble. H. 2.43 m.

this knowledge he passed on to his more gifted son. Pietro's technical expertise was quickly recognized in Rome, for he received prominent commissions in Santa Maria Maggiore, the most memorable being the handsome relief of the *Assumption of the Virgin* for the sacristy. Inspired by contemporary paintings of the subject, Pietro Bernini's relief illustrates his virtuoso marble-carving ability and his exploitation of pictorial affects, more skills that he passed on to the young Gianlorenzo. At the same time, the relief is rooted in an

26 Pietro Bernini, *Assumption of the Virgin*, commissioned 1606. Baptistery, Santa Maria Maggiore, Rome. Marble relief.

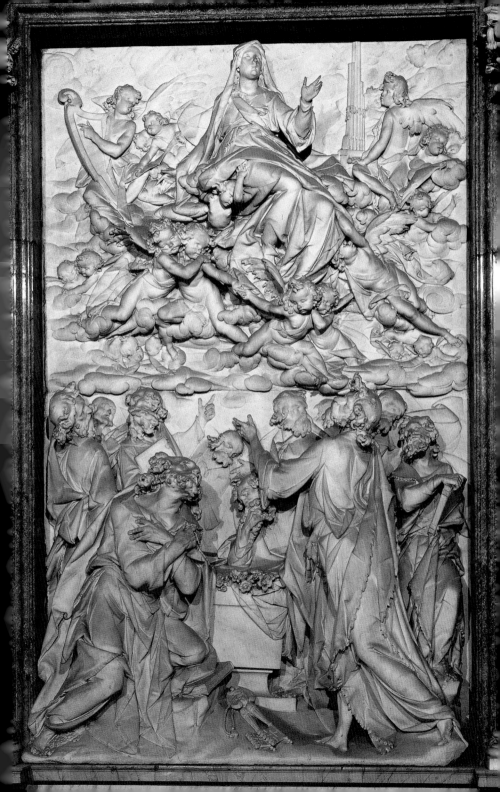

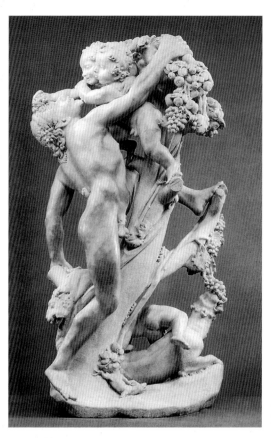

27 Pietro and Gianlorenzo Bernini,
Faun Teased by Cupids, c. 1616–17.
The Metropolitan Museum of Art,
New York. Marble. H. 1.32 m.

approach to relief sculpture which differs little from the famous
scenes of the life of the Virgin by the fourteenth-century Florentine
sculptor Andrea Orcagna.

Pietro Bernini subsequently worked on the tomb of Clement VIII
in the Pauline Chapel at Santa Maria Maggiore and, as we have seen,
in the Barberini Chapel at Sant'Andrea della Valle. His commissions
thus brought him into contact with the foremost ecclesiastical patrons
who were to play a crucial role in the early career of his son. Pietro
Bernini had talent and phenomenal technical ability, and in some
works, such as the *Faun Teased by Cupids* in the Metropolitan Museum,
a strong overlap with the first independent works of his son is appar-
ent. But despite his considerable gifts, he lacked panache; as his
contemporary, Giovanni Baglione put it, 'had he had greater compo-
sitional ability, he would have been a remarkable artist'.

Instead, Pietro Bernini produced a remarkable son, who, more than any other artist, mobilized Italian sculpture in a decisively new and influential manner. Although born in Naples, the younger Bernini was fortunate to grow up in Rome where the best of ancient and modern art was constantly before his eyes. From his father, Gianlorenzo Bernini inherited a formidable prowess in marble carving, and his early training introduced him to leading artists such as Annibale Carracci, and connoisseurs such as Maffeo Barberini, who seems to have taken charge of the young sculptor's education. From the outset, Bernini challenged both the conventions and limitations of his chosen medium, pushing marble carving in new directions. His *Martyrdom of St Lawrence*, executed around 1614–15, displays an astonishing precosity and enunciates many of the preoccupations of his later career. The saint is shown suffering martyrdom on the gridiron, an image frequently depicted in painting, but never before in sculpture. The *Martyrdom of St Lawrence* has been called a 'sculptural painting', and it is not difficult to see why: fire and smoke were among the most difficult effects for an artist to represent, yet Bernini conveys the impression of glowing coals and wood, white hot in a marble fire. The heroic figure of the Roman deacon gestures like a Christian *Laocoön*, midway between the pain of torment and his ardour for martyrdom.

28 Gianlorenzo Bernini, *Martyrdom of St Lawrence, c.* 1614–15. Contini Bonacossi Collection, Florence. Marble. 66 × 108 cm.

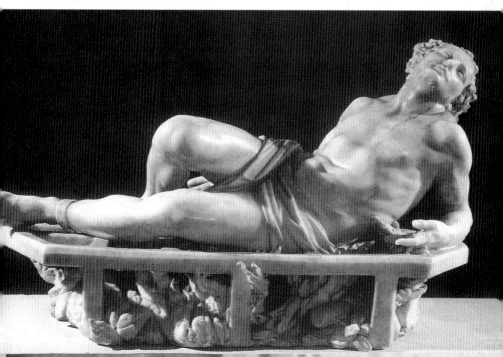

The *Martyrdom of St Lawrence* was created as a vehicle for the young Bernini's art and was an astoundingly assured work for an adolescent. It demonstrated an easy familiarity with the full repertory of artistic expression and placed the age-old debate over the merits of painting versus sculpture, the *paragone* of Renaissance art, on a new footing. It also crystallized aspects of the debate on art that followed the deaths of Carracci and Caravaggio, who had progressed from the self-conscious style known as Mannerism. The best artists, as one contemporary amateur wrote, combined *maniera*, namely imagination and technical expertise, with *natura*, an attention to real objects. This union of *maniera* and *natura* in the art of Carracci and Caravaggio was matched in sculpture by Gianlorenzo Bernini. His talent also attracted the attention of patrons like Cardinal Scipione Borghese, the powerful nephew of Pope Paul V, who shortly thereafter entrusted Bernini with a series of sculptural groups that tested the young man's abilities and pitted him against Michelangelo and Giambologna, the greatest sculptors of the previous century.

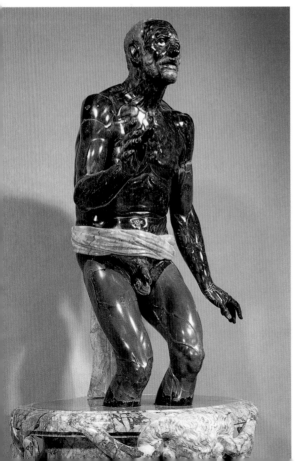

29 *Dying Seneca*, a Roman copy of a Hellenistic sculpture, third century BC. Louvre, Paris. Black marble, enamelled eyes and belt of antique alabaster (restored). H. 1.18 m. (with vase).

30 (*right*) Gianlorenzo Bernini, *Aeneas, Anchises and Ascanius*, 1618–19. Galleria Borghese, Rome. Marble. H. 2.2 m.

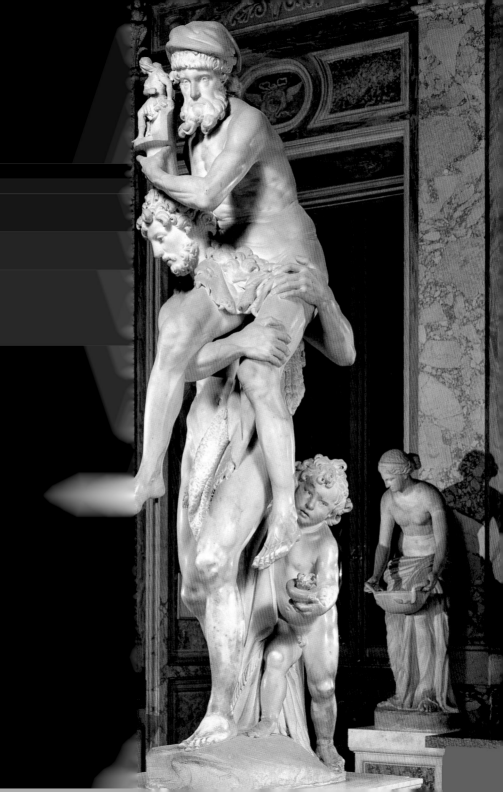

These groups occupied Bernini between 1618 and 1625 and would be remembered only as essays in virtuoso technique were it not for the imaginative capacity and multi-layered allusions they possess. The first was an *Aeneas, Anchises and Ascanius*, which records the flight from Troy of Aeneas, the legendary founder of Rome, and foreshadows the later empire of the Catholic Church. It was a work that contained resonances from literature and the contemporary political scene, invoking Virgil's *Aeneid* and representing, by use of allegory, Cardinal Borghese's piety and support for his uncle in the affairs of state. It was a subject rarely attempted by painters or sculptors, but Bernini found inspiration in an analogous group in Raphael's fresco, the *Fire in the Borgo*, in the Vatican Stanze which had been published as Aeneas fleeing Troy in a woodcut. Bernini's group is a *tour de force*, all the more so as the sculptor had to fit three figures within the confines of a single block of stone. Bernini exploits a creative assymetry by placing the aged Anchises on one shoulder of his son, the pose of Aeneas answering that of his father in the opposite direction. The hero's superb physique also recalls the nude *Christ* in Santa Maria sopra Minerva, one of Michelangelo's most classically conceived works. Despite these associations, *Aeneas, Anchises and Ascanius* differs considerably from Raphael's *Fire in the Borgo*: where Raphael presented the three ages of man in wholly identical form, Bernini adds a greater degree of verisimilitude in his characterization of the chubby child and the skeletal form of the older man, an idea already to be found in Domenichino's *Last Communion of St Jerome* of 1614 or in the late antique sculpture known as the *Dying Seneca*, then in the Borghese collection.

Bernini's early works reveal his engagement with the traditions of Classical and Renaissance art. His works were not entirely novel, but they encompassed *novità*, as his contemporaries understood the term. *Novità* did not mean originality but rather the reworking of an older theme which transformed it into something unexpected. A good example can be found in *Pluto and Proserpina*, created for Cardinal Borghese between 1621 and 1622. The two-figure composition is obviously indebted to Giambologna's mythological groups in which a captive or vanquished figure is held aloft by the victor. The specific work Bernini had in mind was Giambologna's most famous abduction group, the *Rape of a Sabine*, probably known in its earlier two-figure version, but the balletic quality of Giambologna's group has here been replaced by a dramatic collision between captor and captive, a juxtaposition Bernini's son, Domenico, later described as a 'remarkable

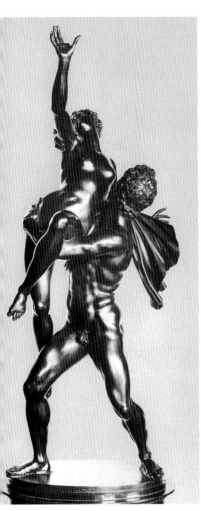

Giambologna, *Rape of a Sabine*.
Cast by Antonio Susini, *c.* 1585.
Kunsthistorisches Museum, Vienna.
Bronze. H. 98.2 cm.

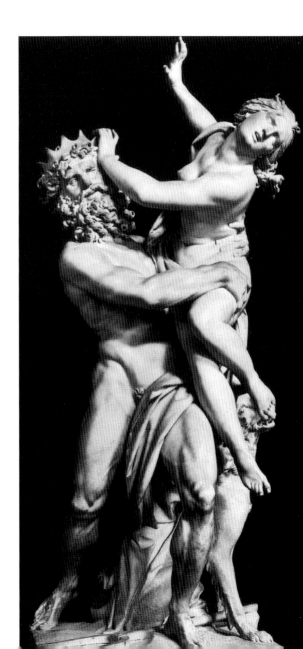

32 Gianlorenzo Bernini, *Pluto and
Proserpina*, 1621–2. Galleria Borghese,
Rome. Marble. H. 2.25 m.

contrast between tenderness and cruelty'. Such a contrast would have been more striking in its intended setting in the Villa Borghese, where the story would have unfolded as the spectator moved around the statue, taking in the striding god of the underworld and, gradually, his struggling captive and menacing three-headed dog, Cerberus. Yet it is this collision of physical types and emotional gestures that makes the work so memorable. The puzzled amusement of Pluto contrasts with the frozen tears and cry of Proserpina, while his bristling Hellenistic torso contrasts with her soft voluptuous form. The overall effect is heightened by small touches such as Pluto's fingers sinking into Proserpina's flesh, or her hand distorting his brow and left eye.

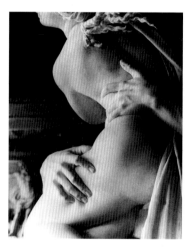

33 Gianlorenzo Bernini, *Pluto and Proserpina*, 1621–2. Detail.

The fluid, sensuous nature of Bernini's creations animated mythological sculpture to such an extent that it was never the same again. Some years later, Pietro da Cortona (1596–1669) seems to have created his *Rape of the Sabines* as a challenge to Bernini's sculpture, reasserting painting's ability to render such scenes. Bernini's most celebrated contribution to this genre was the *Apollo and Daphne*, begun for Cardinal Borghese in 1622; it was a substitute for the *Pluto and Proserpina*, which had been given to the new papal nephew, Cardinal Ludovisi, as a peace-offering. Here again, Bernini's genius lay in harnessing his formidable technique to an episode rarely attempted by earlier artists: the moment when the nymph Daphne is saved from Apollo's unwanted attentions by her transformation into a laurel tree.

36, 37

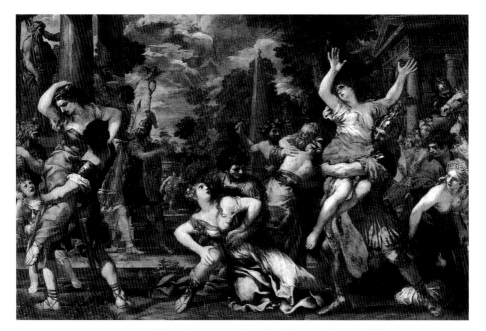

34 Pietro da Cortona, *Rape of the Sabines*, 1629. Capitoline Museum, Rome. Oil on canvas. 2.75 × 4.23 m.

Bernini doubtless knew and admired Domenichino's frescoes dedi- 35 cated to Apollo at the Villa Aldobrandini at Frascati where the chase of Daphne was depicted, but Domenichino makes this an episode in a large landscape. The sculptor would also have known Ovid's version of the story and the reinterpretation of it in Giambattista Marino's poem *Dafne* of 1620, with its emphasis on flight and immobility which builds to a crescendo at the moment of transformation. The group was originally placed against a wall in the Villa Borghese, and the first thing visible would have been the back of Apollo, the full nature of the sculpture only being revealed gradually as the spectator strode around it. When viewed straight on, it functioned like a three-dimensional relief, and part of the delight engendered by the group came with the growing recognition of the famous myth and Bernini's miraculous presentation.

Apollo and Daphne was immediately greeted as a modern classic; it remained virtually the only work by Bernini admired in the eighteenth and nineteenth centuries. Apollo proclaims his pedigree as a descendant of the famous *Belvedere Apollo*, but acclaim has chiefly

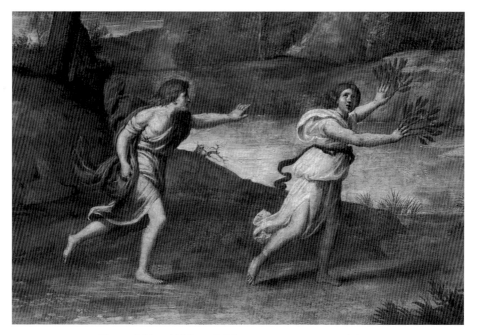

35 Domenichino, Aldobrandini frescoes, *c.* 1616–18. Detail showing Apollo and Daphne. National Gallery, London. 3.11 × 1.89 m.

been drawn to the astonishing mimicry of flesh, bark and leaves in marble. The use of various degrees of polish within the work was a revolutionary technique, and as Bernini's biographer Baldinucci observed, 'the chisel [was] used in such a way that one could believe it had been cutting wax instead of marble'. The daring would have seemed all the greater since the original base was much smaller and only later expanded to its present dimensions. Of course, Bernini did not carve the *Apollo and Daphne* alone. Giuliano Finelli (1601–1657) was responsible for some of the more dazzling passages of tendrils and sprouting leaves, but Bernini had envisaged the potential of marble for new and unexpected effects.

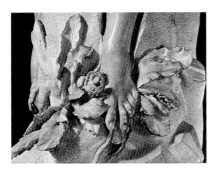

36 Gianlorenzo Bernini, *Apollo and Daphne*, 1622–5. Detail of roots and bark.

37 (*right*) Gianlorenzo Bernini, *Apollo and Daphne*, 1622–5. Galleria Borghese, Rome. Marble. Life-size. H. 2.43 m.

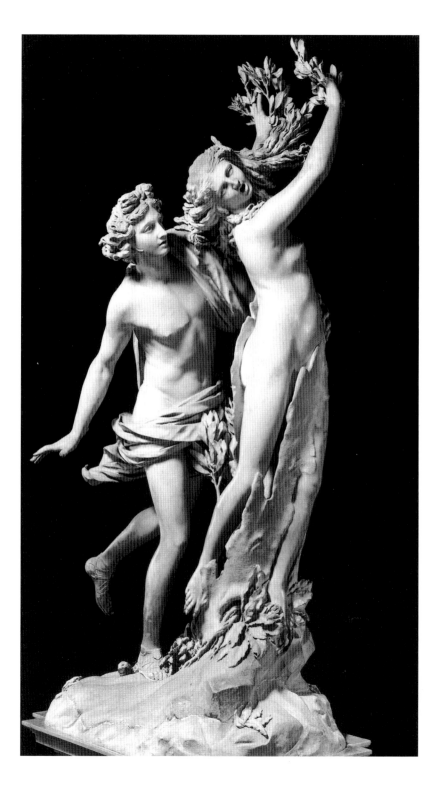

His capacity and imagination were soon placed upon a greater stage with the election of his mentor Maffeo Barberini as Pope Urban VIII in 1623. Urban believed that Bernini would be the Michelangelo of his reign, hoping that the sculptor would eventually produce masterpieces of painting as well as sculpture and architecture. Though Bernini never proved himself a great painter, he quickly demonstrated his flair for architecture with the gilt bronze Baldacchino in the crossing of St Peter's. Domenico Bernini perceptively remarked that his father had 'to leave behind the rules of art' in order to create a structure that would register under Michelangelo's dome, and Bernini's fusion of two distinct types of structure, the ciborium and suspended canopy or baldachin, was characteristically audacious, bending the rules of architecture without quite breaking them. Bronze allowed Bernini to create the famous Solomonic columns on a scale in keeping with the gigantic proportions of the crossing; much of the Baldacchino's fascination stems from its constantly changing relationship with spectators moving through the basilica, combined with the corkscrew effect of the columns.

38 (*below left*) Andrea Bolgi, *St Helen*, 1630–9. St Peter's, Rome. Marble. H. 4.5 m.

39 (*below right*) Gianlorenzo Bernini, model for *St Longinus*, 1630–1. Fogg Art Museum, Cambridge, Mass. Gilded terracotta. H 52.7 cm.

40 (*right*) Gianlorenzo Bernini, *St Longinus*, 1629–38. St Peter's, Rome. Marble. H. 4.5 m.

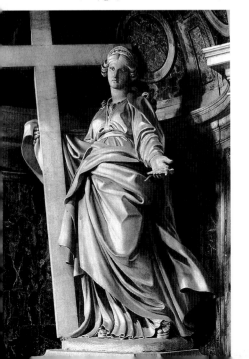

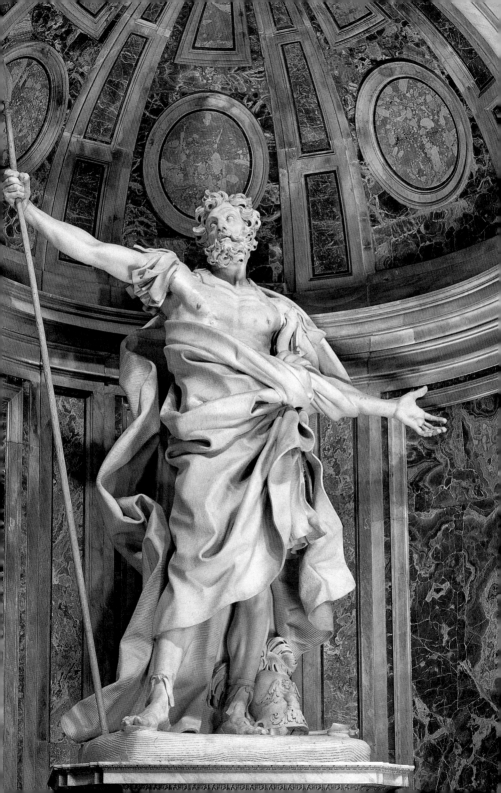

As part of the project, Bernini was charged with reorganizing the crossing piers of St Peter's with colossal statues of the four saints whose relics were to be contained in niches above. The original models for the figures were planned by Bernini as early as 1628, although their execution required the participation of three other sculptors whose personal styles did not always harmonize with Bernini's. To create a colossal sculpture required numerous models, and we know that Bernini made over twenty for the work he carved, the *St Longinus*. One small model survives, whose gesture and drapery are far more conventional than the finished work; the model's sense of repose is not very different from the rather bland *St Helen* by Bernini's trusted assistant Andrea Bolgi (1605–1656). Bernini perceived, however, that a finished marble based on this model would lack conviction across the distances of the great basilica; instead he decided to exploit the dramatic moment when Longinus, the Roman centurion present at the Crucifixion, acknowledged Christ to be the son of God. Bernini conveyed this by the expansively spread arms (a pose unprecedented for statuary), by the cascades of drapery and the dishevelled locks of hair. In effect, Bernini built upon the example of his own *Neptune and Triton*, indulging in the rhetorical amplification of his theme much as an orator would elaborate on a point with figures of speech. He realized that drapery could not really quake of its own volition, but took liberties with the rules in order to create the resonance his statue needed. He might have justified the emotionally charged body language of his work by the need to externalize the inner turmoil of conversion. St Augustine had written of the amplification of internal, invisible movements by visible ones so that 'the emotions of the heart, which preceded them in order to produce them, increase because they have been executed'.

Thus, with *St Longinus*, the full-blown Baroque statue came into being, but it is important to remember that what we might call the 'theatrical' appearance of the work was the result of a reasoned study of human psychology coupled with the problems of working with five blocks of marble on an outsize scale of almost four and a half metres. Bernini always demonstrated an acute sensitivity to the settings of his works and their visibility. The massive bulk of the statue was methodically scored with a toothed chisel so that it would absorb light and create balanced contrasts. This made it more intelligible from a distance than the companion pieces by Bolgi, Mochi and Duquesnoy. Of these three sculptors, Bolgi collaborated on this project very much as a safe and competent pair of hands but not as a

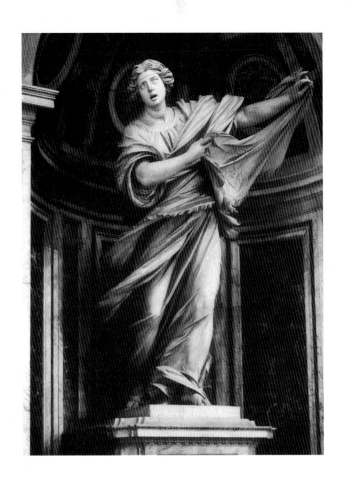

41 Francesco Mochi,
St Veronica, completed
1629–32. St Peter's, Rome.
Marble. H. 5 m.

threatening competitor. Mochi and Duquesnoy were of a different
order, though Mochi spectacularly misjudged the opportunity with a
histrionic treatment of *St Veronica*. The eighteenth-century critic
Giovanni Battista Passeri famously objected to its movement, which
seemed contradictory to the static nature of statuary, but praised the
extraordinary carving of the drapery and the cloth on which Christ's
face was imprinted. Such judgments still hold true, for Mochi never
turns these self-consciously assembled elements into a coherent
image. Possibly as a result of Mochi's long absence from Rome, the
St Veronica did not please a critical audience increasingly enthralled
by Bernini.

Duquesnoy might have posed a more formidable threat to Bernini
had he lived longer and been more productive. He arrived in Rome

in 1618 and shared lodgings with Poussin, probably imbibing from the painter an interest in the mythologies of Titian and the works of Annibale Carracci. Duquesnoy imparted great warmth to his sculptures, whether of putti or his first acknowledged masterpiece, the *St Susanna* in the church of Santa Maria di Loreto. Based upon an antique statue of Urania, the saint's severity is mitigated by the gentle expressiveness of her face and the palpable sense of the body beneath the folds of drapery. Warmer and more accessible than a Classical sculpture, the *St Susanna* received immediate acclaim at its unveiling in 1633 and was accorded the status of an honorary antique. When Filippo della Valle (1698–1768) created a statue of *Temperance* a century later, he instinctively returned to Duquesnoy's much-admired statue rather than a Classical model for his personification of restraint.

Duquesnoy's *St Andrew* for St Peter's also became one of the most esteemed sculptures of the Baroque. Nothing could be further removed from the final form of Bernini's *St Longinus* although the distance between the *St Andrew* and the earlier terracotta model for Bernini's *St Longinus* is not so great. The sobriety of pose and drapery, and the pathos of the saint's expression gave the *St Andrew* an authority that made it a touchstone for late Baroque sculptors and critics alike. Like the *St Longinus*, the *St Andrew* carries off its grand gesture; the saint's outstretched arms and upturned head – the latter reminiscent of the *Laocoön* – show his resignation towards his impending martyrdom.

Duquesnoy and Algardi have traditionally been aligned with the painter Andrea Sacchi (1599–1661) in a 'Classical' camp, opposed to the full Baroque style of Bernini and Pietro da Cortona, but this was a construct placed upon these artists by later critics searching for alternatives to Bernini in sculpture of the period. The situation was in fact much more fluid: Algardi and Cortona were good friends, while Sacchi wanted Bernini to execute his tomb. At the same time, it is helpful to realize that Bernini's style was not absolutely predominant in the 1630s and 1640s and that other sculptors, such as Giuliano Finelli and Alessandro Algardi, could find their own distinct idioms.

Finelli came from a family of stonemasons in Carrara and trained in Naples before entering Bernini's workshop in 1622. His prowess in carving marble was put to use by Bernini on some of the more astonishing passages of the early groups and portraits, but the two men fell out when Bernini did not award him one of the four statues for the crossing of St Peter's. Finelli eventually left Rome for Naples in 1634 and enjoyed many productive years there, creating a notable series of

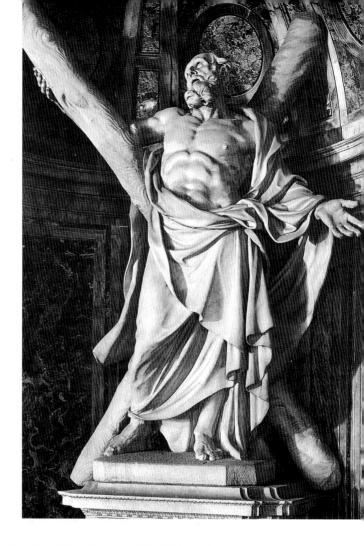

42 François Duquesnoy,
St Andrew, 1629–40.
St Peter's, Rome. Marble.
H. 4.68 m.

saints for the cathedral church of San Gennaro. His *St Peter* gives some 43
idea of what a statue for the crossing of St Peter's might have looked
like: there is something of Bernini's manner here, though the work is
more subdued in its characterization. What is most striking about the
St Peter is its concentration on technical proficiency, something
which ultimately distracts the spectator from the nominal subject.
This preference for the particular rather than the whole prevented
Finelli from being a great statuary artist, although it enabled him to
evolve a striking flair for portraiture.

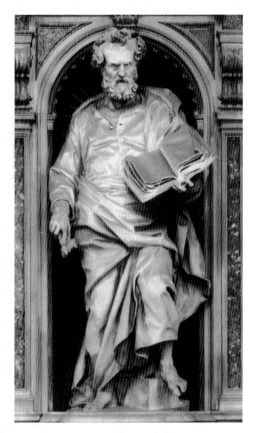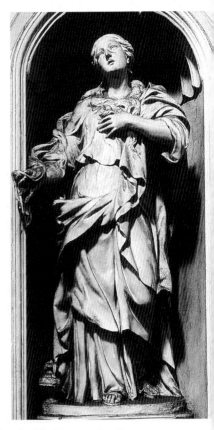

43 Giuliano Finelli, *St Peter*, 1639–40. Chapel of the Treasury, San Gennaro, Naples. Marble. Life-size.

44 Alessandro Algardi, *St Mary Magdalen*, 1629. San Silvestro al Quirinale, Rome. Stucco. Over life-size.

So effectively had Bernini monopolized the major commissions that few sculptors had the option to work independently in the Rome of Urban VIII. In the end Algardi assumed the role of major rival to Bernini. Bolognese by birth and early training, Algardi trained initially as a stuccoist and modeller of decorative works, tastes which remained with him throughout his highly productive career. After his arrival in Rome in 1625, he used his Bolognese connections to gain work from Cardinal Ludovisi as a restorer of antique statues. Friendship with the Bolognese painter Domenichino led to his first independent commission, the stucco figures of *St John the Evangelist*

45 Alessandro Algardi, *St Philip Neri*, 1636–8. Sacristy, Santa Maria in Vallicella, Rome. Marble. H. *c.* 3 m.

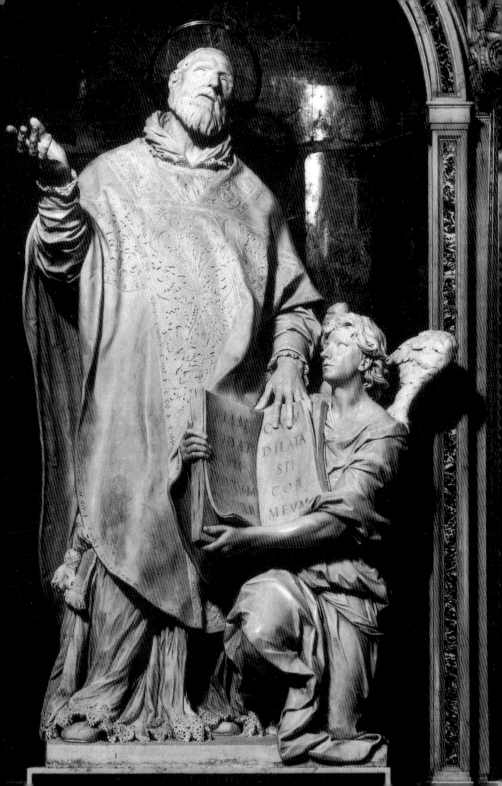

44 and *St Mary Magdalen* of 1629. These reveal a remarkably self-assured artistic personality, one that did not alter significantly over the course of his career. Bolognese training is evident in both works, which are reminiscent of Domenichino in drapery style and of Ludovico Carracci (1555–1619) in sweetness of expression. Less reserved than Duquesnoy's *St Susanna*, the *St Mary Magdalen* is more emotionally accessible without any sacrifice of clarity or directness.

45 Algardi was too junior a sculptor to work with Bernini on the crossing of St Peter's, but he was soon able to display his considerable skill with an over-life-size statue of *St Philip Neri* for the Oratorians at Santa Maria in Vallicella, which he completed in 1638. The intimate setting of a sacristy argued against a grandiloquent attitude, and the statue was conceived in keeping with the amiable character of St Philip Neri. The saint gestures with his right hand in offering as he glances up towards the ceiling where Pietro da Cortona had painted the instruments of the Passion of Christ; with his left, he indicates a passage from the offertory of his feast day, 'I will run in the way of Thy commandments when Thou shalt enlarge my heart', which is held by a kneeling angel. Algardi's understated manner here is far removed from Bernini's *St Longinus*, and as Jennifer Montagu has observed, the *St Philip Neri* displays the 'rejection of the dramatic in favour of the expression of timeless physical and spiritual grace'. No doubt this was an innate part of Algardi's artistic temperament, for understatement also runs through his portraiture, yet it was also nurtured by the tradition of Bolognese art. Behind the noble simplicity of Algardi's saint stand earlier religious works by Domenichino, Guido Reni and ultimately their common source: Raphael's Bolognese altarpiece, the *Ecstasy of St Cecilia*. By the same token, Algardi's *St Philip Neri* is quite unlike the embodiment of the saint in a celebrated Roman altarpiece

128 of 1708–10 by Pierre Legros the Younger (1666–1719) where clouds of cherubs are summoned to enhance the pietistic pose of the saint. Algardi instead focuses upon restraint and simplicity with the only hint at violent emotion being a rippling of the chasuble over St Philip's heart, which became enlarged during an ecstatic trance in the Roman catacombs.

 There was definitely a Bolognese 'mafia' at work in Rome during the early seventeenth century, and Algardi benefited from it as much as his fellow countrymen. Virgilio Spada, a career ecclesiastic whose family had established itself in Bologna, may have recommended the untried Algardi for the *St Philip Neri*, but he definitely engineered one of Algardi's greatest triumphs of the 1630s, the dramatic altarpiece

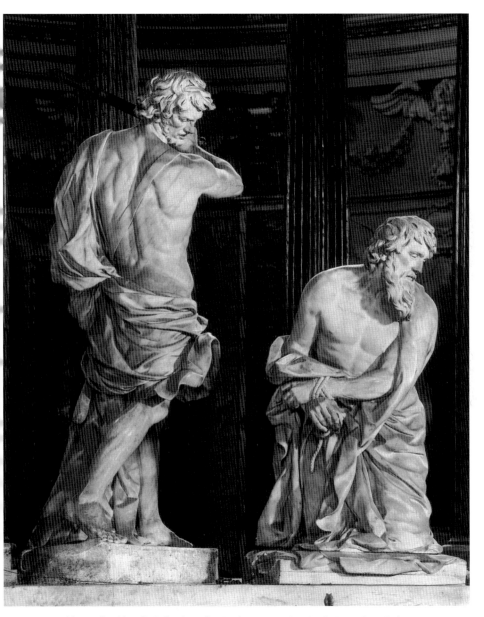

46 Alessandro Algardi, *Beheading of St Paul*, 1634–44. San Paolo Maggiore, Bologna.
Marble. H. 2.82 m. (executioner); 1.9 m. (St Paul).

of the *Beheading of St Paul* for the Bolognese church of San Paolo Maggiore. Moreover, Spada arranged the unwitting collaboration of Bernini as designer of the free-standing aedicule which houses the apostle and his executioner. Unusual in Rome, such sculptural altars were not unknown in Venice and in the region around Bologna. The original conception may have been Spada's, before he turned it over to the two sculptors for realization. Algardi was an inspired choice, for he created here a masterpiece without equal in Baroque sculpture. Often compared to painted altarpieces, Algardi's tableau exploits the traditional strengths of sculpture by achieving a fully rounded, spatially complex group which plays upon the contrasting types and emotions of the figures. Having established action frozen in time, the sculptor sets a spiral pattern in motion, from the poised right arm of the executioner through the shoulders and arms of the kneeling saint and back to his assailant's right leg and drapery. The centre of the composition is a void, and tension builds up because of the imminent execution and the inevitability of martyrdom. In this way, the *Beheading of St Paul* can be compared with the great biblical tragedies of Racine, where the drama lies in the delay of an inevitable denouement.

With these works and the tomb of Leo XI, Algardi established himself as a major sculptural presence in Rome, quite distinct from the overwhelming personality of Bernini. The Bolognese antiquarian Carlo Cesare Malvasia praised him as 'a new Guido [Reni] in marble', a tribute as grandiloquent as it is difficult to define. From contemporary evidence, however, it seems that Algardi never pretended to be an ideological rival of Bernini. Influential critics such as Giovan Pietro Bellori exalted him to this position long after his death in 1654, and it is only recently that Algardi has been disentangled from Bellori's interpretation of Italian Baroque sculpture.

Portraiture

Since the Renaissance, portraiture had traditionally been a bread-and-butter issue for most artists, ranking low in the hierarchy of genres. Although we now think of it as one of the defining aspects of Renaissance art, analysis of the subject was sparse until as late as 1584, when the Milanese painter Gian Paolo Lomazzo (1538–1600) wrote the first extended account of the subject, his *Trattato dell'arte della pittura* of 1584. Not surprisingly, Lomazzo stressed that only the greatest persons – those in authority or held in public esteem – should be portrayed, and that, to be successful, the image should convey an intellectual conceit as well as a physical likeness. Characteristically, Lomazzo wove together predictable observations from Classical and more recent sources, but he particularly lamented the decline of portraiture in his own day: so many people wanted to have themselves immortalized that 'any crude dauber [could] set up as a portraitist'.

There were, of course, exceptions to Lomazzo's strictures. Great painters like Raphael and Titian left their stamp on portraiture; Benvenuto Cellini (1500–1571) and Alessandro Vittoria did the same for the portrait bust. Such exceptions do not, however, weaken Lomazzo's observation about the mediocrity of most portraitists, something which can be confirmed by studying a typical bust from the turn of the seventeenth century. The work in question depicts an unknown prelate and was originally part of a monument in a Roman church. Although it is more competently executed than most, it reflects the marked tendency towards abstraction of the features common in late sixteenth-century busts, as if the rank of the sitter counted for more than an expression of individuality. The lineaments of face and hair are recorded, but insensitivity to the medium of marble has resulted in a blanched and lifeless expression. By comparison, even the earliest known bust by Bernini, that of Giovan Battista Santoni in the Roman church of Santa Prassede, displays the first glimmer of an approach that was to revitalize the portrait bust.

Probably carved around 1610 when the sculptor was twelve years old, the bust of Santoni demonstrates an ability to fashion works that

47

49

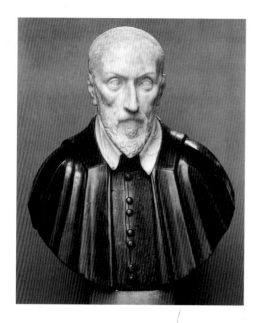

47 Anonymous, Portrait of an ecclesiastic, turn of the seventeenth century. Victoria and Albert Museum, London. Marble. H. 54.3 cm.

48 (*right*) Gianlorenzo Bernini, Bust of Monsignor Pedro de Foix Montoya, *c.* 1621. Santa Maria di Monserrato, Rome. Marble. Life-size.

49 (*far right*) Gianlorenzo Bernini, Bust of Giovan Battista Santoni, *c.* 1610. Santa Prassede, Rome. Marble. Life-size.

more mature rivals would have envied. Inevitably the bust reveals the tutelage of the sculptor's father in the features and in the almost imperceptible transitions from skin to hair; in format, it falls within the conventions of Roman funerary monuments of the period. But there is something distinctive about the way the cleric leans forward from the oval niche, turning pointedly to our left and fixing an imaginary interlocutor with his stare. Bernini builds up the brow to create shadows around the eyes and forehead; he heightens the cheek-bones to impart a tautness to the lower face, and carves out the pupils of the eyes. Indeed, so vivid is the characterization that it comes as a surprise to learn that Santoni died two decades before his bust was created. The young Bernini probably relied upon a painting of the deceased, thereby nudging the portrait into the realm of artistic licence. The resultant work is modest in scale, but one already endowed with many features associated with Bernini's later creations.

In his early career, Bernini often turned to portraiture to supplement his income and soon acquired a reputation for coaxing living images from stone. His bust of Monsignor Pedro de Foix Montoya was executed some ten years later, during the period of the great mythological sculptures, and conveys a much stronger sense of presence. The format is similar to the bust of Santoni, although it is subtly reworked to make a more vivid and imposing image. Unlike Santoni's

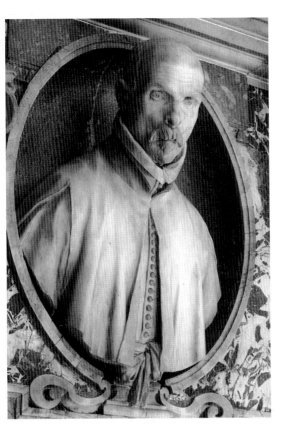

bust, this portrait was done from life, and when Cardinal Maffeo Barberini famously said that it was more lifelike than Montoya himself, he meant that the sculptor had employed the tilt of the head, the incipient smile, the half-length torso and the motif of the sash hanging over the edge of the cartouche to suggest the whole person beyond the niche. This sense of presence is further enhanced by an astonishing grasp of facial anatomy, coupled with a flair for nuances which encompasses even the bristles of Montoya's moustache.

Bernini's portraiture diminished substantially after the 1620s, and his subsequent forays into the field were either personal gestures or instruments of papal policy. They also became vehicles for his artistic preoccupations, particularly the notion of a 'speaking likeness' that lay behind Cardinal Barberini's witticism about the bust of Montoya. The busts of Bernini's patron Scipione Borghese and his mistress Costanza Bonarelli are often linked together although the latter, like Raphael's

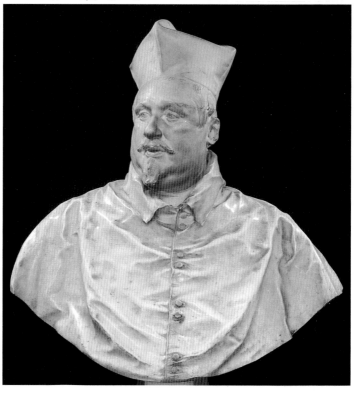

50 Gianlorenzo Bernini, Bust of Scipione Borghese, 1632. Galleria Borghese, Rome. Marble. H. 78 cm.

Fornarina, was initially meant for private contemplation. Both busts illustrate the twin concerns with movement and speech that clearly preoccupied their creator. Years later, Bernini made the famous observation that a person's features were at their most characteristic either prior to or just after speaking. He may have noted this feature in paintings, particularly those of Titian, who had been praised for the lifelike qualities of his portraits in sixteenth-century literature. An ancient Greek epigram was often invoked in accounts of Renaissance portraiture: 'If the painter had but added speech, this would be your complete self.' Bernini took this concept further than his predecessors in the bust of Scipione Borghese where the sense of interrupted speech is even more obvious. Long regarded as one of the outstanding portraits of any age, the bust was not intended for a niche or a

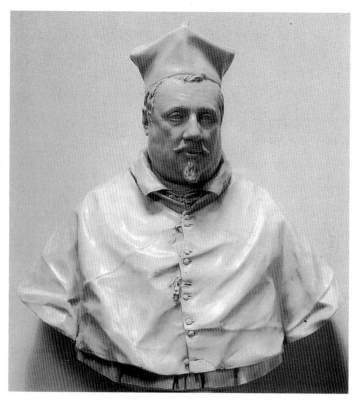

51 Giuliano Finelli, Bust of Scipione Borghese, 1632. The Metropolitan
Museum of Art, New York. Marble. H. 98.5 cm. (with socle).

monument, but for display, rather like an easel painting. It presents the
Cardinal turning to address an interlocutor and caught in full conver-
sational flow; the broad cut of the torso and the treatment of the
drapery evoke the presence of the man as much as the turn of the
head and expression. A comparison with another bust of Borghese,
this one admittedly derivative, helps to explain some of Bernini's
craft. The latter work is attributed to Bernini's sometime collaborator,
Giuliano Finelli; the lower inclination of the head and bland expres-
sion offer a much less engaging image of this most notorious of
churchmen. Bernini, on the other hand, constructs a jovial, even
avuncular image of a man given to repartee, and although it may have
been intended to flatter its subject intellectually, the bust deftly
accentuates the more positive aspects of the Cardinal's nature.

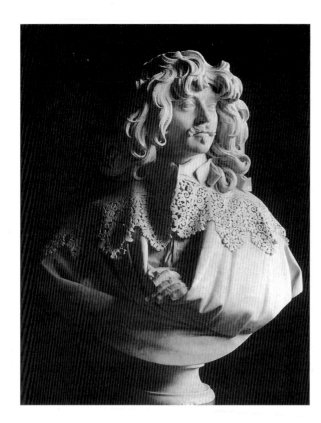

52 Gianlorenzo Bernini,
Bust of Thomas Baker, 1638.
Victoria and Albert Museum,
London. Marble. H. 81.6 cm.

53 (*right*) Gianlorenzo Bernini,
Neptune and Triton, 1620. Detail.
Victoria and Albert Museum,
London. Marble. Over life-size.

54 (*far right*) After
Gianlorenzo Bernini,
caricature of Frenchman,
c. 1650–65. Corsiniana,
Rome. Pen and ink.

Bernini claimed to model his portraits from memory, and
certainly the rare surviving drawings could not be described as working
drawings. Some of them are little more than informal sketches or
caricatures in which the features have been reduced to a few essential
lines in order to evoke the character of the subject. Inevitably, these
quickly realized vignettes had an impact on Bernini's portrait busts,
for they combined two elements fundamental to his approach to
sculpture: the *concetto*, or general idea, and a manipulation of the
medium to obtain a telling likeness. The art of caricature uses exag-
geration to arrive at an essential truth about its subject; Bernini was
acutely aware that any successful sculpted portrait required a degree
of exaggeration in order to succeed. He once observed that 'in a
marble portrait it is sometimes necessary in order to imitate nature well
to do what is not in nature'. Bernini well understood that forms have
no objective quality and that the impression of their appearance there-
fore depends upon light and colour. Consequently, he exaggerated

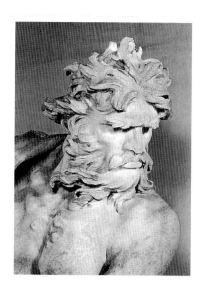

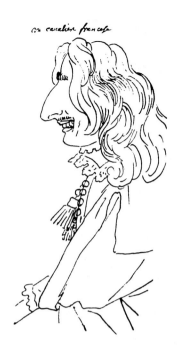

en cavalier françois

some features in order either to make them register or to create the
colouristic contrasts necessary to bring an image to life.

Occasionally, these elements burst the bounds of decorum, as with
the bust of Thomas Baker. Baker accompanied the famous Van Dyck
triple-portrait of Charles I to Rome where Bernini was charged with
making a marble portrait bust from it in 1639, but he also bribed
Bernini to make his own bust. When Pope Urban VIII heard of this,
he forbade the sculptor to continue because his talents were too
important to be wasted on any but papal projects. Though the bust
was finished by the workshop, enough had been achieved by the mas-
ter to create a portrait of great panache. While there are no caricatures
of Thomas Baker, they would undoubtedly have resembled Bernini's
sketches of French courtiers. A dandified mop of hair and elaborate
lace seem to be Baker's most distinguishing features, and Bernini
employed shadows as well as various degrees of polish to establish the
face. This technique was not entirely new to Bernini's art, for he had
used it more than a decade before in his fountain group of *Neptune
and Triton*, now in the Victoria and Albert Museum in London. Here,
the face of Neptune, which was intended to be seen at some distance
in bright sunlight, has been reduced to essential, caricature-like

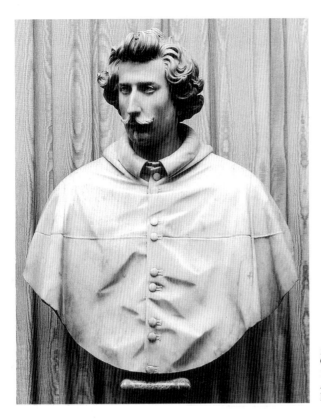

55 Francesco Mochi, Bust of Cardinal Antonio Barberini, 1628–9. Toledo Museum of Art, Toledo, Ohio. Marble. Life-size.

forms. There are no eyes, but an illusion of them is conveyed by the shadow cast by the projecting eyebrows. With the bust of Thomas Baker, these traits are not present in such a dramatic fashion, but the blank eyes, sometimes interpreted as a Classical citation, can more readily be explained by the aesthetic requirement of an unfocused gaze to counter the exaggerated treatment of the hair. Be that as it may, the bust of Thomas Baker occupies a crucial place in the gradual erosion of the distinction between Bernini's portraiture and his 'high art'.

Bernini's radical reformulation of the portrait bust had an inevitable effect on his followers and competitors, although few dared to be as extreme in their work. Of his competitors, only the older Francesco Mochi explored what could be termed an alternative style. His bust of the papal nephew, Cardinal Antonio Barberini, part of a series of family portraits commissioned by Urban VIII in the late 1620s, seems almost a reversion to the austerity of late sixteenth-century

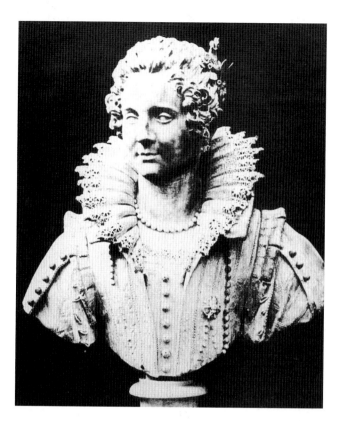

56 Giuliano Finelli, Bust of Maria Barberini Duglioli, 1626–7. Location unknown. Marble. H. *c.* 57 cm.

sepulchral monuments. The features have been simplified, and the drapery and hair reduced to almost formal patterns, but the combination of an especially long torso and the delicate handling of the features makes for a portrait that is both imposing and sensitive. More abstract than contemporary taste, Mochi's portraiture nonetheless anticipated qualities that would be more highly valued in the eighteenth century.

Giuliano Finelli has already been mentioned, and his remarkable technique gave him a distinctive approach to portraiture. Had he still been with Bernini at the time of the Baker bust, Finelli might have made the lace collar a *tour de force* as he had done earlier in a bust of Urban VIII's niece, Maria Barberini Duglioli; indeed, this bust was originally kept in a wire cage to protect the perforations of the lady's collar, the flower in her curly hair, her ropes of pearls and her clasp with the Barberini family's armorial bee. Portrait busts of women have always been comparatively rare, and Finelli's work in this case

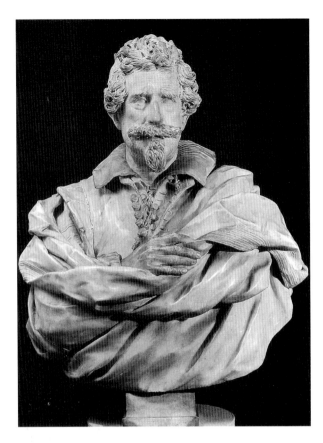

57 Giuliano Finelli, Bust
of Michelangelo Buonarroti
the Younger, 1630.
Casa Buonarroti, Florence.
Marble. Life-size.

58 (*right*) Giuliano Finelli,
Bust of Cardinal Giulio
Antonio Santorio,
c. 1633–4. St John Lateran,
Rome. Marble. Life-size.

conformed to the accepted formula by focusing on the accessories, leaving the expression vague and the eyes blank. Apparently, Bernini subcontracted this bust to his assistant in 1626, promising to recommend Finelli to the Pope for future employment. None was forthcoming, but the bust raised the standard for female portraits, becoming a touchstone for subsequent works. Finelli's love of technique sometimes told against him, but the best of his portraits, such as that of Michelangelo Buonarroti the Younger in Florence, revels in an almost miraculous evocation of hair, hands and fabric. At the same time, his sepulchral bust of Cardinal Giulio Antonio Santorio transformed the traditional praying figure into an image of Counter-Reformation zeal. As Bernini does in his bust of Montoya, Finelli here conveys the illusion of the whole figure at prayer. The idea evidently touched a chord with the contemporary public, alluding, as it

did, to the beneficent power of the mass and hopes of eternal life. Even Bernini must have been impressed by his rival's creativity here, for he adapted the same motif in subsequent funerary monuments such as those in the Raimondi and Cornaro Chapels, and it thereby passed into the convention of Baroque memorial portraiture.

Finelli was only intermittently involved with busts, but portraiture became a staple part of Algardi's career. We saw in Chapter One that he came to be championed, posthumously, as an 'anti-Berninian' sculptor, and, although this grossly exaggerated differences between their styles, Algardi's portrait busts are indeed much less flamboyant or self-consciously artistic in character. Where Bernini sought movement and engagement in his portraits, Algardi's approach was more understated, and more concerned with evoking presence through minute attention to physiognomy. His busts seem more aloof than those of Bernini because they functioned generally as part of funerary monuments where meditation and piety were the primary requirements. Algardi was, of course, aware of Bernini's achievements in this field, but it was from Bernini's less demonstrative and subtler works, such as the bust of Monsignor Pedro de Foix Montoya, that Algardi drew lessons in how to convey much within a small compass.

DEO SALVATORI
IVLIO ANT SANCTORIO CASERTANO

IOANNI·GARSIAE·MILLINO·S·R·E·CARDINALI·NATVRAE·VIRTVTISQVE·BONIS
EMINENTISSIMO
EM·ADOLESCENTEM·INGENII·COGNATIONISQVE·PRAEROGATIVA·CARISSIMVM·NONDVM·PO
VRBANVS·VII·QVASI·PRAECEPTOR·INSTITVIT·SIXTVS·V·SACRI·CONSISTORII·ADVL
GREGORIVS·XIV·ROMANAE·ROTAE···
·VIII·AVGTVM·CENSV·DIGN····

59 (*above*) Alessandro Algardi,
Bust of Cardinal Giovanni
Garzia Mellini, 1637–8. Santa
Maria del Popolo, Rome. Marble.
Life-size.

60 Alessandro Algardi, Bust of
Monsignor Antonio Cerri,
c. 1637. City Art Gallery,
Manchester. Marble. H. 85.5 m.
Life-size.

The hallmarks of his approach to portraiture were established by the mid-1630s, when he created the bust of the papal advocate, Monsignor Antonio Cerri, and the posthumous portrait of Cardinal Giovanni Garzia Mellini. The bust of Cerri is an example of the sculptor at his most skilful, moving from the precisely defined modelling of the head and crisply carved folds of collar and drapery to the passages of hair and skin which appear to have issued from a brush rather than a chisel. The downward turn of the head indicates that the bust was once intended to be seen from Cerri's wall monument, but in the event the original was kept back and an inferior copy from Algardi's shop was placed on the tomb. The bust of Mellini stands in his chapel in Santa Maria del Popolo and shows the Cardinal turning towards the altar, his left hand on his heart and his right holding his place in a prayer book. The work was much admired in Algardi's day, and the critic Bellori praised the illusion of the deceased 'almost kneeling, in the act of praying to the altar'. Less demonstrative than Finelli's bust of Cardinal Santorio, Algardi's bust of Cardinal Mellini nonetheless conveys a similar sense of Baroque piety and a technique no less assured: the lace appearing at the Cardinal's sleeves and the *mozzetta*, or short cape, carelessly folded behind his left hand are brilliantly observed, and such details contribute to the uncanny sense of a physical presence in the niche.

The combination of minute attention to detail and miraculous tonal control are the most engrossing feature of Algardi's busts. When the need arose, he could also produce a striking performance, as in the splendidly imposing bust of Donna Olimpia Maidalchini, one of the 61 greatest portraits of the period. Disagreeable and domineering, Donna Olimpia did not exude charm, but as the sister-in-law of Pope Innocent X she was a power in Rome during his reign. Algardi transmutes his unpromising sitter into an image of majesty and determination, the tilt of her head and the expression of her face being amplified by a billowing veil. Unusually, Algardi reverses the normal approach to flesh and drapery tones by giving the latter a bright, milky sheen and leaving the former matt. This transposition was dictated by Algardi's emphasis upon the veil which is so integral to the bust's impact. Younger sculptors imitated Algardi's stratagem here, most notably Lorenzo Ottoni (1648–1736) in his bust of the Duchess of Mirandola, but even the bust's extension to half-length, showing 62 arms, handkerchief and book, cannot compensate for Ottoni's inanimate treatment of his sitter, something which merely emphasizes the distance between Algardi and his successors.

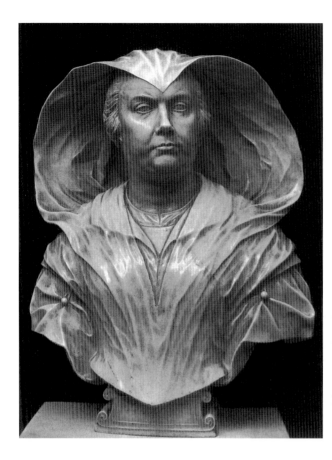

61 Alessandro Algardi, Bust
of Donna Olimpia
Maidalchini, *c.* 1646–7.
Doria Pamphilj Gallery,
Rome. Marble. H. 70 cm.

62 (*right*) Lorenzo Ottoni,
Bust of the Duchess of
Mirandola, 1689. Palazzo
Ducale, Mantua. Marble.
Life-size.

State portraiture formed a distinct category, celebrating rulers and
others of high rank. Although an expectation of physical likeness
was normally associated with such images, it was not an absolute
criterion: from antiquity onwards, artists had been censured for pur-
suing a mere imitation of nature rather than an idealized version of it.
Aristotle argued in his *Poetics* that tragedy should express the universal
rather than the particular, urging poets to follow the example of the
best artists by elevating their characters without sacrificing their dis-
tinctive features. This concept was endorsed by later art critics such as
Giovanni Battista Agucchi, who inverted Aristotle's observation when
he praised 'the most valiant painters, who, without modifying the
resemblance, enhanced nature with art, thus rendering the face more
handsome and more noteworthy than strictly true'. Such ideas came

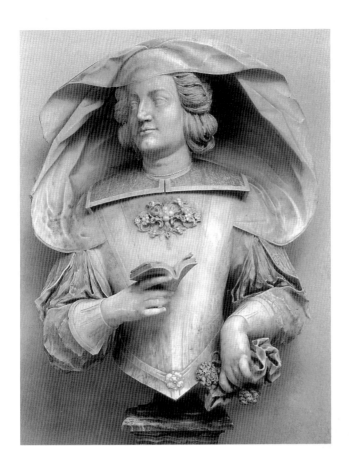

into play especially where rulers were concerned. Here, the concept of decorum or appropriateness was frequently invoked so that princes and leaders should display the qualities expected of men of their rank. This should be borne in mind when considering Bernini's bust of Francesco I d'Este, the great equestrian portraits by Mochi and Tacca, and papal busts of the period. 63, 66–7

At over one metre high, the bust of Francesco I d'Este, Duke of Modena, is considerably larger than most of Bernini's busts. It is dominated by a single conceit: the idea of command. As if to emphasize his point, Bernini has enlarged the torso *vis-à-vis* the head, and wrapped the whole in a billowing mantle through which a glint of steel armour can be seen. Although he famously objected to carving like-nesses from painted portraits, Bernini did so here, and it is interesting

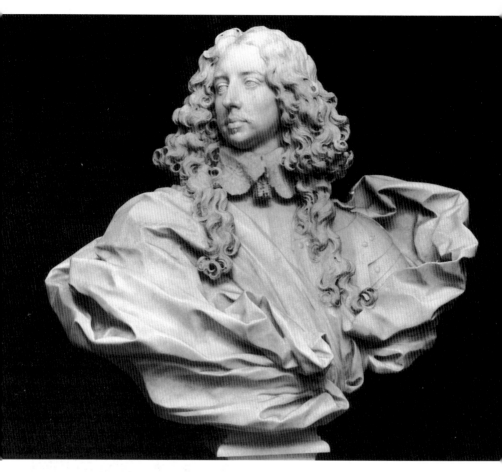

63 (*above*) Gianlorenzo Bernini, Bust of Francesco I d'Este, 1650–1. Galleria Estense, Modena. Marble. H. 1.07 m.

64 (*left*) Diego Velázquez, *Francesco I d'Este*, 1638. Galleria Estense, Modena. Oil on canvas. 68 × 51 cm.

65 (*right*) Giovanni Battista Foggini, Bust of Grand Prince Ferdinando de' Medici, *c.* 1685. Fürstliche Fürstenbergisches Schloss, Donaueschingen. Marble. H. 80 cm.

to compare his image of the Duke of Modena with an earlier one by the Spanish painter Velázquez which suggests the feckless and vacillating character attributed to the Duke by his contemporaries. In contrast, the sitter's face is only a small aspect of Bernini's marble; the bust's most distinctive feature is the mass of ringlets and the decisive pose of the head. The artist avoided particular details in favour of a more general observation on rulers. In the event, the Duke was so taken with Bernini's image that he paid him the huge sum of 3,000 scudi, as much as Innocent X paid for the *Fountain of the Four Rivers* in Piazza Navona, and far beyond Algardi's fee for a bust of 150 scudi.

So persuasive was the bust of Francesco I that it established the model for portrait busts of rulers well into the eighteenth century. Giovanni Battista Foggini (1652–1725), who studied at the Florentine Academy in Rome, adapted Bernini's model for his bust of Grand Prince Ferdinando de' Medici. The general proportions of head to torso are similar to Bernini's example; the drapery, flowing hair and elaborate cravat distract us from the features of the melancholy sitter, while the very remoteness of his gaze underscores a sense of distance, suggestive of a higher sphere of duty. Such an image remained the preferred icon of the state portrait in marble or bronze until the age of King Louis XV of France.

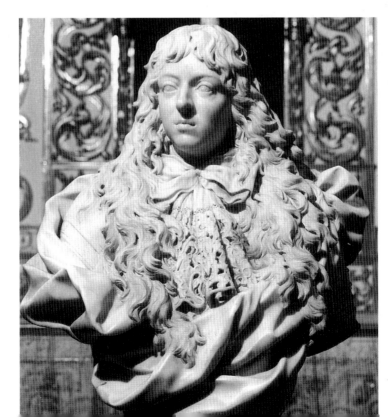

Equestrian monuments to honour heroes were established well before the seventeenth century. One of the most famous and imitated Classical examples was the bronze mounted figure of Marcus Aurelius, which was re-sited on the Capitoline Hill in Rome by Michelangelo in 1538–9. Horsemanship had long been a symbol of authority, extolling rulers as well as conveying a subtext about man's control over natural forces; bronze enjoyed a higher cachet than marble and was also a more expensive medium in which to work. Giambologna and his workshop gave such monuments an international vogue during the late sixteenth century; Francesco Mochi and Giambologna's follower Pietro Tacca (1577–1640) produced new variants on this theme in the following century.

Mochi had been summoned from Rome to Piacenza by Ranuccio Farnese, Duke of Parma and Piacenza, in 1612, and given

66 Francesco Mochi, Equestrian Monument to Alessandro Farnese, 1620–9. Piazza dei Cavalli, Piacenza. Bronze.

67 Pietro Tacca, Equestrian Monument to Philip IV, 1634–40. Plaza de Oriente,
Madrid. Bronze.

the task of creating two equestrian monuments of the Duke and his
father, the celebrated soldier Alessandro Farnese, for the main piazza
in Piacenza. As it turned out, his sojourn extended over seventeen
years and included a trip to Padua and Venice to study the great
mounted figures by Donatello and Verrocchio. In the end, it was the
Roman equestrian monument to Marcus Aurelius that guided
Mochi's approach, though the resulting monument to Alessandro
Farnese could hardly be described as Classical. Instead, the work por-
trays the Duke as a *condottiere*, or soldier of fortune, and where earlier
equestrian monuments had been studies in passive obedience,
Mochi's monument to Alessandro Farnese conveys an urgency in

75

both horse and rider, as if the misplaced energy of the sculptor's colossal *St Veronica* for the crossing of St Peter's here found its proper outlet.

In 1608, Giambologna died and left his workshop to Tacca, who completed a conventional mounted statue of the Spanish king, Philip III, some years before receiving a second commission from Philip IV in 1634. Correspondence between Madrid and Florence reveals that the bronze group was to be based upon an equestrian portrait of the King by Rubens, showing the horse 'with the weight resting on the hind legs so that it appears to be leaping and curvetting'. Such images were derived ultimately from Classical art and had been reintroduced in the Renaissance by Antonio Pollaiuolo and Leonardo da Vinci, before gaining further popularity through Rubens's equestrian portraits in the seventeenth century. Hence there was an element of the *paragone* in Tacca's commission, but the resulting work amply confirmed the sculptor's ability: a vast warhorse, teeth bared and nostrils flaring, rears on its hind legs, only to be reined in effortlessly by the King. As if to emphasize his authority, Philip sits bolt upright and remains completely passive, with his right arm extended to display his baton of command, as he was reportedly depicted in the lost painting by Rubens. Tacca's work was a superb image of political propaganda as well as being an extraordinary technical feat in terms of maintaining the equilibrium of horse and rider. It also set a standard for later equestrian monuments by Coysevox and Falconet.

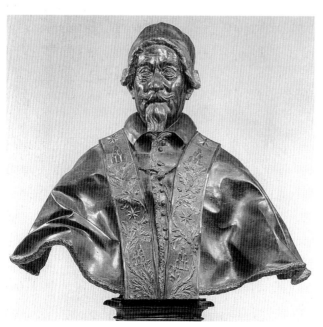

68 Melchiorre Cafà, Bust of Alexander VII, 1667. The Metropolitan Museum of Art, New York. Bronze. H. 75 cm.

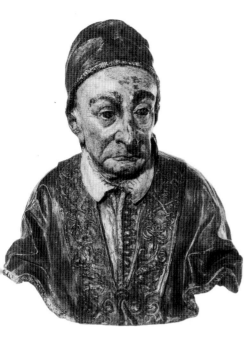

69 Pietro Bracci, Bust of
Benedict XIII,
1724. Palazzo Venezia, Rome.
Terracotta. H. 41 cm.

70 Pietro Bracci, Bust of
Benedict XIII,
1762–73. Thyssen-Bornemisza
Collection. Marble. H. 76.4 cm.

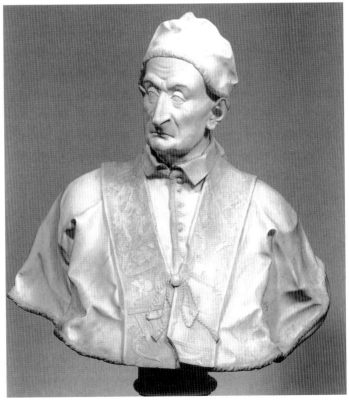

Papal portraiture followed conventions similar to those for portraits of other rulers, although few changes from the examples of the late sixteenth century are apparent. Bernini and Algardi favoured a fuller treatment of the torso, extending down to the fringe of a short *mozzetta*, embellished by a stole in which the papal arms often figured. Movement was suggested by deep folds in the cape and was accompanied by a benevolently resolute gaze, as in the imposing mid-century example of the bust of Alexander VII, who reigned from 1655 to 1667, by Melchiorre Cafà. Bernini was fond of saying that portraiture consisted in finding the unique feature of a sitter and reproducing it; he added that the feature should be beautiful and *not* ugly. This approach often presented problems with busts of pontiffs, who tended to be old and sometimes uninspiring to look at, none
70 more so than the monkish Pope Benedict XIII, who reigned from 1724 to 1730. Several representations of Benedict XIII were produced by the Roman sculptor Pietro Bracci, and we are fortunate in having an
69 early terracotta study to compare with the official version in marble. The terracotta does not hesitate to convey the unheroic, slightly dyspeptic expression of the sitter and would have been used for reference whenever Bracci was called upon to produce official portraits. In the marble, although one cannot say that the sculptor completely remade his sitter, he has certainly regularized the features and conveyed a more benign expression. A greater scale and the upward tilt of the head also contribute to a more positive image in Bracci's marble, which seems as much concerned with representing the office as its individual holder. Overall, it is a considerably more restrained work
68 than Cafà's bust of Alexander VII, an index of changes underway in late Baroque portraiture.

Portraiture in marble or bronze was generally linked to commemoration in a religious or official context, but at the turn of the eighteenth century the bust began to enjoy wider popularity as did all forms of portraiture. With the increased interest in portraits came a shift away from commemoration in an official context towards an emphasis upon character and naturalistic, bourgeois values. Characteristically, Filippo Parodi (1630–1702) achieved a synthesis of elements originally popularized by Bernini and Algardi half a century earlier introducing the new Roman format to his native Genoa. A work like the bust of Marcantonio Grillo by Parodi's son-in-law, Giacomo Antonio Ponsonelli (1654–1735), betrays a familiarity with Bernini's bust of Louis XIV of 1665 and demonstrates how quickly such regal prototypes were absorbed into representations of the upper

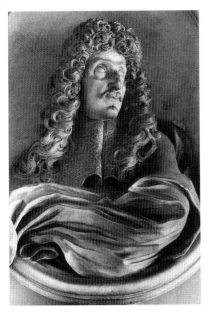
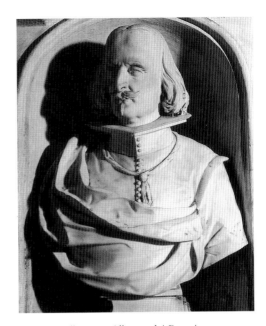

71 Giacomo Antonio Ponsonelli, Bust of Marcantonio Grillo, 1683. Albergo dei Poveri, Genoa. Marble. Life-size.

72 Lorenzo Vaccaro, Bust of Vincenzo Petra, 1701. Chiesa di San Pietro a Maiella, Naples. Marble. H. 82 cm.

bourgeoisie. More generally, however, the trend was towards gentler, more reflective depictions of sitters. One can find a distinctive element of restraint in the handsome bust of Vincenzo Petra by the Neapolitan sculptor Lorenzo Vaccaro (1655–1706). The accoutrements of Baroque portraiture are present here, but in an understated way, much as in the painted portraits of Vaccaro's contemporary Francesco Solimena (1657–1747). The features and facial structure are secure but more summarily treated than in busts by Bernini or Finelli, and the result is a dignified if essentially low-key presentation.

One of the most sensitive creations in this new fashion was Camillo Rusconi's bust of Pope Clement XI's aunt, Giulia Albani degli Abati Olivieri, commissioned by her nephew in 1719–20. Though posthumous, the bust is suffused with a feeling of life, thanks largely to Rusconi's sensitive execution of the features. The pose of the figure in prayer recalls Algardi's bust of Cardinal Giovanni Garzia Mellini, yet the spiritual tension so evident in Algardi's marble has been replaced by a *bienséant* manner reminiscent of French portraiture.

79

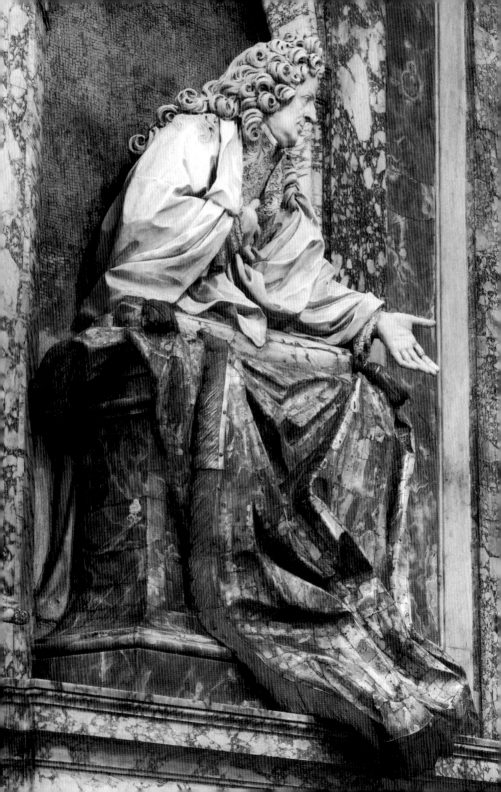

The same trait is more pronounced in the busts of Giovanni Andrea Muti and Maria Colomba Bussi Muti by Bernardino Cametti (1669–1736) which were executed for their family chapel in the Roman church of San Marcello al Corso. The virtuoso sculptor delighted in rendering the fashionable clothes and sophisticated airs of his patrons, who are seen framed between a blue mosaic background and fictive drapery of Sicilian jasper. There is little overt religiosity about the images, and, in another context, they could pass as wholly secular portraits.

Colour is often present in Baroque sculpture, but it was rarely employed by Italian sculptors to evoke verisimilitude. One notable exception to this rule was the remarkable coloured bust of Vittoria della Rovere by the Florentine sculptor Giuseppe Antonio Torricelli (1662–1719). Work in hardstone or *pietra dura* was a great Florentine speciality of the seventeenth and eighteenth centuries, normally seen in decorative mosaics where the technique was used to imitate painting. Commissioned posthumously by her son the Grand Duke Cosimo III, the bust of Vittoria della Rovere occupied Torricelli for almost two decades until 1713 and was the first such life-size bust ever made. The face is carved from a large block of flesh-coloured chalcedony, with pupils of sardonyx, lips of Sicilian jasper, and a bodice and veil of black touchstone. For all its technical brilliance, the bust remains more of a curiosity than anything else and is much less penetrating than, say, Algardi's bust of Donna Olimpia Maidalchini. 74

It comes as no surprise that Torricelli studied with Gaetano Giulio Zumbo (1656–1701), one of the greatest sculptors in wax of the Baroque period. Wax was the customary medium for a popular genre of portraiture in miniature, one which was to flourish throughout the nineteenth century. Many of its practitioners also made anatomical models and nativity scenes as well as working in ephemeral media such as papier mâché. In contrast to busts in marble or bronze, great premium was attached to veristic qualities; coloured wax, glass eyes and real hair were commonly used. A portrait of the architect Carlo Dotti, fashioned by the Bolognese sculptor Angelo Gabriello Piò 75 (1690–1770), exemplifies the genre at its most vivid. A commemoration of the collaboration between sculptor and architect on the design of a sanctuary outside Bologna, it seems, at first glance, disconcertingly real, yet it is just this hyper-realism which undermines any lasting impact that such portraits might have. These wax images were not made to last and could be afforded by a wider public than works in marble or bronze. Though the great Baroque sculptors enjoyed

73 Bernardino Cametti, Bust of Giovanni Andrea Muti, 1725. San Marcello al Corso, Rome. Coloured marble, gilt bronze and mosaic. Life-size.

74 Giuseppe Antonio Torricelli, Bust of Vittoria della Rovere, *c.* 1696–1713.
Museo degli Argenti, Florence. Coloured marble. H. 70 cm.

75 Angelo Gabriello Piò,
Bust of Carlo Dotti, c. 1759.
Santuario di San Luca,
Bologna. Wax with real
hair, clothing and glass eyes.
H. 62 cm.

colour, it remained ancillary to their purposes in portraiture, for they knew that too much reality militated against illusion, just as a straightforward transcription of nature was not enough to capture a good likeness in marble. The sculptor had to manipulate the features *and* the medium in order to arrive at the point of recognition, and as Galileo observed, the greater the difference between the medium and the object imitated, the greater the achievement when similitude is obtained. Long before the Neoclassical era, there was a consensus among sculptors that colour did not accord with great sculpture; most Baroque artists would have endorsed the pronouncement of the late eighteenth-century philosopher Johann Gottfried Herder that 'colour is not form ... because when seen it actually hides the beauty of form'.

76 Orazio Marinali, *Bravo*, c. 1710. Fondazione Scientifica Querini Stampalia, Venice. Marble. H. c. 58 cm.

Portraiture broadened considerably during the late Baroque period. An index of this can be seen in imaginary portraits, such as the remarkable series of *bravi* or desperadoes by Orazio Marinali (1643–1720), which are essays in anti-heroic 'types' of a kind that had been popular among Venetian painters in the circle of Giorgione. Though based upon a Classical format, the results vary from the menacing to the humorous and invite comparison with the kind of garden statuary produced in the Veneto from the turn of the eighteenth

77 Giuseppe Piamontini, Bust of a woman, 1688–9. Palazzo Pitti, Florence. Marble. Life-size.

century. Complementary to this was the celebration of ideal beauty in female busts loosely based upon Classical prototypes. These were often commissioned to adorn palace interiors and are related to garden sculpture in that they strike Classical poses without being specifically related to a given prototype. The busts by Giuseppe Piamontini (1664–1742) on the staircase of Palazzo Pitti in Florence epitomize this trend: their heads are vaguely Classical but their drapery retains a flicker of Baroque agitation.

Artists had their attention focused upon Classical sculpture throughout the Baroque period, and the demand for copies and imitations of ancient works eventually had an impact upon the portrait bust. By the late seventeenth century, there was a revival of interest in the Classical bust *per se*, and copies for private collectors and portrait busts in an antique style became fashionable. This seems to have been a vogue prompted by British travellers on the Grand Tour. An extremely early example was made by Vincenzo Felici (*fl.* 1667–1707) for John Percival, later Earl of Egmont, in 1707. Carved in Rome, the bust presents the sitter in the guise of a Roman emperor, the drapery over his shoulder revealing a tunic and breastplate. His hair is treated in a series of tight curls, the face turned to the right, reminiscent of the famous late antique bust of the Emperor Caracalla. Though the pupils are lightly incised, the face is devoid of any expression except Roman *gravitas*. The bust was far removed from Felici's normal style, which generally followed the late Baroque manner of his master Domenico Guidi (1625–1701), but it was a portent of things to come in the latter half of the eighteenth century: the distance between Felici's bust of Lord Egmont and the early Roman portrait studies of Jean-Antoine Houdon (1741–1828) was not very great.

78 Vincenzo Felici, John Percival, First Earl of Egmont, 1707. National Portrait Gallery, London. Marble. H. 83.8 cm. (including socle).

79 Jean-Antoine Houdon, *Peasant Girl of Frascati*, 1774. Musée Cognacq-Jay, Paris. Marble. H. 96 cm.

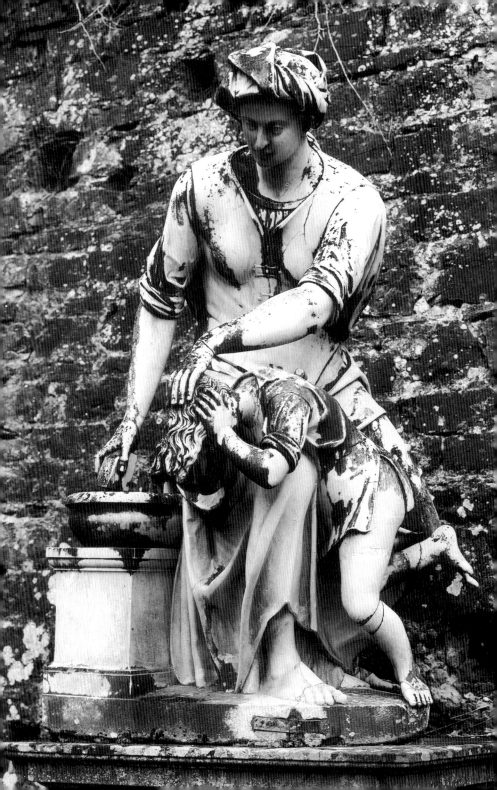

Fountains and Garden Sculpture

Bernini once remarked that he felt a special empathy with water; clearly he appreciated its visual and auditory effects. In one of his stage productions, he contrived a setting in which the River Tiber appeared almost to overflow onto the spectators; towards the end of his life, he made a mechanical fountain which threw crumpled paper against a wall, thus imitating the sound of splashing water, to counter-act Pope Clement X's insomnia. The large number of fountains which survive from the Renaissance and Baroque periods testifies to their popularity, but it is often difficult for us to appreciate what they meant to Bernini's contemporaries. In an age before modern hydraulics, adequate supplies of water were crucial to the well-being of any community, whether urban or rural. The restoration of the ancient aqueducts determined the development of Rome during the sixteenth and seventeenth centuries, and no villa or princely estate was complete without an accompanying display of waterworks. Some architects (for example the Fontana family) literally acquired their surnames from their skill as water engineers, and water itself was a marketable commodity. Bernini was paid for his work on the *Triton* fountain with a share of water from the Acqua Felice, the aqueduct restored and renamed in honour of Pope Sixtus V; he subsequently sold his rights to the water for the substantial sum of 400 scudi.

Fountains served a dual purpose of public utility and princely display. Of course in medieval cities like Perugia and Viterbo large fountains were already a notable urban feature, often with encyclopedic sculptural programmes, but the Renaissance enlarged the scope of the genre with the development of rustic fountains. Cicero and Pliny the Younger, among others, left descriptions of ancient Roman villas where statuary and fountains were a focal point, and Vitruvius devoted considerable space to water in his treatise on architecture. The villas and gardens of Rome and Florence vied with their antique prototypes, not only in the display of Classical sculpture, but also in new commissions for sculpture along similar lines. This had a decided impact upon the design of fountains, and, ultimately, upon the type of

80 Valerio Cioli, fountain with a woman washing a child's hair in the Boboli Gardens, Florence, 1590s. Marble.

sculpture deemed suitable for such settings. Grottoes and inventive structures were created for the Medici villas by sculptors like Niccolò Tribolo (1500–1550) and Giambologna; their themes included a bronze Venus wringing water from her hair, river-gods with flowing vases, and various animals. These were largely confined to country retreats although the Boboli Gardens brought them to the suburban fringes of Florence. By the turn of the seventeenth century, villa fountains had begun to shed much of their architectural structure and were assuming more naturalistic forms. Notable examples of this type were created by Valerio Cioli (c. 1529–1599) with his tableaux of country pursuits – a peasant digging, scenes of wine-making and a woman washing a child's hair – all in the Boboli Gardens.

80

Such celebrations of everyday life and a detachment from an architectural context would become prominent features of Italian Baroque fountains and garden sculpture. They occasionally impinged on urban life as did the embellishment by Taddeo Landini (c. 1550–1596) of Piazza Mattei in Rome with the celebrated *Tortoise* fountain of the 1580s, where mussel shells assume the function of the lower basin and four bronze youths make a visual connection with the upper basin. Similarly, Pietro Tacca's twin fountains with marine monsters in Piazza della Santissima Annunziata brought elements of Giambologna's fountain style to the centre of Florence in the 1620s.

The hills around Rome were summer retreats for the papal nobility, much as they had been for their ancient Roman forebears, and, from the sixteenth century, fountains assumed an important role in these establishments. The remains of the Emperor Hadrian's villa at Tivoli conveyed the scale and opulence of imperial villas and served as a frame of reference for the Villa d'Este at Tivoli and the Villa Aldobrandini at Frascati. The fountains of Tivoli and the water theatre at Frascati were among the great sights for foreign visitors during the seventeenth and eighteenth centuries. Both villas were the creation of powerful cardinals, prominently engaged in international politics. Cardinal Pietro Aldobrandini proudly wrote of his villa that its chapels, hippodromes, fountains, columns and statues were raised 'more with a view to beauty and magnificence than to functional need'. He also explained the centrepiece of the water theatre, a sculpture of Atlas and Hercules with the globe, by alluding to the study of astronomy and celestial matters. The water that fell through the cascades and pools was appreciated on one level as an example of contemporary hydraulics, but on another it signified the wisdom and happiness sent down from God to man.

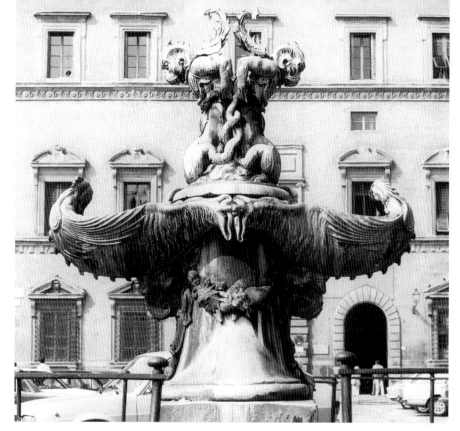

81 Pietro Tacca, fountain in Piazza Santissima Annunziata, Florence, 1629. Bronze.

At the same time, understanding grew about the role fountains could play in adorning public piazzas in cities like Genoa, Bologna and Messina. Indeed, the *Orion* fountain by the Florentine sculptor 82 Fra' Giovanni Montorsoli (*c.* 1507–1563) enjoyed great fame beyond Sicily, not only through its ambitious programme, but also through an admiring description given in Vasari's *Lives of the Artists*. Its polygonal base and candelabrum-like structure were richly festooned with river-gods, nymphs and other subjects 'appropriate to water', as Vasari wrote. It typified a common approach to fountain design in the late sixteenth century with its use of a sequence of basins around a central core, reminiscent of antique candelabra and sometimes surmounted by a presiding deity. By the end of the sixteenth century, Montorsoli's fountains were held up as a new standard by Lomazzo in his treatise

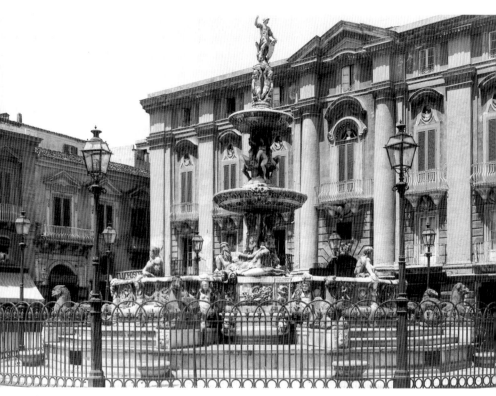

82 Fra' Giovanni Montorsoli, *Orion* fountain, Messina, *c.* 1550–1.

on art, and, as late as 1668, Donato Antonio Cafaro (*fl.* 1662–1669) turned to the *Orion* fountain for inspiration when designing his Neapolitan fountain in honour of King Charles II of Spain.

Roman Baroque fountains stand out as a novel reworking of a venerable civic tradition, especially when compared with fountains produced elsewhere in Italy. The major factor contributing to the new prominence of fountain design in Rome was a practical one: the restoration of the city's extensive network of ancient aqueducts. Marvels of engineering, these had fallen into disrepair between the sixth and the fifteenth centuries. From the reign of Pope Nicholas V (1447–1455) onwards, most pontiffs paid attention to the city's water supply, both out of necessity and in emulation of their imperial pre-decessors. This became an even greater feature of Roman life during the later sixteenth century when water was brought to parts of

the city which had been uninhabited for centuries. Some twenty fountains were erected between the reigns of Gregory XIII (1572–1585) and Clement VIII (1592–1605). Most of these – such as the many created in Rome by Giacomo della Porta (c. 1533–1602) – remained essentially geometric in design.

84

Here, as elsewhere, the example of Sixtus V proved decisive. The restoration by Giovanni Fontana (1540–1614) of the Acqua Felice (the ancient Aqua Alexandrina) brought water to the slopes of the Esquiline, where Sixtus created the enormous Villa Montalto, and to the Quirinal, site of some of the great Baroque churches and palaces. This feat of engineering was duly celebrated in Piazza di San Bernardo by a major fountain known as the *Acqua Felice*, which was finished in 1587. Its design was self-consciously adapted from Roman triumphal arches, complete with papal arms and a laudatory Latin inscription. Antique columns of coloured marble divide the main body into three fields, beneath which stand basins flanked by Egyptian and medieval stone lions. Although the quality of the sculpture is mediocre, its iconographic programme is noteworthy, for instead of mythological themes, biblical personages are portrayed. The

85

83 Donato Antonio Cafaro, fountain in honour of King Charles II of Spain, 1668. Largo di Monteoliveto, Naples. Marble with bronze statue.

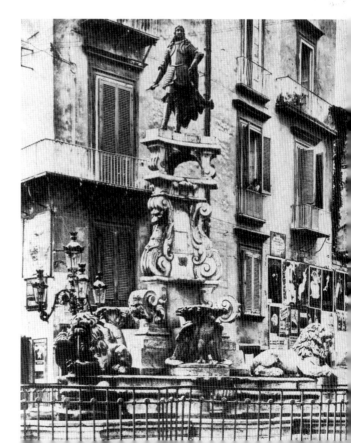

central figure is a rather ungainly statue of Moses by Prospero Antichi (d. 1592) and Leonardo Sormani (d. 1589); the lateral bays contain reliefs showing Aaron leading the Israelites to water and Joshua leading them across the Jordan with dry feet, carved by a group of minor sculptors. The perfunctory execution and religious themes are typical of the sobriety of Sistine Rome, but the *Acqua Felice* was a harbinger of the greater prominence that was to be enjoyed by fountains during the seventeenth century. A sculptor capable of exploiting the potential of fountains as an artistic form was required, and that genius was, of course, Gianlorenzo Bernini.

Bernini's first Roman fountain was actually made for Sixtus V's Villa Montalto, which had been inherited and further embellished by the Pope's nephew, Alessandro Damasceni-Peretti, known as Cardinal Montalto. He commissioned a group of *Neptune and Triton* for the oval fishpond in 1619–20. The fishpond already enjoyed fame for its statuary and numerous jets of water; steps led down into the basin itself so that visitors could explore a grotto and see the jets of water at

87

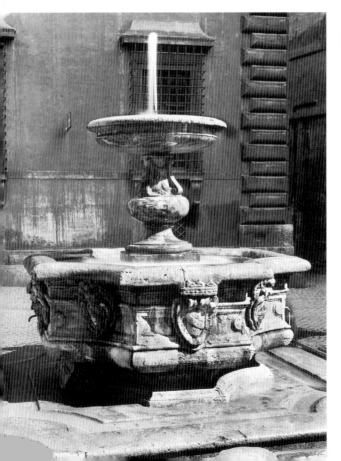

84 Giacomo della Porta, *Fontanina*, Piazza Campitelli, Rome, 1589.

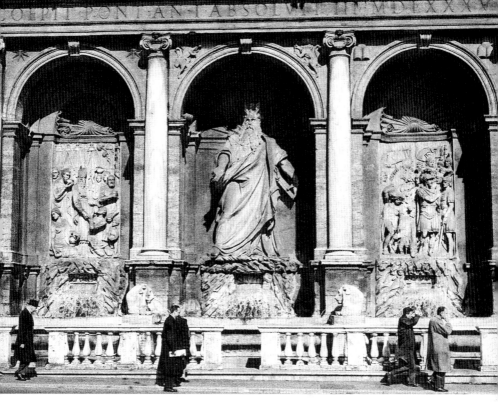

85 Domenico Fontana, *Acqua Felice*, Piazza di San Bernardo, Rome, 1585–7.

close quarters. Bernini's sculpture was certainly designed to be the focal
point of the pond, and, like his contemporary sculptures for Cardinal
Borghese, it drew upon the dynamic, two-figure groups of
Giambologna and the tradition of rustic fountains with Neptune
commanding the water. Bernini combined these elements into a
conceit of the sea-god calming the waters after a storm while the mer-
man Triton blows upon a conch. Compared to earlier representations,
this Neptune displays a notable vehemence which is expressed by
every aspect of his body, even down to the set of his jaw and his
wildly flowing hair. Neptune's spiralling *contrapposto* is complemented
by the more pacific form of Triton, whose conch originally spouted
water as a substitute for sound. This inclusion of water as part of
the fountain's conceit is also noteworthy because it corresponds to

95

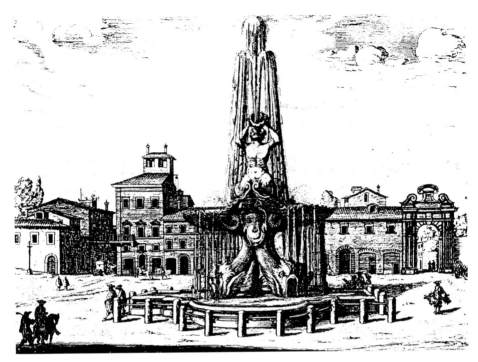

86 G. B. Falda, engraving of Bernini's *Triton* fountain, Piazza Barberini, Rome. From *Le Fontane di Roma* (1675).

Bernini's fascination with movement and variety, twin elements which feature in all his later fountains.

The *Neptune and Triton* could be understood as an extension of the villa fountains of the sixteenth century, and, in a sense, it fell within the tradition of rustic sculpture. But it actually stood inside the city walls of Rome, in a suburban setting, so it is not surprising that its more conspicuous features would later be adopted in fully urban settings by, say, the *Triton* fountain in Piazza Barberini, much as the dramatic emotionalism of Neptune anticipated the *St Longinus* for St Peter's. Executed between 1643–4, the *Triton* fountain abolished an architectural framework in favour of a wholly sculptural one. Triton is shown seated on an enormous shell supported by four dolphins, between whose tails the arms of the Barberini family are displayed. The fountain was carved from several blocks of travertine in an attempt to keep costs down, but the flair of Bernini's design transcends the fountain's rather ordinary materials. Re-siting, traffic and

87 Gianlorenzo Bernini, *Neptune and Triton*, 1620. Victoria and Albert Museum, London. Marble. H. 1.82 m.

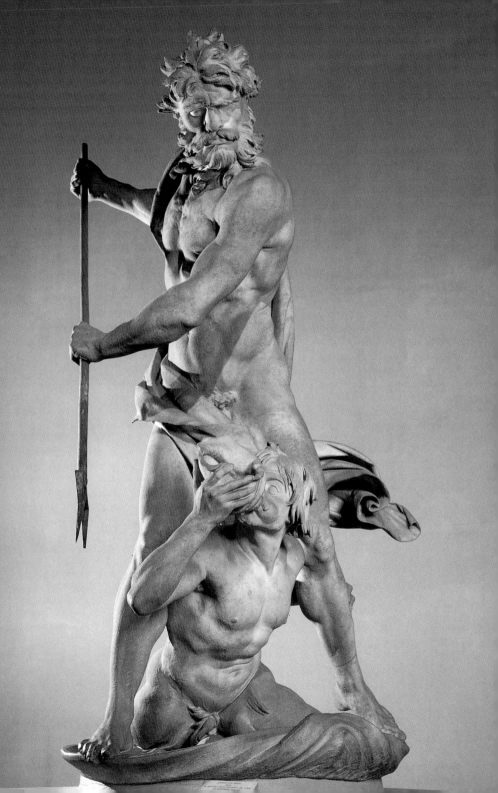

low water pressure have all but wrecked the impact of the *Triton* fountain, which is best appreciated now through drawings and old engravings. Bernini exploited the rise and fall of the Triton's jet to link the discrete elements into a whole. Here water became not only an element, but a totally integral part of the sculptor's conception. The Triton and dolphins appear to have just emerged from their native element to form a momentary ensemble. The illusion of movement was achieved here in terms reminiscent of festival decorations, but it also conveyed a subtext, namely the aggrandisement of the former Piazza Grimani as an extension of Palazzo Barberini, which at that time was being built on the hill above the piazza.

In Baroque Rome, fountains inevitably became a reflection of the largesse associated with papal families. The Barberini were trumped by the succeeding pope, Innocent X Pamphilj (who reigned from 1644 to 1655) and Bernini's greatest achievement in this genre, the 88 *Fountain of the Four Rivers*. The location was Piazza Navona, the ancient stadium of the Emperor Domitian and site of the papal family's palace. As early as 1647, Innocent had decided to erect an obelisk as a central ornament for the piazza in tandem with a fountain, which was emphatically not to be designed by Bernini, who was then out of favour through his close association with the previous regime. Bernini, however, arranged for his model to be seen by the Pope, and Innocent immediately determined to have the model executed, reputedly remarking that the only way to avoid employing Bernini was not to see his designs. As it turned out, Piazza Navona gave Bernini the opportunity to create a multi-layered tribute to the Pope as both spiritual leader and secular prince. He produced a design in a bold, direct language quite unlike the more abstract concepts of Borromini or the refined and decorative style of Algardi.

89 Bernini's original model may be reflected in a drawing at Windsor Castle, which is instructive in showing how radically the initial concept grew in the artist's mind. Below the obelisk, river-gods are seated near the openings of a grotto; beneath them water gushes from the rock into large shells supported by dolphins and thence into an oval basin. Each river-god supports the Pamphilj arms, crowned by the papal tiara and crossed keys. At this stage, the design seems to be a natural extension of the earlier *Triton* fountain, and it reminds us of the observation made by Filippo Baldinucci that Bernini liked to give his fountains 'some noble idea or concept' which was expanded in execution. This was habitual to his working process, for, unlike those of most sculptors, Bernini's works grew steadily more dynamic as they

proceeded. Thus the river-gods exchange the static poses of the Windsor drawing for vigorous postures that link them with one another as they respond to the obelisk as a symbol of light and divine inspiration. The four continents, here represented by their great rivers, were a fairly recent addition to artistic allegory and were generally invoked as a sign of international dominion by Church and Empire. It took Bernini to translate such figures from passive to active roles, each accompanied by an attribute: a horse for the Danube, a lion for the Nile, a palm tree for the Ganges and an armadillo for the Río de la Plata. A contemporary shrewdly noted that the obelisk was comparatively small and would need a special setting to register in the large piazza; this Bernini achieved through the jagged, travertine base which exalts the Egyptian monument over a central void and acts as a backdrop to the splendid marble statues. Water, travertine, marble and granite thus constitute a hierarchy of substances, mirroring the chain of being that links all elements to their supreme creator. Bernini continued to make designs for fountains throughout his career, but none surpassed the *Fountain of the Four Rivers* in its fundamental rethinking of fountain design; few, if any, later works in this genre could afford to ignore Bernini's legacy. 90

Although Roman fountains had experienced a thorough transformation by the mid-seventeenth century, those elsewhere in Italy changed more slowly. Ironically, perhaps, fountains and garden sculpture achieved new status through the examples of Versailles and Marly in France; Italian princely families, just like their counterparts across Europe, felt obliged to emulate King Louis XIV of France. Great estates were created, such as that of the Farnese at Colorno near Parma or that of the Spanish Bourbons at Caserta near Naples. With their endless façades, parterres, cascades and basins with sculpted fountains, these were creations very much in the French style, and although Colorno can today only be appreciated through paintings, Caserta still impresses the visitor with its scale and ingenious design. At the same time, the older style of Renaissance fountains persisted in many smaller retreats, sometimes crossed with more modern features. The fountain erected for the Borromeo family on Isola Bella in Lago Maggiore, for example, employs a folly in the style of Borromini to provide a series of bays for antique statues and mosaic decoration. 91

Due largely to the example of Versailles, copies of ancient or modern 'classics' for gardens became one of the great export industries for Italian sculptors during the late seventeenth and early eighteenth

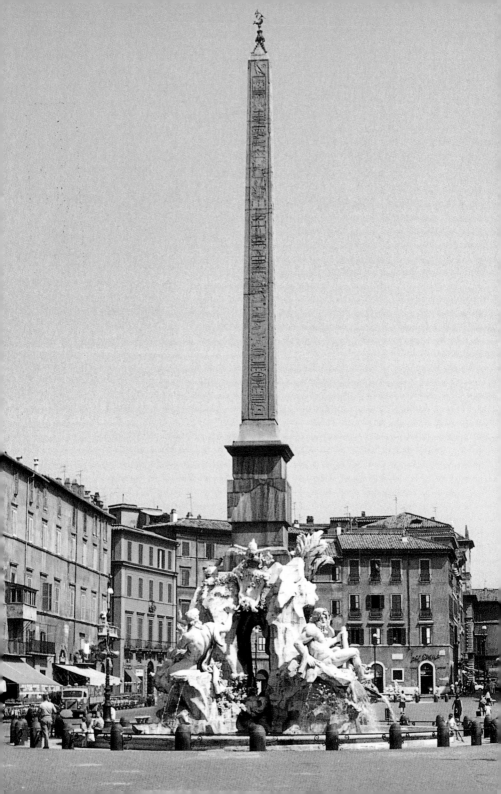

88–90 Gianlorenzo Bernini, *Fountain of the Four Rivers*, 1648–51. Piazza Navona, Rome. (*Left*) Travertine and marble. (*Above*) Preliminary study, 1647. Royal Collection, Windsor Castle. Pen, ink and chalk with wash on prepared paper. (*Below*) Francesco Baratta after Gianlorenzo Bernini, detail of Río de la Plata. Marble.

Teatro Massimo dell' Isola Bella *Grand Theatre de L'isle Belle*

91 Marcantonio dal Re, engraving of Isola Bella, Lago Maggiore, eighteenth century.

centuries. Artists like Domenico Guidi and Antonio Corradini were in demand from Paris to St Petersburg, purveying works which drew heavily upon the examples of Giambologna and Bernini. They tended to follow set formulas which encompassed the seasons, abductions and other mythological groups. Guidi's involvement with the French Academy in Rome led to his executing sculptures after the designs of the French King's painter Charles Lebrun (1619–1690), such as his celebrated *Fame of Louis XIV* for the Bassin de Neptune at Versailles. This commission was indicative of the shift in artistic influence from Rome to Paris.

Garden sculpture in Italy experienced a revival of interest, not in the great court residences but in the relatively minor villas of the Veneto at the turn of the eighteenth century. The Veneto was, of course, an area renowned for its traditions of *villeggiatura* or villa life, though few of these residences aspired to the princely status of those

102

around Rome or Florence. The protagonist of this change was Orazio Marinali, whose *bravi* were discussed in the previous chapter, a sculptor who emerged from a family of stonemasons from Vicenza which produced the full range of religious and secular work. But Marinali had a taste for the unusual as his *bravi* and garden sculpture attest. For one Vicentine villa, La Deliziosa, his workshop produced over one 94 hundred and fifty statues, including a fountain which, inevitably, borrowed ideas from Bernini's *Fountain of the Four Rivers*. More interesting, however, was his series of types drawn from country life and the theatre, the latter undoubtedly inspired by engravings of the *commedia dell'arte* by Stefano della Bella. Executed in local stone and often of poor quality, these sculptures illustrate another side of the seventeenth century's love of genre, combining the tradition of rustic sculpture with stock characters drawn from popular entertainments. Marinali must have found such work congenial, for his best garden sculptures have a *brio* unmatched by his more academic work. The vogue for new kinds of garden sculpture was promoted after Marinali's time by Antonio Bonazza (1698–1763) and his family, especially at the Villa

92 Antonio Corradini, *Nessus and Deianira*, 1718–23. Grosser Garten, Dresden. Marble. H. 2.55 m.

93 Antonio Bonazza, *La Vecchia*, 1742. Villa Widman, Bagnoli di Sopra, Padua. Limestone. H. 1.85 m.

94 Orazio Marinali, *commedia dell'arte* figure, *c.* 1700. Villa Conti Lampertico, 'La Deliziosa', Montegaldella, near Vicenza. Limestone. Life-size.

Widman near Padua where the ancient gods rub shoulders with contemporaries who could have stepped from the comedies of Goldoni. With Marinali and Bonazza, garden sculpture explores a world not unlike that created by Bustelli and Kändler with their porcelain figurines for Nymphenburg and Meissen.

Bernini can be said to have taken garden sculpture inside and made it the subject of high art, but his example was rarely followed. Filippo Parodi had similar aspirations and created a remarkable set of four statues for the garden of Palazzo Durazzo in Genoa. Drawn from Ovid's *Metamorphoses*, his figures were conceived as pairs and shared an appropriately horticultural theme of flowers: one pair featured

Clytie and Hyacinth, who were beloved of Apollo and changed into flowers after their death. The interest here is very much the process of transformation – Clytie into a sunflower, Hyacinth into the flower that bears his name. Although the subject matter is somewhat unusual, Parodi's models are even more remarkable, for he has adapted them from late works by Bernini in an entirely different context. *Clytie* is a witty parody of the master's Truth from his unfinished *Truth Unveiled*, and her sunflower is derived from the sun held by Bernini's figure, but *Hyacinth* follows the unexpected example of the *Angel with the Superscription* from the Ponte Sant'Angelo in Rome, an intensely spiritual meditation that could hardly seem less appropriate. The ethereal aspect of late Bernini may have commended itself as suitable for Parodi's task; evidently, he accorded a seriousness to such sculptures that is rarely encountered elsewhere.

For much of the Baroque period, fountain and garden sculpture developed independently, but the eighteenth century witnessed the apogee of both with the Trevi Fountain in Rome and the sculptures of the Grand Cascade at Caserta. The Trevi was the terminal fountain of one of the most celebrated Roman aqueducts, the Aqua Virgo, which rises at Salone near Tivoli. Restored by Pope Nicholas V in

99–100
101

95, 96 Filippo Parodi.
(*Left*) *Hyacinth*, c. 1680.
(*Right*) *Clytie*, c. 1680.
Galleria, Palazzo Reale,
Genoa. Marble.
Under life-size.

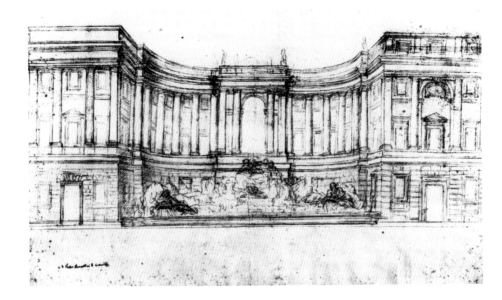

1453, the fountain received Bernini's attentions in 1640, when it was re-sited on the north side of a considerably enlarged piazza. Urban VIII and his sculptor may have intended a more monumental setting for the fountain, but Pietro da Cortona, working for Alexander VII Chigi, produced a radical solution in 1659. This incorporated the fountain into the rusticated ground floor of a new Chigi palace in a different square, Piazza Colonna. Though never executed, Cortona's audacious design anticipated the winning entry for a new fountain in 1732. Completion of what should have been a major project had been hampered by the decline in papal patronage after the reign of Alexander VII and also by the restricted site of the fountain which was hemmed in between the wings of Palazzo Poli.

A number of ingenious schemes were suggested during the early eighteenth century, but no sculptor or architect had the authority or influence enjoyed by Bernini. One of the most bizarre projects advocated a tableau within a proscenium arch that could have been mistaken for a stage setting. The sculptures seem inspired by the *Apollo and the Muses* by François Girardon (1628–1715) at Versailles and Bernini's *Fountain of the Four Rivers*, and enact the legendary revelation of the water's source by the virgin Trivia to Roman legionaries as Roma herself stands nearby. The landscape and ruined arch point to the restoration of the aqueducts by the popes as successors to the

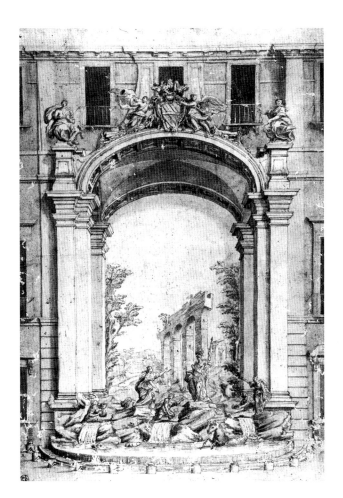

97 Pietro da Cortona, drawing for elevation of Palazzo Chigi with fountain, 1659. Vatican Library. Chalk.

98 Unexecuted project for the Trevi Fountain, Rome with ruined aqueduct, *c.* 1730. Kunstbibliothek, Berlin. Pen and wash.

Roman emperors; alternatively it may have been inspired by Algardi's design for a stucco fountain with Trivia set against a landscape painted by Gaspar Dughet (1615–1675) in Palazzo Pamphilj. These and other proposals lacked, however, the appropriate degree of magnificence. Finally, Clement XII initiated a new competition in 1732, in which the fountain would incorporate the lateral wings of Palazzo Poli. The nature of the commission probably ensured victory for an architect rather than a sculptor, but Nicola Salvi was more formidably educated than even Vitruvius could have imagined. His studies of philosophy, mathematics, medicine and literature were followed by attendance at the Roman Academy of St Luke where he wavered between careers

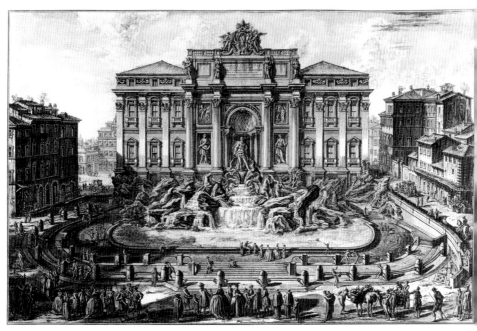

99 Giovanni Battista Piranesi, engraving of the Trevi Fountain, Rome, 1773. From *Vedute di Roma, c.* 1748–78.

in painting and architecture. The latter finally won through, yet his background left him peculiarly well placed to draw together the diverse strands of architecture, iconography and hydraulics into the equivalent among fountains of Bernini's *bel composto*.

Unlike Cortona's project for Piazza Colonna, Salvi's design embraced the whole of the ground-floor level of the façade as well as turning the three central bays of the upper storeys into the focal point. A giant Corinthian order binds together the whole façade and frames the central tableau in which Oceanus, god of all waters, steps into a chariot drawn by sea horses and Tritons. Statues of Fertility and Health, embodying attributes of spring water, flank Oceanus, and the two reliefs above them recall the origins of the Aqua Virgo; four more allegorical statues and the arms of Clement XII crown the attic above. Incontrovertibly Baroque in scale and dynamism, the Trevi Fountain strikes a balance between Classical rigour and extrovert gesture that is entirely characteristic of late Roman Baroque; in much the same way, the subordination of sculpture to architecture marked a notable

100 Detail of central pavilion of the Trevi Fountain, Rome, 1732–62.

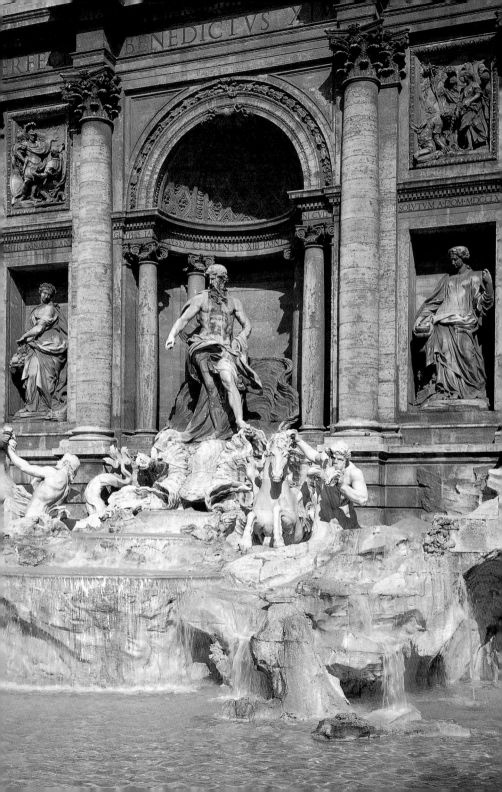

departure from the prevailing tendency in fountain design. Although its construction spanned three decades and a host of sculptors, the final result is very consistent, thereby endorsing the authority of Salvi's winning design.

The Trevi Fountain was symptomatic of a tendency in late Baroque sculpture which saw sculptors working to designs by architects and painters. This reflected the absence of a dominant artistic personality in sculpture after the death of Bernini as well as the need for someone to impose direction on a large commission. The shifts set in motion by the Trevi Fountain culminated in the breathtaking sequence of fountains planned by Luigi Vanvitelli (1700–1773) for the royal palace at Caserta. Vanvitelli, like Salvi, had studied painting as well as architecture, and was charged by Charles III, Bourbon king of Naples, with the design of a major residence some 30 kilometres from the capital. From 1751 until his death, Vanvitelli produced the Italian riposte to Versailles, a work which Wittkower rightly termed 'the overwhelmingly impressive swansong of the Italian baroque'.

Here too, inevitably, French influences were prominent in the programme of the fountains and gardens, but the most striking feature of the design is the way in which Vanvitelli reintegrated garden and fountain statuary into a new ensemble. His great set pieces – *Diana and Actaeon* and *Venus and Adonis* – recall the setting of the *Niobids* in the Villa Medici gardens in Rome in their stage-like presentation of statues, but Vanvitelli planned his groups as a tableau from a festival or an ephemeral creation. Girardon's work seems positively Neoclassical when compared with Vanvitelli's compositions, but the latter have an inventive quality that even Bernini might have envied. Executed by an *équipe* under Paolo Persico (1729–1796), Gaetano Salomone (*fl.* 1757–1789) and Tommaso Solari (d. 1779), the groups were conceived as decoration for the great cascade which ran down a hillside to a larger basin on the same axis as the palace. Some nineteen groups were planned, each taking as its theme a mythological subject associated with water. Although only part of the whole scheme was carried out, under the supervision of Vanvitelli's son Carlo between 1776 and 1779, it is still a remarkable achievement, especially the two focal points, *Diana and Actaeon* and *Venus and Adonis*. In the latter, Venus entreats her lover not to go off to the hunt while dogs, putti and the wild boar whose bite proved fatal thread their way among the rocks. *Diana and Actaeon* is situated on an upper level and exploits its setting brilliantly through the division of the composition into two groups. On one side, Diana imperiously points towards the doomed hunter as

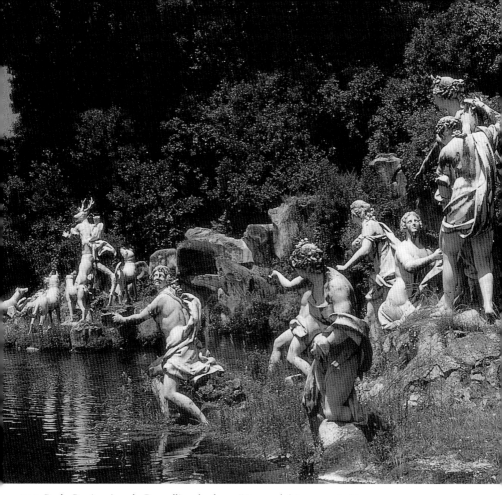

101 Paolo Persico, Angelo Brunelli and others, *Diana and Actaeon*, 1770–80.
Grand Cascade, Caserta. Marble.

her nymphs react in horror or dismay. Across the cascade, Actaeon
staggers off, now transformed into a stag about to be set upon by his
own dogs, and further figures of hunters embellish the balustrade.
Remote from the high Neoclassical mode, these sculptures are too
beguiling to be taken seriously, but at the same time, their combina-
tion of nature and artifice reconciled the disparate strands of Baroque
fountain and garden sculpture and raised them to a level scarcely
equalled elsewhere in Europe.

MARIAE RAGGIAE CHIAE
VIRTVTE DOMINICANA FAMILIAE ORDINI
OCTAVIA VS CARD RAGGIVS IANVEN
ADMIRATVS
RELIGIOSAM FOEMINAE VIRTVTEM
VSQVE AD STVPOREM EXTVLIT
SVB EODEM AGNOMINE CARIOZEM
CONDITORIVM LEGAVIT
ANNO REPARATAE SALVTIS MDCLII

LAVRENTIVS CARD RAGGIVS
EX FRATRE NEPOS ET EXECVTOR CVRAVIT
ET THOMAS RAGGIVS
PONTIFICIAE CLASSIS COMMISS GENERALIS
FRATER ET HAERES

The Art of Dying Well

'Suor Maria held her eyes fixed on the altar of her oratory, and she told me to mark her with the sign of the cross; it was thus that this servant of God always made the sign of the cross when she had some vision, and I was sure that she had one then . . . [later] she extended her arms as if wishing to embrace someone, and she immediately closed them in the form of a cross on her breast, inclining her body and making a great bow. Then she raised her head and . . . uttered the words, Lord Jesus, receive my spirit. She said those words with great devotion; and then she pronounced three times the name of Jesus, and at last, with admirable peace and quiet, she gave up her spirit to the Creator, leaving all those present consoled by so happy a death and melancholy and tearful for her absence.'

Bernini's memorial to Maria Raggi depicts the last moments of a pious nun more than forty years after her death. In so doing, Bernini reflected contemporary preoccupations with making a good Christian end to life; at the same time, he transformed her memorial tablet into a record of the deathbed scene submitted as evidence prior to her beatification. Thus, rather than being a conventional portrait, the bronze medallion presents her at the moment of death, while the cross above becomes a sign of her inner vision, and the billowing cloth of honour is seemingly petrified as coloured marble.

Death and commemoration lay at the heart of Baroque art, for they touched upon aspects of Christian belief concerning this world and the next as well as the overlapping boundaries between normal existence and what we would call 'altered states'. In the seventeenth and eighteenth centuries, death was much more central to everyone's experience of life. Poor sanitation, high levels of infant mortality and frequent epidemics meant that the death of close relations occurred often; life expectancy, too, was very short. A Catholic observer would have been reminded of this when gazing upon the memorial to Maria Raggi, or when participating in funerals or visiting churches with their array of monuments. The concept of Christian death, arising from the medieval *ars bene moriendi*, was part of a strategy for

102 Gianlorenzo Bernini, Memorial to Maria Raggi, 1643. Santa Maria sopra Minerva, Rome. Gilt bronze and coloured marble.

guiding the soul through the afterlife and ultimately to paradise; it involved meditation upon the end of life as well as what happened afterwards. In his spiritual exercises, St Ignatius Loyola recommended meditation upon death, and later writers elaborated upon this, concentrating upon the hour of death and the fate of the body, the pains of hell and the joys of heaven. John Donne, the poet and Dean of St Paul's, posed in a shroud for a portrait on which his marble effigy by Nicholas Stone the Elder (*c.* 1586–1647) was based, and Pope Alexander VII kept two things in his private apartment: a model of the city of Rome to demonstrate his urban projects, and a coffin to remind him of the end of human vanity – a combination both bizarre and Baroque.

After the Reformation, Protestants saw death as a line under the balance sheet of a soul: nothing further could influence one's fate on the dreadful day of judgment. For their part, Catholics interpreted death as the beginning of a second life in the intermediary state of Purgatory, where all but the most holy expiated for their sins in the hope of eventual salvation. This could be facilitated for the wealthy by pious bequests, indulgences and the efficacy of prayer, especially in the mass for the dead and commemorative masses. Engravings of the state funeral of Marchese Ludovico Fachinetti, Bolognese ambassador to the court of Urban VIII, are evocative of the splendour of great Baroque funerals. Designed by Algardi, the *mise en scène* consisted of fictive decorations, painted in grisaille and picked out in gold. The high altar was temporarily graced with a large bronze crucifix, set off against a dark velvet hanging on which the arms of Bologna were woven in gold and silver thread. The centre of attention was the catafalque, which consisted of a high plinth with skeletons in shrouds supporting an upper tier with the sarcophagus and seated virtues. The whole was fashioned out of wood, plaster and papier mâché and crowned by a silvered figure of Immortality holding a portrait of the deceased.

The elaborate nature of Fachinetti's funeral was not atypical; indeed, such ceremonial splendour frequently cost as much as a permanent monument. Nowadays, anthropologists are fond of drawing comparisons between a community and its conception of an afterlife, and such a corollary rings true of Italian culture during the Baroque. Bernini, Algardi and their patrons would have agreed with a sixteenth-century writer, Lilius Giraldus, who discussed types of burial in terms of social standing: interment in a churchyard was plebeian; gentlemen required marble epitaphs; and princes should be commemorated in bronze and porphyry. Reforming clerics, like St

Charles Borromeo, tried to abolish burial in churches and the construction of conspicuous monuments, but such interventions merely encouraged the practice. Questions of status dictated that the presbytery and choir were for the clergy and major benefactors; noble or worthy patrons would opt for chapels or burial in a vault near the high altar so that they would be remembered in the prayers of the mass.

Tombs, like funeral services, assumed greater magnificence during the seventeenth and eighteenth centuries, especially where rulers were concerned. Nowhere is this more forcefully borne out than in papal tombs. Sixtus V established a new standard with his opulent monument in the Sistine Chapel in Santa Maria Maggiore. The lateral walls are given over to triumphal arches in which a kneeling image of Sixtus on one side is faced by an enthroned statue of his predecessor and benefactor, Pius V. Both statues are derived from distinctive iconographic traditions: the enthroned figure from the venerated medieval image of St Peter in his basilica, and the praying Sixtus from the medieval tradition of chapel patrons kneeling in perpetual adoration. Each statue is framed by polychrome marbles, narrative reliefs with caryatids and further reliefs in the register above. One of Paul V's first acts was to emulate his great predecessor by building a pendant chapel with tombs for himself and his patron, Clement VIII, in the same church. Although more opulent, Bellori rightly judged the Pauline Chapel less successful than Sixtus's chapel, but it reflected the perennial concern of pontiffs to leave behind a conspicuous monument to themselves and their families. Given the conservative nature of the papacy, it is surprising that such monuments ever varied, but the unusual artistic alliance between Urban VIII and Bernini led to a reworking of the papal tomb which had repercussions on the makers of tomb sculpture well into the eighteenth century.

In keeping with many of his predecessors, Urban commissioned his tomb early in his reign, and from the outset Bernini had to take account of the mid-sixteenth-century tomb of Paul III, which had been moved from the crossing to the choir of St Peter's, as a pendant for Urban's proposed monument. A workshop drawing allows us to gauge the sculptor's initial *concetto* as work began in 1628. Ensconced in a niche, the seated bronze statue of the Pope surmounts a marble plinth while figures of Charity and Justice incline against the sarcophagus, at the centre of which lies a skull with some bones; the papal arms and semi-recumbent virtues crown the pediment above. The pyramidal composition recalls the design of Paul III's tomb, albeit

104

103

with a more vertical emphasis as well as an awareness that both pontiff and allegories had to be visible across the vast expanse of the choir. The splendid and imposing gilt-bronze statue of Pope Urban was cast between 1630 and 1631; the definitive design for the allegories had been approximately fixed by then, as their marble blocks were acquired towards the end of the year. By that time, however, Bernini had begun to revise his conception of the tomb by introducing Death in an active role, thus changing the tenor of the composition somewhat. A winged and partially shrouded skeleton is presented inscribing Urban's name in the book of history, effectively composing his epitaph. At the same time, the attendant allegories are less abstracted than those on Paul III's tomb, and the vivacious putti now create minor episodes which contrast with the principal figures. The early statue of Urban remains totally unaffected by the presence of Death, but, as a whole, the component parts sit somewhat uneasily together, as if Bernini were groping piecemeal towards a concept that would coalesce effortlessly in his subsequent tomb for Pope Alexander VII.

103 Workshop of Gianlorenzo Bernini, early design for tomb of Urban VIII, 1627–8. Royal Collection, Windsor Castle. Pen, ink and wash over chalk.

94 Gianlorenzo Bernini, Tomb of Urban VIII, 1628–47. St Peter's, Rome. Marble and bronze, partly gilt. H. 5.6 m.

The belated addition of Death to Urban's tomb reveals one of those sudden changes of direction that characterize the middle decades of Bernini's career, and for several generations sculptors embraced the personification with enthusiasm. Bernini was doubtless inspired by the skeletal figures so often used in funeral decorations, and the macabre cemetery decorations which survive in the Capuchin cemeteries in Rome and Palermo. But his genius lay in conflating the distinct personifications of Death and Time, for the skeleton not only underscores the mortality of the Pope, but also renders him immortal in the book of history. It was the kind of conceit congenial to seventeenth-century writers, and Bernini was to return to it several times in later works. The memorial to Alessandro Valtrini, who died in 1633, is another example. It consists of a winged personification of Death displaying the image of the deceased, the inverse of the traditional *memento mori*, where the deceased was shown contemplating a skull as a sign of mortality; here, Death strikes a monitory pose while exalting the fame of a pious benefactor.

Bernini's preoccupation with death reached a climax in the famous tomb of Pope Alexander VII. Erwin Panofsky observed that it makes the earlier tomb of Urban VIII seem conventional by comparison, but it is also a highly personal statement about confronting death.

105 (*left*) Gianlorenzo Bernini, Memorial to Alessandro Valtrini, 1641. San Lorenzo in Damaso, Rome. Marble.

106 (*below*) Cemetery in the crypt of Santa Maria della Concezione, Rome.

107 Gianlorenzo Bernini, Tomb of Alexander VII, 1671–8. St Peter's, Rome. Coloured marble
and gilt bronze. Over life-size.

Executed between 1671 and 1678, the tomb of Alexander VII stands at the very end of Bernini's career when he was reworking traditional aspects of sepulchral imagery in terms of the visionary nature of his later works. The initial idea of the Pope kneeling bare-headed had been sketched out in Alexander's lifetime, but it was only when the final site – a relatively narrow pier in the south-western aisle of St Peter's – was chosen that the inconvenience of an existing door was turned to advantage as the centrepiece of the monument. Though the setting is cramped, the sculptor obtains maximum effect by making the spectator follow the 'storyline' across a wide visual arc, much as in the earlier *Apollo and Daphne*. Four virtues are grouped around the base of what could be called a reductive version of Bernini's earlier proposals for the tomb: no sarcophagus, only a plinth with the pontiff's name; no figure of Fame with a trumpet, only the menacing arm of Death as it emerges, clutching an hourglass, from beneath a shroud-like canopy of Sicilian jasper. The door thus becomes the gate of death, through which all mankind must pass; its adaptation blurs illusion and reality in a manner Bernini made peculiarly his own. The juxtaposition of Death and Alexander turns the Pope into everyman, fortified by his virtues, especially Truth, whose serenity mitigates what St Paul famously called 'the sting of death'. The mystical and meditative nature of the monument is evident in the two most prominent virtues, the self-absorbed figures of Truth holding a sun and Charity surging impulsively towards Alexander.

The ingenuity of Bernini's design for the tomb of Alexander VII was much admired by later sculptors like Pietro Bracci and even Canova, but it was the outward forms rather than the overall concept that attracted imitation. Instead, Algardi's one, grand essay in papal funerary monuments became the touchstone for the majority of Alexander VII's successors. Algardi's tomb of Leo XI has often been compared with Bernini's tomb of Urban VIII as a device for polarizing their creators' artistic personalities. This technique tends, however, to distort Algardi's reasons for executing Leo's monument as he did, not least because the setting, an even darker and narrower aisle of St Peter's than that given to Bernini, ruled out flamboyant gestures, and bronze and coloured marble would have seemed out of place. Moreover, Algardi was set the difficult task of celebrating a shadowy cleric who enjoyed the papal throne for only twenty-seven days in 1605. Algardi was fortunate in obtaining this commission when still relatively unknown in 1634, possibly owing to Bernini's extensive commitments elsewhere. Algardi's design did, in fact, begin with a

108 Alessandro Algardi, Tomb of Leo XI, 1634–44. St Peter's, Rome. Marble.

formula not unlike Bernini's early project for Urban's tomb, but its restraint and the incipient Classicism of the attendant virtues of Magnanimity and Liberality won great admiration from the late seventeenth century onwards. In one sense, a happy conjunction of impediments, both of setting and subject, turned Algardi's work into an icon for later sculptors. The white Carrara marble and reductive scale of the work are complemented by the elegiac nature of all three figures. Although Algardi's virtues appear more Classical than Bernini's for Urban VIII, Liberality bears evidence of a study of Duquesnoy's *St Susanna* as well as Bernini's Charity; Magnanimity strikes a Minerva-like pose, but there is a warmth about her expression and a voluminous quality to her drapery which no Classical or Neoclassical sculptor would accept. Above all, there is a marvellous delicacy to the ensemble and a wealth of decorative elements – from the wreath around Pope Leo's name to the superbly carved scenes on the sarcophagus – that make this monument to an unmemorable pope one of the most memorable of all such sculptures.

Algardi's tomb of Leo XI illustrates an important fact concerning many monuments of both the Renaissance and Baroque periods, namely that such works were often conceived as family memorials to reflect as much the honour of the office as the merits of an individual. Many of the most imposing monuments in Venice commemorated doges who reigned only briefly. The most celebrated of these in the seventeenth century was conceived by the architect Baldassare Longhena (1598–1682) and executed by the German sculptor Melchior Barthel (1625–1672) for Giovanni Pesaro. As a scion of a wealthy Venetian house, Pesaro enjoyed the high office of doge for little more than a year before his death in 1659. He left elaborate instructions concerning his tomb in a codicil to his will drawn up the day before he died. He left 12,000 ducats – enough for a modest building – towards the erection of a tomb adjacent to the chapel of his ancestors in Santa Maria dei Frari. The Doge further stipulated that the tomb should be finished within ten years of his death and that he should be buried in the family vault beneath. Pesaro's preoccupations were typical of the period; most testators were concerned that their mortal remains should find a secure and permanent resting place, literally until the Last Judgment. Monuments frequently had a family context as several generations would often be buried in the same vault or in a chapel. In Pesaro's case, the towering structure was completed within a decade, on a regal scale. Four large moors divide the structure into two bays, either side of a doorway; two skeletons

109 Baldassare Longhena, Tomb of Doge Giovanni Pesaro, 1659–69. Santa Maria dei Frari, Venice. White and coloured marble, and bronze.

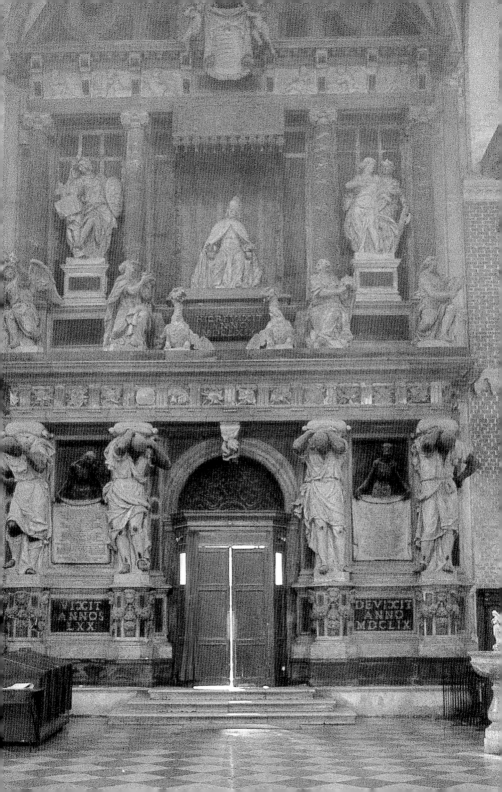

carry inscriptions while on the upper register four statues of virtues flank the central tableau of the Doge, who is enthroned beneath a baldachin of red marble and above a fictive sarcophagus, crushing the enemies of the state.

Cumbersome and unsubtle, the tomb celebrated what anthropologists would call the social as opposed to the natural body, in this case, the continuity of the Venetian Republic rather than Giovanni Pesaro's brief reign. Most tombs involving an image of the deceased inevitably projected a social likeness, and in this way their concern was not far removed from portraiture, with its emphasis on class and status. Even the traditional image of death as the great leveller never dislodged an overriding preoccupation with the soul as constituent of another world in which the social hierarchy of this world would be maintained. Papal tombs endorse this concept, and similar concerns were expressed at other levels, as in Bernardino Cametti's confident

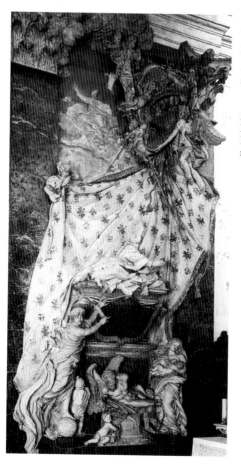

110 Filippo Parodi, Monument to Giovanni Francesco Morosini, c. 1678–83. San Nicolò dei Tolentini, Venice. White and coloured marble, gilt bronze and stucco.

111 (right) Bernardino Cametti, Monument to Prince Taddeo Barberini, 1704. Santa Rosalia, Palestrina. White and coloured marble. Life-size.

memorials to Giovanni Andrea Muti and Maria Columba Bussi Muti in the Roman church of San Marcello al Corso, or in Filippo Parodi's monument to the patriarch of Venice, Giovanni Francesco Morosini. Clearly inspired by Bernini, this latter monument reads like an amalgam of familiar motifs: fictive drapery and angels carry the deceased's shield; the Patriarch himself prays on his tomb while allegorical figures act out a pantomime below; and Charity is a free copy of the same figure from the tomb of Urban VIII, while Truth with her foot on the globe stands poised to inscribe Morosini's eulogy. Novelty comes in the presentation of Time, who is chained and will ultimately die like Death even as Morosini rises from his tomb and turns heavenward, towards a vision of St Mark, the patron of Venice.

The Baroque period saw the high-water mark of such allegorical monuments, for, as we have seen, allegory and metaphor encapsulated much of the contemporary outlook on the world. In particular, works by Bernini and Algardi furnished a point of departure for a wide variety of memorials, not simply papal monuments. It becomes evident during the course of the eighteenth century that the emphasis shifted

away from the fervour reflected in High Baroque tombs towards greater attention to the posthumous fame of the individual. This shift can be seen most directly in the monuments to Cardinal Antonio and Prince Taddeo Barberini, executed by Bernardino Cametti for the Barberini family fiefdom of Palestrina in 1704. In both, the memorial consists of a pyramid in which the bust of the deceased has been placed; a figure of Fame inscribes the epitaph or sounds the trumpet. The pyramid was an ancient symbol of eternity which had been given new cachet by Bernini's completion of Raphael's Chigi Chapel in Santa Maria del Popolo in Rome; yet no minor key is struck by these monuments, nor is their religious content very much to the fore. The same holds true for a later variation on this theme by Pietro Bracci in his tomb of Cardinal Giuseppe Renato Imperiali for the Roman church of Sant'Agostino. Begun in 1741, Bracci's work adroitly manipulates elements from earlier models then recognized as classic, especially Bernini's memorial inscription to Alessandro Valtrini; Bracci shows Fame holding a mosaic portrait of the deceased, and allusions to death are reduced to the slightly frivolous winged skulls over the twin doors beneath. The whole ensemble,

111

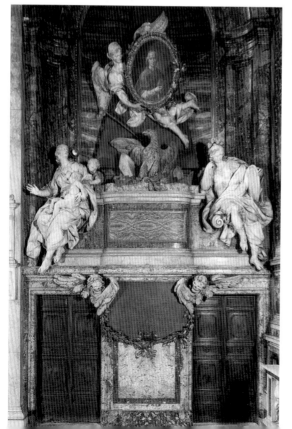

112 Pietro Bracci, Tomb of Cardinal Giuseppe Renato Imperiali, 1741. Sant'Agostino, Rome. White and coloured marble, gilt bronze and mosaic.

113 Angelo Gabriello Piò, Memorial to Count Alvise Marsilio, 1733. San Domenico, Bologna. Stucco.

set off by polychrome marbles, has a porcelain lightness and invites comparison with a whimsical tablet erected in the Bolognese church of San Domenico to Count Alvise Marsilio. The sculptor was Angelo Gabriello Piò, a master mentioned earlier in connection with the Bolognese tradition of stucco work and wax, who turned what would have been a conventional tribute into a witty conceit: Fame bears the deceased's image aloft while an inscribed tablet slips downwards, pinning Time beneath its weight.

We are a very long way from Bernini and the solemnity of High Baroque monuments here. Rationalism and doubts about the 'other-world' began to undermine the fears of punishment and eternal damnation that had featured in seventeenth-century literature on death and purgatory. In the 1720s, one French abbé cynically referred to purgatory as 'the fire which cooked the priest's stockpot'. Indeed, one of the supreme ironies of the period can be found in Giovanni Battista Foggini's design for the tomb of Galileo, whose astronomical writings were condemned by the Church under Urban VIII but whose monument borrowed significantly from Algardi's tomb of

114

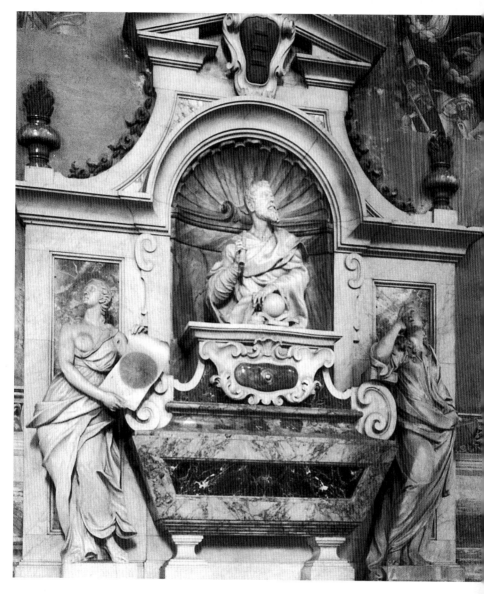

114 Giovanni Battista Foggini, Tomb of Galileo, 1732–7. Santa Croce, Florence. Marble.

115 (*right*) Camillo Rusconi, Tomb of Gregory XIII, 1719–25. St Peter's, Rome. Marble.

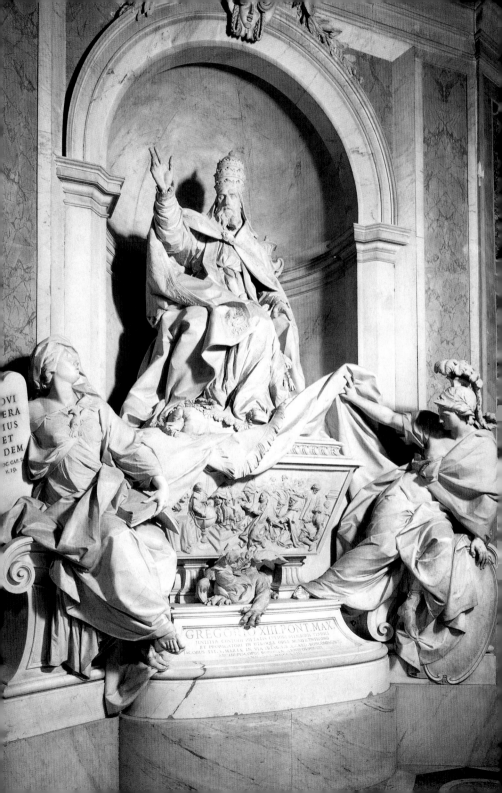

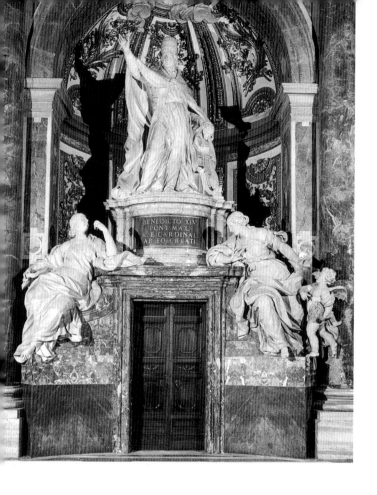

Leo XI. Galileo's attendant allegories are of course Astronomy and Geometry; these are not cardinal virtues, and despite the monument's presence in the Florentine basilica of Santa Croce, it commemorates the astronomer as a secular saint, showing him gazing to the sky for scientific rather than religious enlightenment. Even the uncle of Pope Clement XII, Cardinal Neri Corsini, was memorialized on his ceno-taph in St John Lateran more in the manner of a Roman senator than a prince of the Church. Giovan Battista Maini (1690–1752) presents the Cardinal with his hand on his heart in a gesture which Algardi would have understood, but the effect is much more of *gravitas* than piety, a precocious anticipation of Neoclassicism.

Even papal memorials were not immune to the changing climate

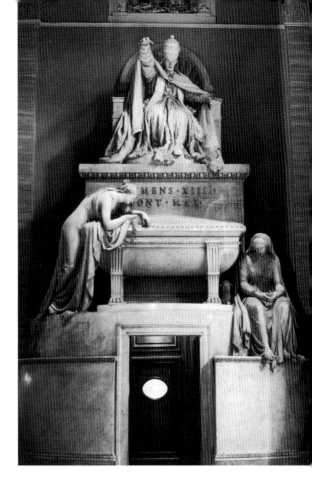

116 (*left*) Pietro Bracci, Tomb of
Benedict XIV, 1763–70. St Peter's,
Rome. Marble.

117 Antonio Canova, Tomb of
Clement XIV, 1783–9. SS Apostoli,
Rome. Marble. H. 7.4 m.

of opinion. Like most such memorials in the early eighteenth century, that of Gregory XIII by Camillo Rusconi subscribed to the basic formula of Algardi's tomb of Leo XI, albeit with Berninesque touches. Religion looks up to the figure of the Pope giving benediction as Fortitude lifts the massive drapery to reveal a sarcophagus with a relief commemorating the Gregorian emendation of the calendar. Despite the ostensible religious context of the monument, its focal point remained the Pope as enlightened reformer rather than spiritual leader. Much the same could be said of Pietro Bracci's monument to Benedict XIV which is also in St Peter's and is really the last of the great Baroque papal monuments. Executed between 1763 and 1770, the monument bears a clear affinity with Bernini's tomb of Alexander

115

VII, although the differences which exist are instructive. The pyramidal structure around a door remains, as does the plinth and papal statue, but, deprived of the voluminous shroud and winged skeleton, the doorway seems merely an inconvenience, the potential unity of the work dissolved into many discrete elements. Evidently, Bracci and his patrons were aware that no one could work wholly in Bernini's style by that date, but it still remained unclear what should replace it. Hence the timidity and half-heartedness that undermines the work, especially in comparison with a defining monument of the next generation: the tomb of Clement XIV by Antonio Canova (1757–1822) in SS Apostoli, Rome. With this monument, the rigour and conviction of Neoclassical taste have replaced the empty rhetoric of Bracci's monument to Benedict XIV; the virtues of Temperance and Humility are so restrained, their draperies so severe and their attributes so understated that they appear to be generalized mourners.

Similar adaptations affected major monuments outside Rome, especially those for the House of Savoy in their royal foundation, the Superga, sited on a hill to the east of Turin. Like most of the sculpture provided for the court, these were the product of Ignazio Collino (1724–1793) and his brother Filippo (1737–1801), who trained in Rome under Maini and directed the schooling of sculptors in Turin from 1767. Able and receptive, the two brothers studied the best examples of ancient and modern sculpture and were capable of reproducing Classical models when required; when faced with the tombs of Vittorio Amedeo II and Carlo Emanuele III, however, they instinctively reverted to the great papal tombs of earlier generations as models. This is particularly the case with the tomb of Carlo Emanuele III, which, despite its veneer of Classicism, betrays an unmistakable affinity with the world of Algardi, Rusconi and Cametti. The inclination towards narrative links the gestures of Prudence, Valour, Military Genius and the two putti, all of whose actions centre upon the medallion of the late King. In fact, the gesture of Valour drawing back the drapery is modelled closely upon Rusconi's memorial to Gregory XIII, itself a work midway between the Baroque and Neoclassical styles. The main difference comes in the treatment of the figures, whose drapery and – in the case of Military Genius – semi-nudity point towards a closer study of antique models. But the great Baroque *macchine* were slow to be banished by newer styles, and even as late as 1788, a year after Canova completed his tomb of Clement XIV, the Collino brothers' royal tombs at the Superga paid their predecessors a final, if oblique, tribute.

118 Ignazio and Filippo Collino, Tomb of Carlo Emanuele III, 1788. La Superga, Turin. White and coloured marble, and gilt bronze.

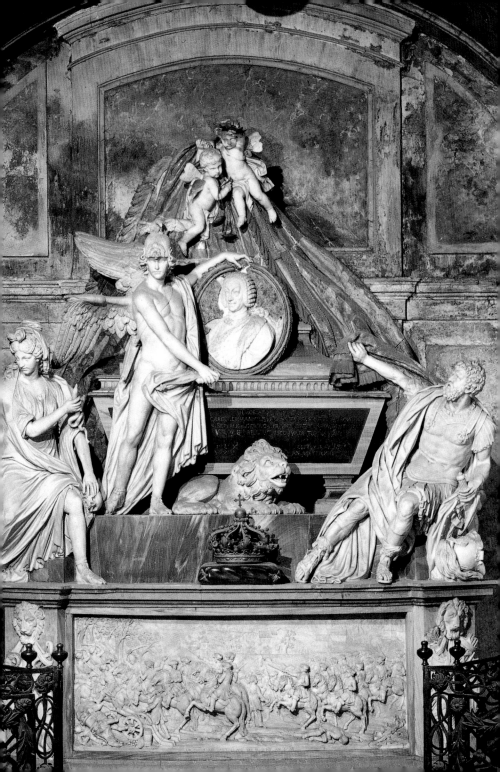

The Bel Composto

The advent of Pope Innocent X marked the one brief period in which Bernini fell from papal favour. So unpopular had been the twenty-one-year reign of Urban VIII and so absolute had been Bernini's artistic sway that the sculptor was inevitably tarnished by association as well as by deed. This period in the wilderness during the 1640s provoked a change within the sculptor and also led to the creation of his greatest masterpiece, the Cornaro Chapel in Santa Maria della Vittoria in Rome. Filippo Baldinucci said of the Cornaro Chapel that there Bernini exceeded even the talents of Michelangelo, for although Michelangelo had been supreme in painting, sculpture and architecture, Bernini was the first to combine all three in one work, creating a *bel composto* or beautiful synthesis. In so doing, he fused the arts into a statement which crossed space and indeed time, drawing the spectator and the deceased members of the Cornaro family into a perpetual re-enactment of the mystical union of the soul with God.

Bernini's achievement was not, as has sometimes been said, a mere flouting of the rules, but rather the fruit of a long period of experimentation with the problems of representing the miraculous while maintaining the distinction between truth and fiction. Nor was he, strictly speaking, the first to attempt this; his son, Domenico Bernini, put it more accurately when he placed his father 'among the first' to forge an ensemble of the arts. Michelangelo's New Sacristy in Florence and Raphael's Chigi Chapel in Rome – the latter actually completed by Bernini in the 1650s – anticipated facets of the Cornaro Chapel, and Pietro da Cortona's sojourn in Florence gave rise to a rich combination of media in his decoration of the state rooms at Palazzo Pitti during the 1640s. But none before and few after rivalled Bernini's elevation of the arts to a level of interpenetration where new rules applied.

In an affectation of modesty, Bernini described the Cornaro Chapel as one of the 'least bad' of his works; it has long been seen as the definitive statement of his approach to art. What makes the chapel

so stimulating and inexhaustible is its use of visual metaphors; in this context, it may be worth recalling the definition of metaphor given by the Aristotelian scholar Emanuele Tesauro in 1655: 'A metaphor packs tightly all objects into one word and makes you see them one inside the other in an almost miraculous way, and your delight is the greater because it is a more curious and pleasant thing to watch many objects from a perspective angle than if the originals themselves were to pass successively before your eyes.' In a definition which would have been appreciated by poets like Giambattista Marino or Richard Crashaw, Tesauro believed that this combination of unexpected images produced a kind of perception more stimulating than rational truth, an observation which could be applied to Bernini's *bel composto*.

Cardinal Federico Cornaro, the patron of the chapel, was the scion of a powerful Venetian family and son of a former doge. He lived in Rome and had a special attachment to the new order of Discalced (barefoot) Carmelites; so it is not surprising that he chose the Carmelite church of Santa Maria della Vittoria for a burial chapel and obtained the most prestigous site there, to the left of the high altar, for the purpose. Previously the chapel had been dedicated to St Paul and housed a painting of that saint in ecstasy, a subject which anticipated the theme of the new chapel since it was on the feast of St Paul that St Teresa experienced her first vision. In any event, the rededication of the chapel to St Teresa would have been logical as she was the first saint of the Discalced Carmelite order, having been canonized as recently as 1622. Cornaro took advantage of Bernini's temporary disgrace and obtained his services for a work intended to be a memorial to himself and his family. The chapel was ceded to him in January 1647 and was finished by 1652, a year before his death. The price, too, was remarkable at over 12,000 scudi, more than the entire cost of Borromini's San Carlo alle Quattro Fontane and a fifth of the expenditure on Bernini's later church of Sant'Andrea al Quirinale, considered the most opulent Roman church of its day.

The best guide to the original appearance of the Cornaro Chapel comes in an anonymous painting, which must have been executed shortly after the chapel's completion. It shows the bare, rather drab interior of the nave and cupola prior to their wholesale redecoration, which began with frescoing in 1663. Against the monochrome crossing, the Cornaro Chapel explodes into a richly orchestrated combination of fresco, coloured marbles, alabaster and, of course, white marble for the three principal statuary groups: the two lateral reliefs of the donor, his father and six earlier Cornaro cardinals, and the

celebrated central tableau of the mystical experience of the Spanish saint, commonly known as the *Ecstasy of St Teresa*. The lighting was dimmer then, with the principal source coming from a window in the wall above the altar while a smaller, secondary source filtered through yellow-tinted glass in the lantern above the sculpture of St Teresa and the angel, making the chapel an illusionary experience. The vault, painted by Guidobaldo Abbatini (*c.* 1600–1656) after Bernini's design, depicts light emanating from the dove of the Holy Spirit and descending through clouds to illuminate the scene below. This light melts into stucco clouds, casting a shadow on the mouldings and appearing to enter our own space. Bernini would later advise his protégé, the painter Baciccio (G. B. Gaulli 1639–1709), to enlarge his design of the fresco for the vault of the Gesù to make his figures and their shadows project over the frame to heighten the illusion of a coextensive space, the beginning of a device which would be repeated in ceiling paintings all over Europe during the next century. Below, in the main body of the chapel, the marble figures emerge like phantasms, an effect heightened by Bernini's creation of a special alcove to house the central sculpture. This added depth appears to place St Teresa's mystical experience in a realm beyond the confines of the chapel itself. The impact is cumulative because all the elements are employed to reinforce one another, thereby conveying what could be described as an irrational experience presented in a rational manner.

Some light is shed on the intentions of patron and artist in a dedicatory epistle presented to Federico Cornaro upon completion of the chapel; as it bears the signatures of the prior and members of the convent, the letter also reveals how the chapel was interpreted by its first spectators. It speaks in unstinting praise of Cornaro's devotion to St Teresa, a devotion expressed 'in metal and marble'; the saint is actively interceding for Cornaro's happiness in heaven. Significantly, the letter dilates upon the presence of Cornaro and his deceased relations on the chapel's lateral walls by analogy with Christ's Transfiguration. Just as that miracle was witnessed by the living and the dead, so, too, 'there are seven admirers of Teresa glorified with the splendour of your liberality . . . six of whom come from the other life'. Bernini achieves this communion of the living and the dead by placing the bust-length figures in what are sometimes mistakenly called theatre boxes. Such

boxes came later; Bernini's are better likened to *coretti* or oratories from which distinguished or royal personages observed services. The Cornaro family cannot see what is happening on the altar, so to speak, but their poses reinforce the chapel's principal theme of the

119 Anonymous, *The Cornaro Chapel, Santa Maria della Vittoria, Rome*, seventeenth century. Schloss Museum, Schwerin. Oil on canvas. 1.68 × 1.2 m.

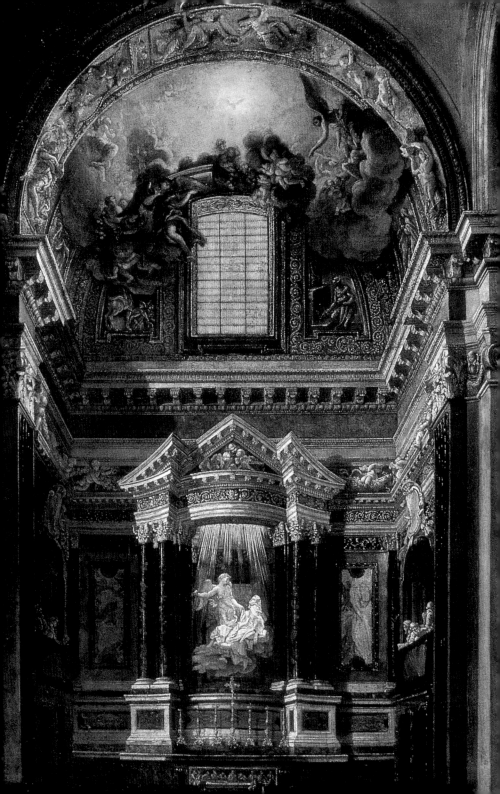

beneficial nature of the mass. Bernini incorporates them much as a painter might include donors in a polyptych and activates their poses in a fashion reminiscent of his mature portraiture.

The most remarkable feature of the chapel is the altarpiece itself. The walls of the church part to disclose the saint and an angel levitating before our eyes. This focal point treats the most celebrated of St Teresa's mystical experiences, the transverberation, which combined a visionary and ecstatic state not unlike the famous stigmatization of St Francis of Assisi. In her spiritual autobiography, St Teresa described the moment when an angel struck her with a fiery dart, which was subsequently cited in the bull for her canonization: 'Beside me ... appeared an angel in bodily form ... not tall but short and very beautiful; and his face was so aflame that he appeared to be one of the highest rank of angels ... called cherubim ... In his hands I saw a great golden spear, and at the iron tip there appeared to be a point of fire. This he plunged into my heart several times so that it penetrated to my entrails. When he pulled it out, I felt that he took them with it, and left me utterly consumed by the great love of God. The pain was so severe that it made me utter several moans. The sweetness caused by this intense pain is so extreme that one cannot possibly wish it to cease, nor is one's soul then content with anything but God. This is not a physical but a spiritual pain, though the body has some share in it – even a considerable share.'

Reading St Teresa's words, it is difficult to imagine them em-
121 bodied concretely; earlier depictions of the transverberation were relatively rare and chiefly confined to didactic images. As in so many cases, Bernini recognized the episode's dramatic potential and went to the heart of the saint's account, rendering her metaphor of nuptials and death in vivid terms; as Irving Lavin memorably put it, 'the transverberation becomes the point of contact between earth and heaven, between matter and spirit'. This is evident in the juxtaposition of the saint and the angel which constitutes a miniature *bel composto* in itself. They could be described in antithetical terms as a clash of spirit and matter, of ascent and descent, of pleasure and pain. Even their drapery – by now Bernini's habitual metaphor for inner states – establishes a counterpoint that amplifies the emotional content of the work.

The placement of the two figures has sometimes been compared
122 to Bernini's first ideas for a major project which was underway at the same time as the Cornaro Chapel, the unfinished sculpture known as *Truth Unveiled*. As originally conceived by the sculptor, the group would have been a secular equivalent to the Cornaro Chapel in

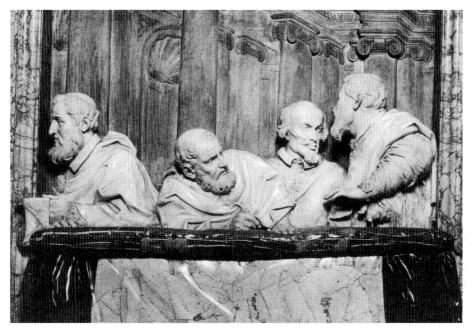

120 Gianlorenzo Bernini, relief of the Cornaro family, completed 1652. Detail.
Cornaro Chapel, Santa Maria della Vittoria, Rome. Marble. Life-size.

which a winged figure of Time unveiled an ecstatic personification
of Truth against a backdrop of ruins and obelisks. For Bernini, Truth
became an emblem of his ability to triumph over the envy and anger
of others, and the role of Time as agent of Truth had affinities with
the role of Death in his sepulchral monuments. In the Cornaro
Chapel, the angel occupies the role of Time, unveiling and exalting
the saint. The expression on the angel's face invites comparison with
Bernini's Truth, as both express an unearthly joy also found in the
sculptor's late works. In contrast, the saint's face is tilted back, and
her half-closed eyes and open mouth allude to that combination of
ecstasy and death first seen in the memorial to Maria Raggi which
reappears later in the *Blessed Ludovica Albertoni*. St Teresa's face is, how-
ever, youthful and reduced to an abstraction, as if to convey an image
of her soul rather than one of the middle-aged woman she was at the
time of the transverberation. Bernini took great pains to indicate the
saint's transformed state through the pose of her body, the convulsive
arching of her left foot, the inclined head and the eyes rolled back

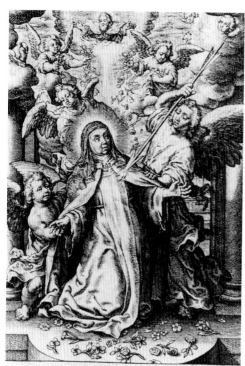

Fulcite me floribus, stipate me malis:
quia amore langueo. *Cantic. cap. 2.*

121 (*left*) Anton Wierix, engraving of
transverberation of St Teresa, 1614–22.
The Metropolitan Museum of Art,
New York.

122 (*below*) Gianlorenzo Bernini, drawing
of *Truth Unveiled, c.* 1646. Museum der
Bildenden Künste, Leipzig. Black chalk.
25.1 × 36.9 cm.

123 (*right*) Gianlorenzo Bernini,
Ecstasy of St Teresa, 1647–52. Detail.
Cornaro Chapel, Santa Maria della
Vittoria, Rome. Marble. Life-size.

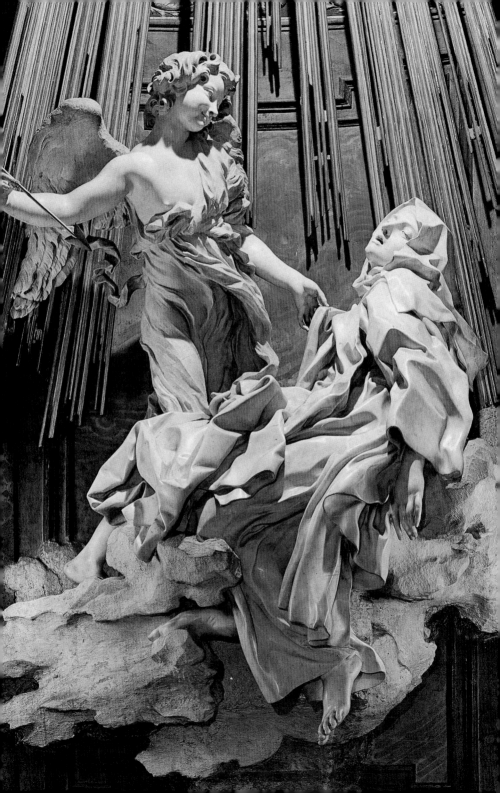

under their lids. Although her body responded physically to the angel's actions, St Teresa experienced her vision 'with the eyes of her soul'. Two types of vision had been distinguished by St Thomas Aquinas: that which is perceived by the eye and that which the imagination apprehends internally. Because St Teresa does not actually see the transverberation and because it takes place outside time and physical reality, her vision corresponds to Aquinas's second type. Moreover, it reflects a penchant encountered frequently in Baroque art for depicting otherworldly states which encompasses Algardi's *St Philip Neri* and Parodi's *St Martha in Glory*.

Bernini returned to the principles of the Cornaro Chapel in several later works, most effectively in the small-scale Fonseca and Altieri Chapels, both in Rome. The latter, situated in the small church of San Francesco a Ripa, enjoys a joint dedication to St Anne, the mother of the Virgin Mary, and to a pious Roman matron of the sixteenth century, the Blessed Ludovica Albertoni, who was beatified in 1671. By that date, the Albertoni had married into the family of the reigning pope, Clement X Altieri, which explains Bernini's involvement. His intervention focused upon the chapel's altar wall, which he opened to create an alcove. Inside, a marble, semi-recumbent figure of Ludovica Albertoni became both the chief object of attention and a mediator between the worshipper and a new altarpiece painted by Baciccio. Concealed windows provide a dramatic burst of light, and stucco cherubim – representing, as always with Bernini, a transitional form between the material and immaterial worlds – perch on the picture frame and gaze compassionately upon the figure below; the dove of the Holy Spirit hovers above. Some drapery, originally of painted wood but later substituted by Sicilian jasper, establishes a visual link between the sculpture and the altar beneath, in which Ludovica Albertoni's remains were buried; it also modifies the sense of termination of the marble sculpture, rounding the work off in much the same manner as Bernini used drapery on his portrait busts.

Executed between 1672 and 1674, Bernini's *Blessed Ludovica Albertoni* returned to the challenge of conveying a visionary state through the medium of the *bel composto*. Documents submitted for her beatification state that just prior to her death Ludovica Albertoni had a vision and was found by a servant flushed and 'full of joy' as if she had 'just returned from paradise'. It seems probable that Bernini chose this moment of mystical ecstasy rather than the 'sweet sleep' of her death as the subject of his sculpture, although her pose, drapery and expression are so extreme that the message is rendered somewhat

ambiguous. The figure's pose invites comparison with a work by a younger contemporary, the Maltese sculptor Melchiorre Cafà. Bernini admired Cafà's work and certainly knew his *St Rose of Lima*, which was the first sculpture to show a saint dying and formed the centrepiece of her canonization ceremony at Santa Maria sopra Minerva in 1668, yet Bernini strove here for something more than the representation of death. The antithetical qualities enacted by St Teresa and her angel are here compressed into the single form of Ludovica Albertoni, whose lower body and drapery register a state of agonized convulsion while her face and upper torso express an ecstatic surrender to her vision. This contrast is achieved by an elongation of the figure, something partially disguised by the flurry of drapery at her waist. Like the *Ecstasy of St Teresa*, the sculpture becomes a visual metaphor for the 'lovesick soul' of the Bible's Song of Solomon, the foundation of much of the erotic imagery of love and death in later religious writing, especially in connection with St Teresa but also with Ludovica Albertoni. Bernardino Santini's panegyric, *I voli d'amore* (*Flights of Love*), published in 1673, celebrated the sanctity of Ludovica Albertoni's life and visions in prose that weaves biblical and Classical allusions into a description of her mystical union with Christ: 'Observe . . . Ludovica rising from the earth and embracing Jesus on the Cross, and see if the strength of Samson could tear them apart, or if the wisdom of Solomon could untie the knot . . . Between these two persons there is only one death, yet both have died of love: "love *is* strong as death" [Song of Solomon, ch. 8, v. 6] . . . Neither life nor death can separate the lover of God from God, so says the apostle.'

Santini's text could almost serve as a commentary on Bernini's sculpture, but most importantly it draws upon the same rich tradition of imagery with which Bernini informed his composition. The chapel's design forces the spectator to experience a disturbing contrast between the turbulence of the marble figure and the warm tones and peaceful setting of Baciccio's *Virgin and Child with St Anne*, yet both images are ultimately reconcilable because they deal with the reception of Christ: St Anne accepts the Christ Child literally, and Ludovica Albertoni accepts him spiritually. Together, they constitute a version of the Aristotelian *catharsis* which the spectator of a drama experiences through the stylized union of contrasting emotions.

Bernini's contemporaries were not slow to appreciate the artistic potential of the *bel composto*, and it enjoyed something of a vogue in the later seventeenth and early eighteenth centuries, primarily in Rome, but also in other parts of Italy and beyond. But Bernini proved

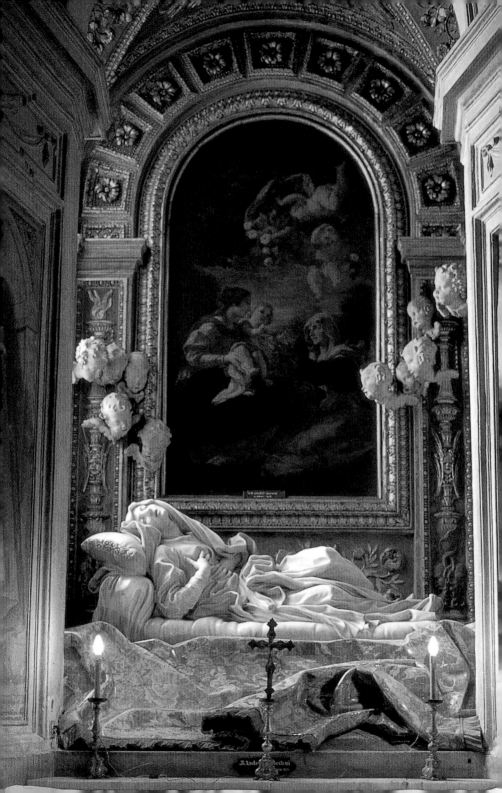

125 Antonio Gherardi, the dome of the Ávila Chapel, Santa Maria in Trastevere, Rome, *c*. 1680. Stucco.

a hard act to follow, for while the principle of a beautiful synthesis was often imitated, the result rarely reached the intensity or degree of fusion he had made so distinctively his own. In part, the problem stemmed from a change in temperament from the late seventeenth century to the eighteenth, a change mirrored in funerary monuments as well as chapel decoration; emotive statements of religious belief, such as the Cornaro and Altieri Chapels, gradually fell from favour. Moreover, no sculptors after Bernini possessed sufficient authority to impose their wills on the design of a chapel or a church; instead, they worked as part of an *équipe*, usually under the direction of an architect. The success or failure of such collaborative enterprises depended upon how well the individual contributions merged.

One of the most remarkable and inventive responses came from Antonio Gherardi (1638–1702). A painter and decorator, Gherardi

124 Gianlorenzo Bernini, *Blessed Ludovica Albertoni*, 1672–4. Altieri Chapel, San Francesco a Ripa, Rome. Marble. Over life-size.

turned to architecture in the latter part of his career, creating some of the most unusual interiors in late seventeenth-century Rome. He applied his talents with great panache to the chapel of St Cecilia in San Carlo ai Catenari, where he not only painted the altarpiece, but also designed the rich, festooning stucco decoration at every level. The combination of media is very successful here, and Gherardi showed himself receptive to the architecture of Guarino Guarini (1624–1683) as well as to that of Bernini. The chapel is turned into an extended metaphor of St Cecilia's progress from this world to the next, and is abetted by concealed lighting that dazzles the eye in the lantern above. Gherardi accomplished this effect by opening the shallow, oval cupola to reveal a lantern through which music-making angels and the soul

125 of the saint can be glimpsed. Equally impressive is Gherardi's Ávila Chapel in Santa Maria in Trastevere, with its reminiscences of Borromini as well as Bernini. Completed in 1680, the Ávila Chapel might more aptly be described as a sequence of spaces, linked by perspectival effects and telling combinations of concealed and direct lighting. The most Berninesque feature of the Ávila Chapel is the dome over its crossing, in which stucco angels appear to support an Ionic lantern – an effect derived from Bernini's chapel decorations.

More conventional was the response of Carlo Rainaldi (1611–1691), an architect of an older generation who knew the work of Bernini, Borromini and Cortona at first hand. His late masterpiece, the Roman church of Gesù e Maria, expanded the principles of the Cornaro Chapel to embrace a whole interior. The walls between the lateral chapels were designed to receive memorials to various members of the patron's family, placed beneath statues of the cardinal virtues. Set against an interior smothered in Sicilian jasper and gilt bronze, the marble figures adopt poses reflecting prayer and meditation on the mass, much as their position above the confessionals alludes to the efficacy of that sacrament. Significantly, they were executed by several sculptors, Francesco Aprile (*fl.* 1642–1685), Francesco Cavallini (*fl.* 1672–1703) and the Frenchman known as Michele Maglia (*fl.* 1678–1700), all working to Rainaldi's design. This helps to explain the vaguely heterogeneous nature of the monuments, which were slotted into an architectural framework which provided an ambiguous spatial context.

Occasionally, such collaborations fused perfectly. A good example

128 is the exquisite Antamoro Chapel in the Roman church of San Girolamo della Carità. Constructed between 1708 and 1710, the chapel was dedicated to St Philip Neri and could be described as a

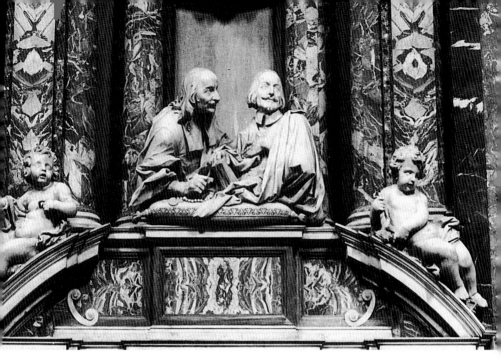

126 Michele Maglia (?), Monument to Ercole and Luigi Bolognetti. Gesù e Maria, Rome, completed 1687.

résumé of themes from the sculpture and architecture of the previous century. Its architect, Filippo Juvarra (1678–1736), went on to distinguish himself as architect to the House of Savoy. His principal collaborator was the French sculptor, Pierre Legros the Younger. Measuring only 5.1 by 3.2 metres, the chapel is interpenetrated with ovals at every level, from the lantern and altar window to the decorative, inlaid patterns. All of this is further enriched by the subtle orchestration of coloured marbles in yellow and green, as well as the window's golden-tinted glass. In contrast to Bernini's Cornaro Chapel, Juvarra employs colour and light to suggest a warmer, mellower and more intimate mood, in keeping with the personality of the saint and with the late Baroque pathos evoked by Legros' statue and stuccowork. As his first and only Roman work, the Antamoro Chapel exacted great attention from Juvarra; his early studies show his exploitation of 127 Bernini's *bel composto* for the right combination of elements to display St Philip in mystical contemplation. He even indicated the basic pose of the saint and calculated the impact of the altar from the body of the

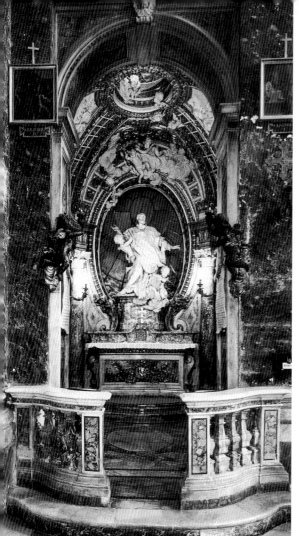

127 (*above*) Filippo Juvarra, first design for the Antamoro Chapel from the Juvarra Sketchbook, 1708. The Metropolitan Museum of Art, New York. Pen and ink.

128 (*left*) Filippo Juvarra and Pierre Legros the Younger, the high altar of the Antamoro Chapel, San Girolamo della Carità, Rome, 1708–10. Coloured marble, gilding and stucco.

church in a manner that Bernini himself would have approved. Even so, Juvarra must have been receptive to Legros' suggestions; the final design would have been reached in consultation with Legros, who was older and more established. The result is a sculpture of great presence, a refinement of Juvarra's concept which falls effortlessly into place against the undulating, celestial backdrop. The saint thus appears to be buoyed up by angels and glances to the lantern of the dome as the source of his ecstatic vision.

148

129 Antonio Gaspari, study for
the Chapel of St Dominic in
SS Giovanni e Paolo, Venice,
c. 1692–3. Museo Correr, Venice.
Pen and ink.

Comparable collaborations also occurred outside Rome.
Baldassare Longhena exploited multimedia effects in the Vendramin
Chapel of the then Venetian cathedral, San Pietro di Castello, as early
as the 1660s. The synthesis of coloured marbles and reliefs by Michael
Fabris Ongaro (1644–1684) and an altarpiece by Luca Giordano
(1632–1705) seems, however, a pallid reflection of the Roman
chapels. Longhena's follower Antonio Gaspari (c. 1660–c. 1749) appar-
ently knew Rome at first hand and attempted to introduce the effects
of Bernini and Borromini into Venetian architecture, though with
little tangible success. His designs for the Chapel of St Dominic in SS
Giovanni e Paolo constitute a striking essay in the *bel composto*.
Gaspari wanted to combine statues and marble reliefs on the lateral
walls with an elaborate altar in which a painting of St Dominic was
framed by an image of the Virgin with a rosary and a glory of putti

149

while clouds and rays exploded from an oculus in the vault. Some work was undertaken on Gaspari's project during the 1690s, but it was demolished in 1701 when a sober, neo-Palladian design by Andrea Tirali (c. 1660–1737) replaced it.

More successful, if more modest, creations occurred in the region now known as Emilia-Romagna, an area containing the duchies of Parma and Modena as well as the second papal city, Bologna. It was a part of Italy with little tradition in stone carving, but distinguished in terracotta and stuccowork. Giuseppe Mazza (1653–1741) was the most celebrated Bolognese sculptor after the death of Algardi. Like the young Algardi, he studied with artists rather than sculptors and evolved a distinctive, painterly style in his reliefs. This was unusual, but meant that Mazza's work fitted well into large, decorative projects, such as the transformation of the old church of Corpus Domini in Bologna where he collaborated with the architect Giovan Giacomo Monti (1620–1692) and the painter Marcantonio Franceschini (1648–1729) from 1686 to 1695. Mazza evidently got on well with Franceschini, who was the dominant artistic influence in the area, and their collaboration appears to have enjoyed something of the give and take that existed between Juvarra and Legros in the Antamoro Chapel. At the church of Corpus Domini, the renovation included elaborate frescoing complemented by Mazza's reliefs and statues in plaster. The arts were brought together most memorably in the presbytery, where Franceschini executed a canvas of the *Last Supper* and lateral paintings as well as giving general guidance to Mazza for the surrounding elements. Franceschini provided basic designs for Mazza's statues of St Francis and St Clare to either side of the high altar, but the sculptor was given freer rein with the glory of God the Father and angels above. Mazza's figural style is fluently modelled and closer to the early works of Franceschini or Algardi than to the High Baroque mode then fashionable in Rome, which is understandable given that Mazza only saw Rome when he was seventy years old.

It is one of the ironies of the *bel composto* that its eighteenth-century growth was more spectacular outside Italy than within. The true heirs to Bernini came from the lands of the old Holy Roman Empire. The churches of the Asam brothers and J. M. Fischer's Benedictine abbey of Zwiefalten lie beyond the scope of this book, but it would be appropriate to conclude this chapter with one of the few eighteenth-century Italian works which rival the great Central European creations of the period: the Chapel of the Visitation at Vallinotto by Bernardo Vittone (1702–1770), a little-known Piedmontese architect.

Largely self-taught and working in a backwater, Vittone forged an extraordinary synthesis of elements from the Roman Baroque of the previous century and more recent buildings by Guarini and Juvarra in Turin. The Chapel of the Visitation at Vallinotto fits into the tradition of pilgrimage churches which was then undergoing a revival across Central Europe, and its independent status allowed Vittone greater freedom in combining a hexagonal plan, reminiscent of Borromini's Sant'Ivo della Sapienza in Rome, above which rises a basket vault followed by two further domes. The effect is best described in Vittone's own words: 'the interior consists of one single storey surmounted by three vaults, one above the other, all perforated and open; thus the eye of the visitor ... roams freely from space to space, and, with the help of the light which enters through the windows invisible from inside, enjoys the gradually increasing variety ... offered by these vaults ... which culminates in the little cupola where one sees a representation of the Holy Trinity.' Everything about the chapel turns into a reference to the Trinity, from the plan and triple vault to the frescoes of the angelic hierarchies. Even the light becomes an element as it assumes palpable form in stucco rays descending from the windows in the vault above. Indeed, the impact of the chapel stems from the tension between finite structures and infinity suggested by the play of light. Bernini would have appreciated Vittone's achievement, although by the date of its completion in 1739, it constituted something of a backward glance in the direction of the Cornaro Chapel. The style of the chapel would have struck a jarring note in Rome, where the Corsini Chapel in St John Lateran was the last word in fashionable chapel design.

130 Bernardo Vittone, engraving of the section through the Chapel of the Visitation, Vallinotto, from his *Istruzioni elementari* (1760).

Reliefs and Sculptural Altarpieces

If there was one area of sculpture in which Bernini took little interest, it was the marble relief; the few executed by his workshop do not fully exploit the potential of the medium. The fashion for reliefs as altarpieces owed more to the flair of Algardi than anyone else. This may seem unexpected, given Algardi's fondness for understatement and the manipulation of small-scale tonal nuances which was discussed in connection with portraiture. But it was his *Encounter of St Leo the Great and Attila* for St Peter's that ushered in one of the most characteristic and durable genres in Italian Baroque sculpture.

131

The commission arose through a series of accidents which nonetheless had a bearing on Algardi's composition. A new altar for the relics of Pope Leo I had been planned for the south-western corner of St Peter's as early as 1626. Initially, the altarpiece was to have been a painting by Guido Reni, illustrating the encounter between Pope Leo and Attila which led to the collapse of Attila's planned invasion of Rome in AD 452. This same encounter had been the subject of one of Raphael's greatest frescoes in the Vatican Stanze, and, as Passeri suggested, it may be that Reni drew back instinctively from the inevitable comparison between his handiwork and that of his great predecessor. As well as such psychological factors, other drawbacks existed: the dimensions of the altar meant that the panel would be tall and narrow, a problem which, when coupled with poor lighting, makes Reni's reluctance even more comprehensible. Two decades later, Innocent X decided upon a radical solution: a marble relief to fill the altar, which, at 8.5 by 4.9 metres, was extremely large. As Bernini was very much out of favour with the Pope, the obvious choice for its execution was Algardi.

In the event, the choice of a sculpted altarpiece proved a fortunate, as well as astute, move on Pope Innocent's part, for a sculptor would naturally feel more at ease with such a commission, appreciating that the subject required a drastic reformulation, especially given the proportions of the proposed relief and the dimness of its location. Of course, marble reliefs were not new: sculptors as diverse as Donatello,

Andrea Sansovino and Tullio Lombardo had popularized them in previous centuries, and they never entirely went out of fashion. Certainly, they were much in vogue in the Sistine and Pauline Chapels at Santa Maria Maggiore; Pietro Bernini had also produced a notable *Assumption of the Virgin* for the baptistery there earlier in the seventeenth century.

Despite such precedents, marble altarpieces were relatively rare until the time of Algardi. He instinctively appreciated the nature of the challenge, shifting the encounter of Leo and his adversary from horseback to foot. This brought the main figures into the foreground and focused attention on their confrontation which thus became a study in contrasting psychological states, the commanding authority of Leo being answered by Attila's cringing retreat. From this central event radiate the subsidiary episodes which show the papal and barbarian retinues and, above all, the heavenly apparition of the apostles Peter and Paul, whose gestures form a counterpoint to those of Leo and Attila below. Algardi adapted this split-level approach to his narrative from Raphael, and it was from *The Transfiguration*, Raphael's last altarpiece, that he took the dramatic caesura at the centre of his relief as well as the appeal for divine intervention; yet in Algardi's composition, Attila alone witnesses the intercession of Peter and Paul, thus providing the link between the celestial and the earthly components of the scene.

From its completion in 1653, the *Encounter of St Leo the Great and Attila* immediately established a new conception of relief sculpture, one which exploited the pictorial qualities of marble in ways never considered by Classical sculptors. Whereas most antique models function within three planes of high, medium and low relief, Algardi achieves a more flexible play of high and medium relief by pulling forward the two main figures so that they almost become fully rounded sculptures. Attila's cavalry is pushed up and flattened to suggest a distant horde while Leo's attendants are more prominent, as are the apostles who boldly emerge from marmoreal clouds. Consonant with this, the sculptor introduces a range of gestures which are amplified, in the manner of Bernini, by drapery. In particular, the staccato pattern of Attila's cloak seems to re-echo his fright at the heavenly vision.

Algardi had little time to enjoy the critical esteem which his relief enjoyed, as he died in 1654, the year after its completion, but he oversaw an equally remarkable variation on the marble altar relief prior to his death. This was the high altar of the church of San Nicola da 132

153

131 Alessandro Algardi, *Encounter of St Leo the Great and Attila*, 1646–53. St Peter's, Rome. Marble. H. 8.58 m.

132 (*right*) Alessandro Algardi, Ercole Ferrata and Domenico Guidi, *Vision of St Nicholas*, 1651–5. San Nicola da Tolentino, Rome. Marble.

Tolentino in Rome, a work largely carried out by assistants but bearing the stamp of Algardi's genius nonetheless. In addition to the basic design, Algardi furnished the architectural surround which establishes the specific setting for the sculptural group by creating a curved niche in which two reliefs are placed diagonally opposite each other. The curvature enhances the relationship of the two groups by allowing the sculptor to manipulate the degrees of relief in order to give prominence to the Virgin and Child and St Nicholas holding the bread which cured him of an illness. The altar inevitably invites comparison with Bernini's altar for the Cornaro Chapel, which merely reinforces the differences in the two artists' approaches. Algardi avoids the illusionism favoured by Bernini, and although there are pictorial

qualities in both works, they are markedly different as altarpieces. Bernini employs concealed lighting and an elaborate, three-dimensional framework to create a self-contained illusion to which we are drawn as spectators. Algardi does not transgress the traditional format of an altarpiece, nor does he try to appropriate pictorial techniques here as he did in the *Encounter of St Leo the Great and Attila*; instead, he eschews dramatic potential to focus upon the underlying spiritual value of divine grace.

Although the solution proposed by the altar of San Nicola da Tolentino was never repeated, Algardi still had a profound influence on this genre through the sculptors he trained, such as Ercole Ferrata (1610–1686) and Domenico Guidi, and indirectly through their

pupils as well. Their opportunity to shine came in a number of projects, none more splendid than the decoration of the church of Sant'Agnese in Piazza Navona, which was effectively the personal property of the family of Innocent X and a commission directed by Algardi's patron at San Nicola, Prince Camillo Pamphilj. Unusually, the main altars of the church were to be embellished with sculpture: a statue of St Agnes at the high altar, and reliefs celebrating other early martyrs disposed along the contours of the centralized space. Nothing like this had ever been conceived for a Roman church, but the taste for such schemes was stimulated by Bernini's decoration of the nave of St Peter's under Innocent X and, of course, the luxurious new standard set by the Cornaro Chapel. The varied results of a younger generation of sculptors, working to a greater or lesser degree along lines laid down by Algardi, are the most interesting aspect of Sant'Agnese. Of these, Ferrata's *Stoning of St Emerenziana* (finished by Leonardo Pitti in 1686) was the only work to utilize the curve of the altar in a manner reminiscent of Algardi; the disposition of figures, too, recalled the older sculptor's magisterial example in St Peter's through its juxtaposition of the child saint's tormentors on the right and her frightened

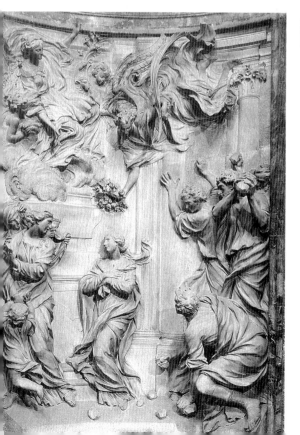

133 Ercole Ferrata, *Stoning of St Emerenziana*, begun 1660. Sant'Agnese, Rome. Marble. H. 3.1 m.

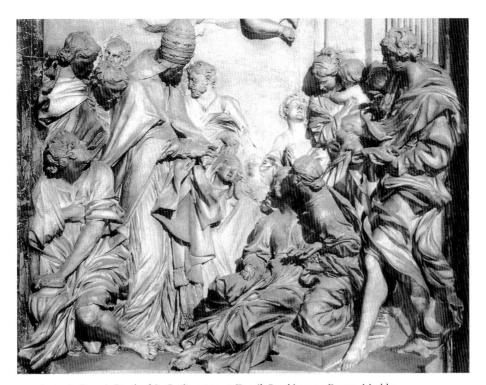

134 Antonio Raggi, *Death of St Cecilia*, 1662–6. Detail. Sant'Agnese, Rome. Marble.
H. *c*. 3.1 m.

sympathizers on the left. Ferrata's work drifts, however, into a kind of
virtuoso incoherence in the upper register where angels prepare her
martyr's crown and palm. Also in Sant'Agnese, the *Death of St Cecilia*
by Antonio Raggi (1624–1686) was actually based upon a model by
Algardi's close collaborator Giuseppe Peroni (*c*. 1626–1663), whose
idea appears to have been followed for the basic disposition of Pope
Urban I and his retinue on the left-hand side of the relief. Raggi
could not resist adding his own mannerisms, especially with the more
emotive figures on the right, whose attenuated proportions and
extravagant drapery recall Bernini's late style. Here, however, narrative
clarity has been sacrificed to Raggi's penchant for surface detail, a
pitfall instinctively avoided by Algardi, but common even in the best
late Baroque reliefs.

Such Berninesque mannerisms compromise the purpose of relief
sculpture by reducing the narrative to a rhetorical exercise. By the
same token, Ferrata's high altar sculpture, *St Agnes on the Pyre*, bears 135

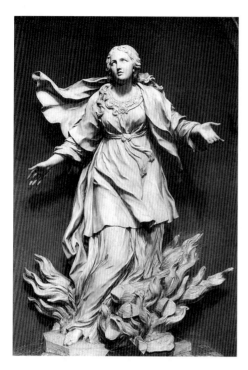

135 Ercole Ferrata, *St Agnes on the Pyre*, 1660–4. Sant'Agnese, Rome. Marble. Over life-size.

136 (*right*) Melchiorre Cafà (completed by Ercole Ferrata), *St Thomas of Villanova*, begun 1663. Sant'Agostino, Rome. Marble. Over life-size.

unmistakable, though not entirely reconciled, elements drawn from Algardi and Bernini. The saint's pose is indebted to one of Algardi's most emotive works, the *St Mary Magdalen*, but the head and drapery are more classically correct. These elements are overlaid, so to speak, by two touches worthy of Bernini: the fire at St Agnes's feet and the drapery billowing out for no apparent reason behind her shoulders. The result is a work whose impact is weakened by overly theatrical gestures.

It would have been difficult for any sculptor of the 1660s to have ignored the example of either Bernini or Algardi, but one of the youngest and most gifted managed to fashion a distinctive style within the span of a single decade. This was the Maltese sculptor, Melchiorre Cafà, who as one eighteenth-century critic wrote, 'worked little and lived little'. Despite his brief burst of activity, Cafà created three of the most characteristic late Baroque sculptures with his *St Thomas of Villanova*, *St Rose of Lima* and the *Ecstasy of St Catherine of Siena*. The dying figure of *St Rose of Lima* has been mentioned earlier as a work which stands midway between Bernini's *Ecstasy of St Teresa* and the *Blessed Ludovica Albertoni*, inspired by the

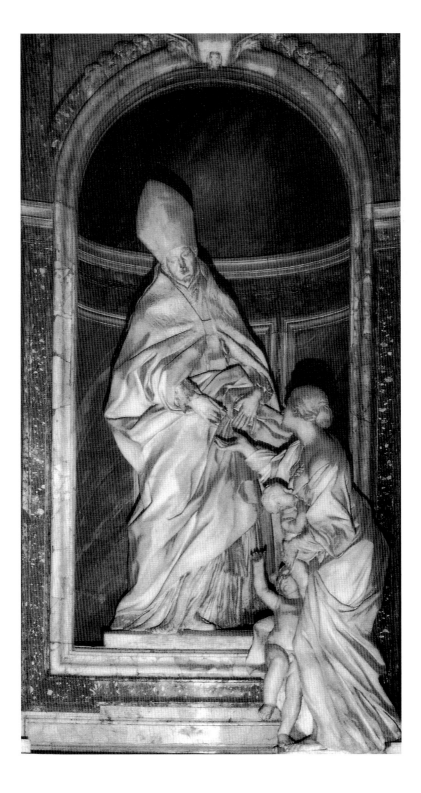

former and probably influencing the latter. Cafà's relief of the Sienese mystic also stands in direct relationship to Bernini's *Ecstasy of St Teresa* and would have been unthinkable without it. A pupil of Ferrata, Cafà quickly established himself through his models and drawings, and even Bernini let it be known that the younger man had overtaken him in his art. Where Ferrata's work veered unsteadily between the styles of Bernini and Algardi, Cafà's sculpture reinvented the aesthetic qualities of Bernini's late style in new terms, thereby establishing a bridge between High and late Baroque sculpture. This is seen most *Frontispiece* clearly in the *Ecstasy of St Catherine of Siena*, in the Dominican convent of Santa Caterina da Siena a Magnanapoli in Rome.

The relief constitutes the centrepiece of the presbytery and would probably have been complemented by lateral panels, thus assuming some of the features of a Berninesque *bel composto* (the accompanying panels by Pietro Bracci represent a later interpolation). Although Cafà's subject, the mystical elevation of St Catherine, bears the inevitable stamp of Bernini, his approach is quite unlike that of his mentor; instead of fully rounded plastic forms against a light background, the emphasis in Cafà's work is upon impasto-like layers of white marble compressed against a kaleidoscope of colour that ranges from dark lapis lazuli and brown at the edges of the altar to lighter shades of alabaster, creating a halo around the saint's head. St Catherine's ascent towards heaven looks as if it were executed with a palette knife rather than carved, and indeed the whole relief assumes noticeable painterly values. Cafà clearly studied everything available by Bernini but applied his lessons in new and unexpected ways. The movement of the saint's body creates an almost Gothic curve to which the angels and cherubim provide a counterweight, but this movement has evolved onto a plane which is both more stylized and more saturated in elegance and delicacy than late Bernini. So, too, the drapery is not so much agitated as inflected. Cafà may have been inspired in this direction by his friendship with the painter Baciccio, one of Bernini's protégés. Even more than Baciccio's, however, Cafà's work expresses a new sensibility, without which the work of eighteenth-century sculptors such as Pierre Legros the Younger would be inconceivable.

Cafà made an equally notable contribution to sculpted altars with his *St Thomas of Villanova*, which was begun in 1663 for the Roman church of Sant'Agostino. Here, Cafà's work was to replace an earlier painting of the same subject by Giovanni Francesco Romanelli (1610–1662), so an element of competition between painting and

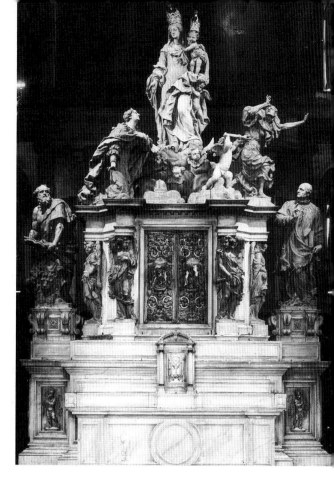

137 Josse de Corte, high altar of Santa Maria della Salute, Venice, 1670. Marble.

sculpture may have featured in the project. Cafà envisaged an altar in which the saint stands in his niche and distributes alms to a woman and small children beneath who symbolize charity. This central tableau is surmounted by God the Father with angels, a work contributed by Ferrata, and flanked by relief scenes from the life of the saint, executed much later by Andrea Bergondi (fl. 1743–1789). A surviving *bozzetto* (sketch-model) reveals that the saint was sculpted according to Cafà's intentions, but death prevented him from addressing the figures below. This task fell to Ferrata, who, as on several other occasions, translated Cafà's sculptural poetry into serviceable but more mundane prose. The *bozzetto* shows a more vivacious group with three children, one of whom was actually sitting on the ledge, while the woman is a clothed version of Bernini's *Truth Unveiled*. The

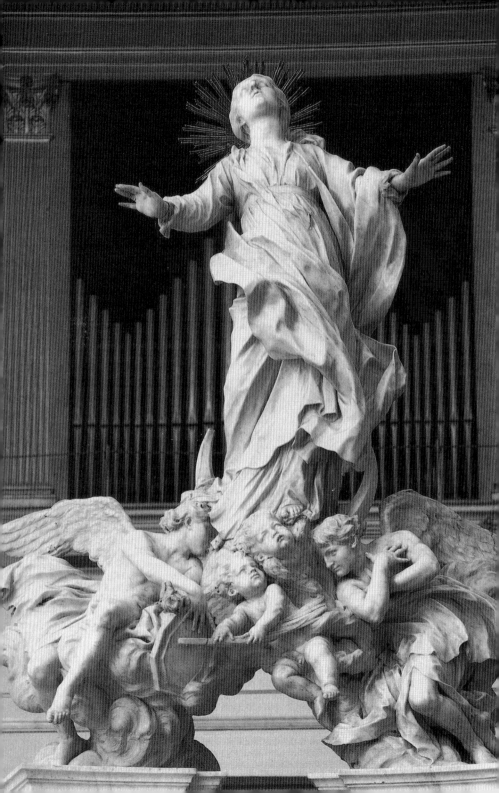

finished group is much more restrained as well as scaled down, yet it still conveys something of the audacity with which Cafà wished to expand his altarpiece into the spectator's world. It was a simple, highly effective gesture, one not seen since Verrocchio's comparable bronze group of *Christ and St Thomas* on the exterior of the Orsanmichelè in Florence.

Outside Rome, sculptural altarpieces enjoyed a particular revival in Venice and Genoa. A tradition of free-standing altarpieces had been introduced by Palladio's churches at the end of the sixteenth century, so it was not surprising that Baldassare Longhena made provision for a similar structure in his great Venetian votive church, Santa Maria della Salute. Raised as an offering against the plague, the Salute housed a miraculous icon of the Virgin which was incorporated into the high altar by the Flemish sculptor, Josse de Corte, in 1670. As the altar stands between the monks' choir and the presbytery, De Corte followed the formula of sculptural complexes for San Giorgio Maggiore and the Redentore by Girolamo Campagna (1549–c. 1625), fashioning a sacred drama of Venice's deliverance from the plague. The Virgin is shown with the Christ Child, interceding on behalf of a kneeling figure of Venice, while on her other side the plague is represented by a witch-like apparition toppling into the void; the city's patron saints Mark and Lorenzo Giustinian look up from below. De Corte's altarpiece is flamboyantly extrovert, but there is little here of the Roman High Baroque; rather it represents a blending of traditional Venetian vocabulary with elements of the 'international Baroque'. As a whole, it does not quite succeed, the statuary being too small in scale and too meticulously worked to register in the vastness of its setting.

De Corte's presence in Venice was mirrored by that of another foreign sculptor in her maritime revival, Genoa. This was the Frenchman, Pierre Puget (1620–1694), whose arrival in Liguria foreshadowed the increasing importance of French artists in Italy during the period. Puget commanded a far greater talent than De Corte and made an impact on Genoese sculpture comparable to Bernini's in Rome. This is not surprising, given Puget's earlier career, which saw him first in his native Marseilles and then with Pietro da Cortona as stuccoist and possibly painter at Palazzo Pitti in Florence. Through his work under Cortona and sporadic visits to Rome in the 1640s and early 1660s, Puget had an enviable training and was seized upon by the Genoese nobility as an artist who could provide a new impetus for a moribund local school.

138 Pierre Puget, *Virgin of the Immaculate Conception*, 1666–70. Chiesa della SS Concezione, Albergo dei Poveri, Genoa. Marble. H. 2.45 m.

These expectations were amply fulfilled by his *Virgin of the Immaculate Conception*, which was designed as the focal point of the centrally planned church of the Immaculate Conception of Mary in Genoa, situated in a charitable foundation for the poor. The theme was a Baroque subject *par excellence*, reinforcing the Catholic belief in Mary's freedom from the stain of original sin. Executed between 1666 and 1670, Puget's work predates the high altar of the Salute by a few years, but displays a firmer grasp than that of Josse de Corte of the new style emanating from Central Italy. His tableau is highly pictorial in conception and suggests that he had an entrée into the workshops of Ferrata and Cafà during his time in Rome. The Virgin here displays an expansive, upturned gesture, reminiscent of Ferrata's *St Agnes on the Pyre*; she stands on the crescent moon and clouds which were her attributes as the Immaculata. Beneath her is a marble arch composed of cherubim and angels, one of whom holds a mirror, the other palm leaves, for the Virgin was the mirror of justice and queen of martyrs. The whole achieves a Berninesque contrast between weightlessness in the soaring figure of the Virgin and the solid medium of stone.

Puget's capacity to translate such a painterly composition into marble was often imitated but never bettered; his altarpiece of the *Virgin of the Immaculate Conception* was copied by Genoese sculptors and painters alike. Among the former, Filippo Parodi was his most gifted rival and remained a force in Italian sculpture long after Puget returned to France in 1670. Like Puget, Parodi was equally at home in carving wood as well as marble but, unlike his French counterpart, he fell more directly under the spell of Bernini, with whom he worked between 1655 and 1661. Parodi, too, brought back to Genoa a personal interpretation of the Roman High Baroque in a range of secular and religious commissions. He, too, benefited from the demand for marble altarpieces that became such a feature of Genoese churches, none more splendid than the unusual *St Martha in Glory*. Conceived as the crowning glory of the Benedictine convent of Santa Marta, Parodi's composition dominates the apse of the church and depicts the elevation of the saint towards the cupola and heaven.

Frontispiece Comparisons with Cafà's *Ecstasy of St Catherine of Siena* are as inevitable here as they are instructive. Parodi was evidently taken with his younger contemporary's work, but its highly keyed vibrancy has been toned down under the influence of Puget's more severe style. The emphasis of the *St Martha in Glory* falls emphatically upon the idealized beauty of the saint and her attendant angels as well as the bravura carving of the drapery; Parodi strikes a compromise here

between Roman and Genoese elements that are not so successfully reconciled elsewhere.

The vogue for marble reliefs also made itself felt in Florence in the 1670s, with the work of Giovanni Battista Foggini in the Corsini Chapel of Santa Maria del Carmine. The chapel was erected by the noblemen Bartolomeo and Neri Corsini in honour of their collateral ancestor, Andrea Corsini, who had died in 1374 and been canonized in 1629. Neri Corsini was a career churchman and a protégé of Alexander VII, who had made him a cardinal in 1664. Thus the chapel was conceived to celebrate the strong connection of the Corsini with Rome, and the patrons found the perfect exponent of the High Baroque style in Foggini. He had been sent to Rome as one of the first pupils of the Florentine Academy there by Grand Duke Cosimo III in 1673. His three years' study encompassed drawing with Cortona's former pupil Cirro Ferri (c. 1634–1689) as well as modelling and carving with Ferrata. Among his tasks were the copying of paintings in relief as well as compositions by Ferrata; consequently, Foggini's approach to narrative was indirectly tinctured by the examples of Cortona and Algardi. These influences emerge in the Corsini Chapel, which was initially to have only one relief, *St Andrea in Glory*, above the altar. Foggini's success there led to the decision to complete the decoration of the lateral walls with further reliefs rather than paintings. Their subject matter, the *First Mass of St Andrea* and the *Battle of Anghiari*, gave scope for pictorial effects probably intended to recall the *paragone*. Both the lateral panels of the Corsini Chapel take Algardi's *Encounter of St Leo the Great and Attila* as their touchstone; in the *Battle of Anghiari*, there are references to Cortona's battle scenes as well. The Florentine troops are massed in low relief on the right, much like Attila's soldiers, while St Andrea looms above them wielding a metal sword, like Algardi's apostles. The levels of relief become more complicated on our left where the Milanese cavalry and foot soldiers pile into a terrorized heap, threatening to spill into our space. Subtlety and allusions to the antique are not paramount here, but, as in Bernini's *Apollo and Daphne*, the novel combination of subject matter, medium and artistic virtuosity commended such works to contemporary audiences.

139

Pages 166, 167

139 (*left*) Giovanni Battista Foggini, *Battle of Anghiari*, 1685–7. Corsini Chapel, Santa Maria del Carmine, Florence. Marble.

140 (*right*) Pierre Legros the Younger, *St Aloysius Gonzaga in Glory*, 1698–9. Sant'Ignazio, Rome. Coloured marble relief with bronze, marble and silver setting. H. *c.* 9 m.

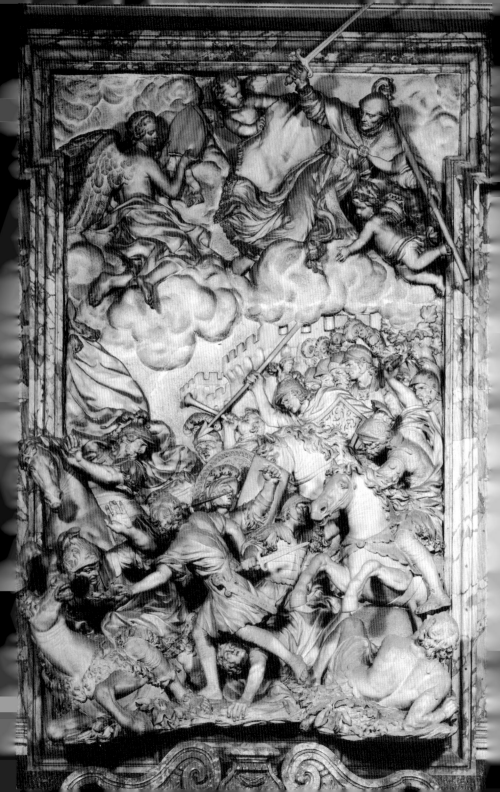

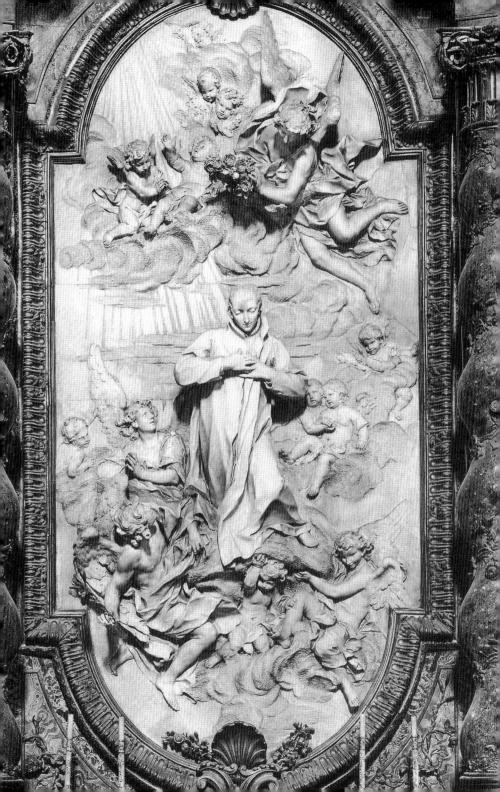

Few Italian Baroque reliefs matched the sheer panache of the *Battle of Anghiari*, but the demand for painterly reliefs continued unabated into the eighteenth century. When Pierre Legros the
140 Younger began the large altarpiece of *St Aloysius Gonzaga in Glory* for the Roman church of Sant'Ignazio in 1698, he could reflect upon several generations of relief sculpture for inspiration, but he must have turned instinctively to Cafà's *Ecstasy of St Catherine of Siena*. This offered the ideal pattern for a meditative image, eminently suitable in the case of Gonzaga, the young Jesuit saint who was often invoked as an example of youthful piety. Like its prototype, Legros' relief is exquisitely modulated though here the colour is confined to the surrounding gilt bronze, the four twisted columns of green *verde antico* marble, and the lapis lazuli and other coloured stones of the grandiloquent altar by Andrea Pozzo (1642–1709). The figure of the saint has been brought forward and is accompanied by clouds and angels, much as in Cafà's relief; so, too, the position of his hands and flowing drapery recall that of Cafà's St Catherine. But the effect is much more restrained. St Aloysius looks down, and Cafà's dynamic movement has been replaced by a more sedate verticality, in which the saint stands out by virtue of a higher degree of polish and relief.

Rome enjoyed a monopoly on the production of reliefs and statuary in the eighteenth century, furnishing products for Spain and Portugal as well as Savoy. Thus, when Vittorio Amedeo II decided to make a votive offering to the Virgin to commemorate the liberation of Turin from the forces of Louis XIV in 1706, his architect, Filippo Juvarra, proposed a royal monastery, the Superga. In some respects, this was a revised version of Sant'Agnese in Rome; above all, there was provision for three large altar reliefs. It is not surprising that the choice of sculptors fell on two artists working in Rome, Bernardino Cametti and, subsequently, Agostino Cornacchini (1686–1754). As a supremely gifted designer, Juvarra had definite ideas about the nature of the reliefs, and Cametti's *Annunciation* of 1729 must have fulfilled them. The high relief principles established by Algardi are adhered to, and although there is much bravura in the projection of God the Father's billowing robe or the Angel Gabriel's upper torso and wings, the tenor of the composition is rather restrained, more like a painting by Carlo Maratti or Guido Reni. Indeed, it is as a marmoreal version of a painting that the work can best be understood, with virtuoso effects reserved for the spectacularly undercut folds of drapery, the studied contrasts between the highly polished figures and the rougher textures for clouds and still-life elements.

141 Bernardino Cametti, *Annunciation*, 1729. La Superga, Turin. Marble. H. *c*. 5 m.

142 Filippo della Valle, *Annunciation*, 1750. Sant'Ignazio, Rome. Marble. H. 9.3 m.

Cametti's monumental altarpiece remained a touchstone of late Baroque reliefs, and when the younger Florentine sculptor Filippo della Valle created the large relief of the *Annunciation* for the altar opposite Legros' *St Aloysius Gonzaga in Glory*, he paid Cametti the compliment of revising his work in line with mid-eighteenth-century expectations. Della Valle had previously essayed this new, restrained style in his first great Roman work, the *Temperance* in the Corsini Chapel at St John Lateran, a statue which was one of the clearest harbingers of the changed taste in late Baroque sculpture. His *Annunciation* was installed in 1750 and stands in relationship to

Cametti's *Annunciation* much as Cametti's work did to the relief sculpture of the late seventeenth century. There is less self-conscious virtuosity in Della Valle's work, and the panache of Cametti's carving has been scaled back to the token projection of angelic wings and the hem of the Virgin's dress. The demure pose and elegant gesture of the Virgin reveal the study of Duquesnoy rather than Bernini or Algardi – the former was by then definitely out of fashion. In general terms, the accent is less on histrionics than sentiment, and the pictorial comparison would be with fashionable contemporary painters such as Pompeo Batoni (1708–1787) or the Frenchman Pierre Subleyras (1699–1749).

Della Valle's *Annunciation* reflects the sense of detached criticism which saved the best of late Baroque sculpture from becoming merely derivative. It was a feature that gradually dominated as the eighteenth century wore on, and the same phenomenon can be seen in the cycle of bronze reliefs by the Bolognese Giuseppe Mazza for the Venetian church of SS Giovanni e Paolo, one of the four executed in this period. Venetian foundries had been producing work of the highest quality since the Middle Ages, and it was appropriate that the great Dominican convent should celebrate its founding saint, Dominic, with a series of six, large-scale reliefs for his newly created chapel. The commission was made possible by the donation of a wealthy friar; Mazza was involved with the project for almost twenty years, from 1716. His reliefs were designed to fit into the lateral walls and were very much subordinated to their architectural setting. Their low-key style displays the grace and polish for which Mazza was famous, but his inspiration seems to have been the one great classicizing relief cycle of the sixteenth century, that conceived by Tullio and Antonio Lombardo for the chapel of St Anthony in the basilica of Il Santo in Padua; there we find a similar range of medium- to low-relief figures and the same paring down of the narrative to a minimal number of characters, all translated from the medium of marble to bronze.

Mazza's unorthodox training with painters rather than sculptors may have made him the perfect exponent of the Baroque relief. Indeed, constant comparisons with painterly values were made from Algardi's day to Della Valle's. Bernini reputedly wished to make marble as malleable as wax, and the same motivation was shared by his contemporaries and successors when it came to fashioning narratives in relief. Such pyrotechnics struck a chord with the public, and Algardi's *Encounter of St Leo the Great and Attila* soon acquired fame as the standard for relief sculpture. One late seventeenth-century critic

143 Giuseppe Mazza, *Death of St Dominic*, 1716–35. Chapel of St Dominic, SS Giovanni e Paolo, Venice. Bronze.

actually claimed that Algardi's work 'should be put on a level with the antique'. Even in 1760, the polemical French sculptor Etienne-Maurice Falconet (1716–1791) praised artists like Algardi for achieving a subtlety and chiaroscuro not to be found in Classical reliefs. By doing so, Falconet touched upon the embarrassing fact that the antique – chiefly Roman – relief sculpture then known was weak and inexpressive when compared with statuary; after all, most reliefs had been designed for triumphal arches or sarcophagi and were merely decorative. Thus, modern sculptors like Algardi or Cametti had little choice but to look to narrative painting for inspiration, much as Leon Battista Alberti had recommended to sculptors in the fifteenth century. The severity and purity of ancient Greek sculpture was only fully appreciated towards the end of the eighteenth century, and this dealt a mortal blow to the painterly character of Baroque relief sculpture.

Ephemeral Decoration and Small Works of Art

Works of art which no longer exist can often tell us as much about a period as those which survive. Just as any account of Italian Renaissance art would be incomplete without some consideration of lost paintings by Leonardo and Michelangelo, so, too, no survey of Italian Baroque sculpture should omit the countless ephemera and decorative artefacts that constituted a large part of a sculptor's daily fare. Such works included triumphal arches and decorative sculptures set up for joyous entries of rulers into cities or the *possesso* which each new pope made through Rome from the Vatican to St John Lateran; they also marked the births and deaths of royalty and persons of high estate. Even table centres for banquets could command the services of established sculptors such as Giuseppe Mazza or Ercole Ferrata.

Such temporary compositions proliferated during the Baroque, and they often combined astonishing technical devices with conspicuous consumption of materials and labour. Their underlying purpose was to reinforce religious beliefs, to delight connoisseurs, or simply to distract the general public from the bleak realities of life. Ephemeral works played a crucial role in the development of a Baroque aesthetic, for they relied upon the same principles of illusionism and multimedia as more durable creations. It would be difficult to comprehend Bernini's Cornaro Chapel or his *Cathedra Petri* fully without some reference to the religious tableaux which the sculptor staged throughout his long career.

The Forty-Hours' Devotion was one of the most conspicuous religious events of the church year, especially during carnival and the period between the evening of Good Friday and dawn on Easter Sunday. First popularized in Milan, these services were introduced to Rome by St Philip Neri in 1548. By the early seventeenth century, they had become occasions for vast representations involving music, dramatic lighting and didactic biblical scenes. As such, the Forty-Hours' Devotion was the descendant of medieval liturgical ceremonies with their emphasis upon the re-enactment of religious mysteries. The choice of forty hours reflected the numerological

symbolism frequently found in the Bible: Noah's forty days in the ark, the forty years of the Israelites in the wilderness, Christ's forty days of fasting, and so forth. In 1628, Bernini devised the first recorded use of concealed lighting in such a display at the Vatican, described as a 'very beautiful apparatus representing the glory of Paradise shining most splendidly though one could see no lights because behind the clouds were more than 2,000 burning lamps'.

No visual records survive for many of these works since they were dismantled almost as soon as their function was over. Beyond that, there was a feeling that such works somehow 'did not count'; even a contemporary listing of Bernini's *œuvre* only mentioned in passing the 'innumerable' scenes, fireworks, catafalques and *mascherati* designed by the sculptor. Nevertheless, they were occasionally recorded in drawings and engravings which remain significant for the light they shed on overlapping practices between temporary and

144 Dominique Barrière, engraving after Niccolò Menghini's *Crossing of the Red Sea* in the Gesù, Rome, 1646.

permanent works of art. One example that can stand for many is the
144 *Crossing of the Red Sea*, raised in the Gesù in Rome during 1646. It
was designed by a minor sculptor, Niccolò Menghini (*c.* 1610–1655),
then in the service of Cardinal Francesco Barberini, and was typical
of such productions, both for its costliness and elaborate use of
painting, sculpture and dramatic lighting.

The set, essentially painted canvas screens, occupied the transept of
the church and stood 40 metres high, 20 metres wide and extended
some 15 metres in depth. The figures were partly painted, but also
included terracotta sculptures, as well as others of papier mâché, this
last being used chiefly for the heavenly throngs of angels. The whole
tableau took six weeks to construct, employed a team of twenty
carpenters, masons and artists, and required 5,500 lamps to create the
proper atmospheric effects. As the engraving makes clear, the safe pas-
sage of Moses and the Children of Israel is contrasted with the
drowning of Pharaoh's army in the Red Sea, while the Eucharist, set
in the sunburst above, is compared to the pillar of cloud which guided
God's chosen people to the Promised Land. In such productions, the
brightest light bathed the monstrance holding the Eucharist which
was, in turn, surrounded by gilt rays piercing the clouds. Whether or
not such tangible symbolism originated with Bernini or Menghini,
the former was not slow to realize its potential in later works such as
146 the *Cathedra Petri*, where the window above St Peter's throne has been
incorporated into the altar's design as a great halo of light, emanating
from the dove of the Holy Spirit and assuming tactile shape in a burst
of golden rays and stucco clouds.

Northern Italy, where the Forty-Hours' Devotion originated at
the turn of the sixteenth century, enjoyed a vigorous tradition of pop-
ular religious imagery in the media of terracotta and wood. The most
famous in terracotta were the *sacri monti* of Lombardy, sequences of
shrines containing religious dioramas set against painted backdrops,
usually dotted along hillsides or by lakes. Much encouraged by the
Franciscans and by St Charles Borromeo, the *sacri monti* formed a
substitute for pilgrimages to the Holy Land and were more a
Renaissance than a Baroque phenomenon; however, a mobile equiva-
lent of these terracotta tableaux enjoyed widespread popularity
during the seventeenth and eighteenth centuries, particularly on the
Ligurian coast. These were the *casse*, or processional floats, carved of
wood and painted, which were commissioned by confraternities for
the celebrations of feast days and other major liturgical events. The
greatest exponent of such works was the Genoese Anton Maria

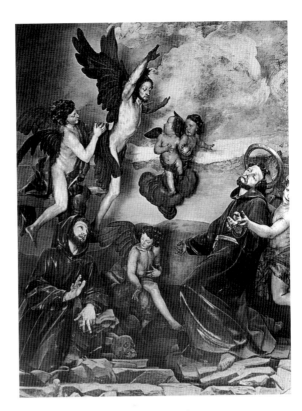

145 Anton Maria Maragliano,
Stigmatization of St Francis, 1708–9.
Chiesa dei Cappuccini e della SS
Concezione, Genoa. Painted and
gilded wood. Under life-size.

Maragliano (1664–1739) whose training in sculpture and cabinet-
making gave him the requisite skills to produce popular items ranging
from religious floats to crucifixes and nativity figures. In the
Stigmatization of St Francis of 1708–9, Maragliano brilliantly drew
upon elements of Roman High Baroque and more popular devo-
tional imagery and presented this most famous miracle of Francis's life
in vivid terms. A painted backdrop suggests the historic scene at La
Verna, where the miracle occurred, as does the presence of Brother
Leo, who witnessed it; yet the saint swoons in languid acceptance of
Christ's wounds in the manner of Bernini's St Teresa in the Cornaro
Chapel rather than his more active reception of these signs in earlier
representations. The creation of such scenes often involved painters,
weavers and embroiderers, working together in the manner of the *bel
composto*; unlike the *bel composto*, however, they strove to transcend art
with a pronounced hyper-realism more typical of Spanish than Italian
Baroque sculpture. The few surviving *casse* are among the most fasci-
nating artefacts of popular worship and convey something of the

frisson of the more sophisticated devotional scenes produced for the Forty-Hours' Devotion.

Ephemeral decorations were not, of course, exclusively religious. In kingdoms and duchies across the Italian peninsula , they were pressed into service to mark births, coronations, deaths and other remarkable events within the sovereign's domain. Naples and Sicily were particularly famous in this regard, always seemingly celebrating a religious observance or public holiday. The proclamation of Philip V as King of Spain and the Two Sicilies led to major celebrations in 1701. Those in Messina were designed by the young Sicilian architect Filippo Juvarra and included a symbolic throne with an image of the King and figures of Fame, several *macchine* or apparatuses, conceived as arches or tableaux with allegorical figures and presumably made of plaster or papier mâché, and a fountain running with wine, erected by the local vintners. The King's arrival in Naples in 1702 brought about similar celebrations, on which the stage designer Francesco Galli da Bibiena (1659–1731) collaborated with the talented young architect Ferdinando Sanfelice (1675–1750). But the most extraordinary of these Neapolitan specialities was the *cuccagna*. These temporary compositions composed largely of food could be seen as forerunners of performance art or even edible art, since the object was to conjure up a tempting image of a land of cockaigne which the rabble would then demolish for the entertainment of courtiers. One of the most celebrated of these was created in the piazza in front of the royal palace in Naples to celebrate the birth of a son to Charles III, the son and successor of Philip V, in 1747. Conceived by Vincenzo dal Rè 147 (*fl.* 1737–1762), chief designer for the Teatro San Carlo, the *cuccagna* consisted of a pavilion decorated with fruits and set in a landscape of which the paths were paved with lard and cheese and the trees hung with salami. A central fountain spewed forth wine while water issued from smaller, flanking fountains and fell into ponds well stocked with fish.

Fireworks were also an Italian speciality and were exported in large numbers across Europe during the eighteenth century. They lent themselves to temporary structures which were often consumed in the process of lighting the fireworks; the combination of allegorical figures and pyrotechnics was frequently employed to convey political 148 messages. One such was designed by Nicola Salvi and erected on the Spanish Steps in Rome for the celebration of the double wedding of the children of Philip V of Spain and John V of Portugal in 1728. Commissioned by the Spanish Cardinal Bentivoglio of Aragon, the

146 Gianlorenzo Bernini, *Cathedra Petri*, 1656–66. St Peter's, Rome. Marble, gilt bronze, stucco and coloured glass.

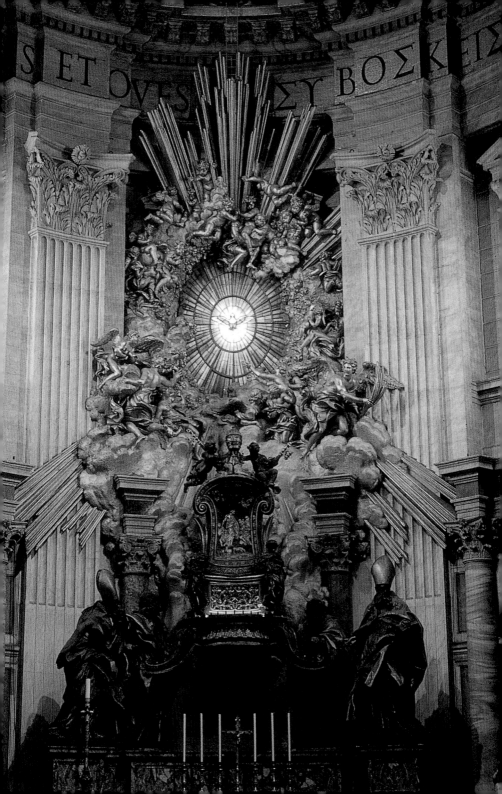

elaborate structure stood almost 47 metres high and 27 metres wide and represented the Palace of Hymen; the God of Marriage sat at the centre of the façade with the God of Love astride a globe beneath, and directly above him was Fame sounding her trumpet while Apollo and the Muses crowned the work above. Hymen was handing the nuptial torches to the horse-tamers, Castor and Pollux, who represented the Spanish and Portuguese bridegrooms. The two countries were evoked by female figures closing the composition to either side of Hymen.

Salvi's *macchina* anticipates many features that would later be translated into marble and travertine for his *magnum opus*, the Trevi Fountain, but the vast structure would have consisted entirely of combustible materials: wood and canvas for Hymen's palace while the figures would have been of papier mâché, stucco, or perhaps wood. The builders of such works are rarely recorded because they would have been considered merely the extra hands needed to transform any large project into reality. The 'intellectual copyright', so to speak, resided with the designer. Indeed, Rainaldi later referred emphatically to the ensemble raised on the Capitoline Hill for the election of Innocent X in 1644 as largely his own creation, saying, 'I as architect had the responsibility for the said arch, to give out and to distribute the work which was to be done on it.' The dominant force in such

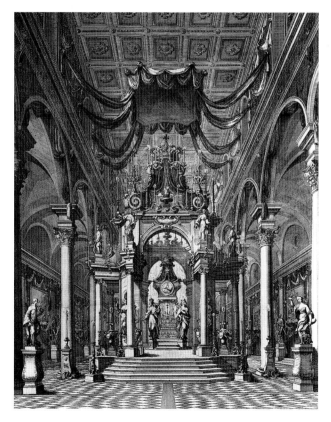

7 (*left*) Vincenzo dal Rè,
cuccagna in Piazza Reale, Naples,
47. Engraving.

8 (*above*) Nicola Salvi,
reworks on the Spanish Steps,
ome, for the double wedding
tween the Spanish and
rtuguese crowns in 1728.
graving.

9 (*right*) Vincenzo
anceschini, engraving of
neral decorations for Gian
stone de' Medici by
rdinando Ruggeri, 1737.

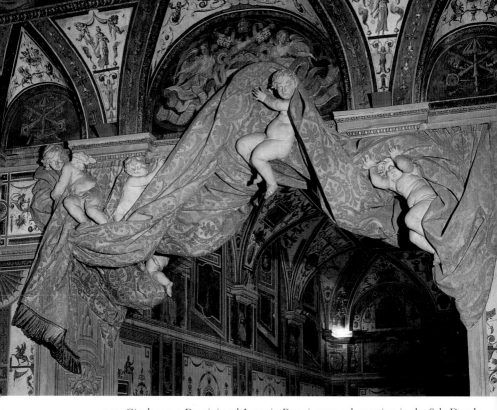

150 Gianlorenzo Bernini and Antonio Raggi, stucco decoration in the Sala Ducale, Vatican, 1656–7.

decorations had increasingly become an architect. Occasionally, as with the elaborate funeral observances for the Bolognese ambassador to Rome, Ludovico Fachinetti, a sculptor would assume charge. Although the decorations were recorded in a small book with a series of etchings by the painter Giovanni Francesco Grimaldi (1606–1680), the accompanying text explains that 'the invention and the form were born from the wonderful judgment of Signor Alessandro Algardi'.

Such works could cost as much as a sepulchral monument in a church, and when a ruler died, the price would often be prodigious. The Florentines were famous for their grand-ducal funeral ceremonies which followed a pattern established with the death of Cosimo I de' Medici in 1574. Where originally the funeral procession was the focal point, attention later shifted to the church ceremonies, which took place weeks or even months after the actual burial. The

151 Abbondio Stazio, stucco decoration at Palazzo Albrizzi, Venice, c. 1718.

reason was to allow enough time for the transformation of San Lorenzo, the Medici Pantheon, into a vast *cappella ardente* or funeral chapel. In place of the body, a symbolic bier formed the centrepiece of an elaborate catafalque or stage on which architecture, sculpture and painting were employed to make political statements. When Gian Gastone, the last of the Medici grand dukes died in 1737, his successor Francis, Duke of Lorraine, ordered an elaborate catafalque in the guise of an antique temple, richly adorned with statues of virtues and the arts as well as personifications of the regions of Tuscany; within this temple stood a fictive urn borne by caryatids and embellished with a portrait of the deceased. All of this was surmounted by a grand-ducal crown and baldachin of black velvet embroidered with pearls. The whole of San Lorenzo was shrouded with black-and-white drapery, and lit by hundreds of candles, some of which were held by fictive skeletons standing like sentries. By no means the most expensive of its kind, this official funeral was intended both to instil awe and provide a sense of dynastic continuity. Typically, it also became the subject of an elaborate volume and engraving, as testament to a memorable scene.

The passion for ephemera reveals a number of apparently contradictory aspects of Baroque art, for it exalted the transitory and ennobled humble materials. Stucco is the pre-eminent example of this transmutation; its basic ingredients – sand, gypsum, lime and water – were found all over Europe and had been employed since ancient times. Stucco could be modelled and moulded, applied to walls or canvas, or substituted for statuary in stone or bronze. Few ages surpassed the Baroque in the variety of uses to which stucco was applied, most notably for interior decoration. Camillo Mariani's stuccoes in the Roman church of San Bernardo alle Terme and Algardi's statues in the church of San Silvestro, also in Rome, are notable examples of stucco statues from the early seventeenth century, but the real impetus for its decorative application came from Bernini and Borromini. Bernini's assistant, Antonio Raggi, excelled in stucco-work, and his ability can be seen in his achievements: the dome of Sant'Andrea al Quirinale, the vault of the Gesù, or the small but telling example of the Vatican Palace's Sala Ducale. This last proved a clever and influential solution for turning two small rooms into one large one, where putti appear to be lifting a fictive drape emblazoned with the arms of Pope Alexander VII. It set a fashion for such flying putti that spread across Italy. Variations on this theme can still be seen in many palaces today, but few are more striking than the work of

Abbondio Stazio at Palazzo Albrizzi in Venice. There, several late sixteenth-century rooms were transformed into canopied tents supported by a squadron of angels and putti.

Stazio was typical of the numerous *stuccatori* who came down from Lombardy and learned their trade in the Rome of Bernini and Borromini, thereafter plying it across Italy and beyond the Alps. Borromini had revealed the potential of non-figural stucco decoration in his churches, and in the later seventeenth and early eighteenth centuries this style was sometimes combined with figural decoration to great effect, as in the chapels designed by Antonio Gherardi. In Naples, stucco and even papier mâché were frequently pressed into service in churches where marble or bronze would have been too costly. Giuseppe Sanmartino (1720–1793) became one of the foremost stuccoists there, and even developed an especially resistant form of plaster for exterior statues. His flair in the medium can be seen in the high altar of Sant'Agostino alla Zecca, where the patron saint casts down Heresy while Faith and Charity minister to the faithful.

152 Giuseppe Sanmartino, high altar of Sant'Agostino alla Zecca, Naples, 1761. Stucco.

Sanmartino only went to Rome as a mature artist, possibly in the years prior to his work at Sant'Agostino in 1761; his *macchina* betrays close study of the analagous marble group by Legros on the altar of St Ignatius Loyola at the Gesù, and is extremely effective in the crossing of the church where the dome floods the altar with light, thereby reinforcing the work's spiritual message.

In Venice, Baroque stuccowork built upon the Renaissance tradition of Sansovino and Vittoria; southern Italy and Sicily enjoyed similar traditions, chiefly in churches, though here the influences came more from the plateresque traditions of Spain. No stuccoist indulged in greater flights of fancy than Giacomo Serpotta, who emerged from generations of artisans to become the greatest Sicilian sculptor of his day. His work in the Palermitan oratory of Santa Zita remains an enduring example of the alchemy of art, converting stucco into a gloriously expressive medium. The themes of his handiwork were the mysteries of the Rosary and the intervention of the Virgin Mary during the Battle of Lepanto in 1571, when Christian forces achieved a rare victory over Turkish galleons in the eastern Mediterranean. The

153 Giacomo Serpotta, detail of 'The Victory of the Christian Army over the Turks at Lepanto' showing stucco ships, after 1688. Oratory of Santa Zita, Palermo.

154 Gaetano Zumbo, *Triumph of Time, c.* 1691–4. Museo della Specola, Florence. Wax. H. 28 cm.

profusion of Serpotta's decorations masks an essentially symmetrical and straightforward disposition of figures and narrative panels, the latter having more in common with fifteenth-century reliefs than the style then prevalent on the mainland. Such idiosyncracy was Serpotta's great glory, and it is often hard to believe that he was an exact contemporary of, say, Camillo Rusconi. Serpotta only knew the Baroque indirectly, from prints and contact with artists who had trained on the mainland, but he achieved a distinctive synthesis of Sicilian and mainland influences, coupled with an extraordinary combination of verve and dexterity.

Like stucco, sculpture in wax (especially small-scale models, portraits and votive effigies) became an art form in its own right during the Renaissance. The ease of modelling in wax did not make the same demands as stone or metal upon sculptors, and, as we saw with the portrait of Carlo Dotti by Angelo Gabriello Piò in Chapter Two, its impact could be heightened by accessories such as colouring, textiles and hair. One of the greatest exponents of wax sculpture was the Sicilian *abate*, Gaetano Zumbo, whose fame as an anatomical modeller took him across Italy and finally to Paris. In addition to his painstaking studies of the human body, Zumbo expanded his repertoire to include tableaux which could be seen as paintings in relief. These generally took the form of Vanitas imagery, a fashionable genre that presented the frailties of life and worldly pleasures in a lugubrious light. In the early 1690s, Zumbo made a series of such reliefs, all dealing with plague, decay and corruption, for the Medici court in Florence. One of the most famous is the *Triumph of Time*, in which the cleric in Zumbo joined forces with the artist to achieve a characteristically Baroque meditation on the transitory nature of human achievements, which incorporates dead bodies, broken statues, peeling plaster and distant vistas with ruined arches and pyramids. Vermin dart across the bodies while a Michelangelesque figure of Time gesticulates on the left. The artist even places a small portrait of himself by the foot of Time, as if to reinforce the fact that there are no exceptions to Time's iron rule, a point further compounded by the artist's use of the fugitive medium of wax.

Few ephemeral materials were more transitory than sugar, but it, too, became the subject of serious attention in centrepieces or *trionfi* for table decorations at banquets. Inedible, such works were obtained by combining melted sugar with an absorbent glue, thereby creating a paste which could be modelled or cast in moulds. These luxurious confections were then displayed on tables after the main meal course had been removed or, alternatively, on a buffet bedecked with a fine cloth. Their themes varied according to the season but frequently featured mythological and religious groups, coats of arms, triumphal arches and even fountains of spun sugar. Not all displays were made of sugar, for there are also accounts of marzipan trees with leaves of silk set on carved wooden bases, as well as elaborately moulded aspics or jellies. When Queen Christina of Sweden abdicated her throne and came to Rome in 1655, she was accorded the rare public honour – for a woman – of dinner with the Pope, something which had not occurred since 1598. For this extraordinary meal, the *trionfi* were

155 P. P. Sevin, drawing of a table decorated with sugar sculptures, including a copy of Pietro Tacca's monument to Ferdinando I de' Medici at Livorno, c. 1667–71. Nationalmuseum, Stockholm. Pen and ink.

modelled by artists rather than cooks, and Ercole Ferrata and Johann Paul Schor (1615–1674), both collaborators of Bernini, furnished the designs. Their models were cast by one of the major bronze founders of the day, Girolamo Lucenti, and were gilded with gold and silver leaf at a cost which equalled that of the models themselves. Although no designs survive from this banquet, others remain for table decorations at later banquets held for Queen Christina, including one presumably given by Cardinal Leopoldo de' Medici which featured the monument to his ancestor Grand Duke Ferdinando I at Livorno.

Sugar sculptures draw attention to a blurring of distinctions between what could be termed 'high' and popular art forms. Many of them replicated famous works and may have been cast from the same moulds as small bronzes. Bronze casting required special expertise not possessed by most sculptors, but sculptors frequently collaborated with founders on projects ranging from Bernini's Baldacchino to small collectors' items. Duquesnoy enjoyed fame as a creator of putti, and many of his terracotta models were cast in bronze, though probably not by his hand. The French sculptor François Girardon had more

than a score of such models in his collection, and Duquesnoy's celebrated group of *Amor Attaching Wings to Mercury's Feet*, originally conceived as a pendant for an antique Hercules in a Roman collection, soon enjoyed independent status as a popular bronze. By the same token, Louis XIV's appetite for Bernini's sculptures was doubtless whetted by his acquisition of a scaled-down replica of *Apollo and Daphne* in silver. The production of Giambologna's small bronzes was jealously guarded by the Florentine grand-ducal workshops throughout the seventeenth and eighteenth centuries. Indeed, this tradition of Giambologna inspired and, to a large extent, determined the development of small-scale bronzes, especially in Florence through the work of his successors, the Susini and Tacca families, as well as Foggini and Massimiliano Soldani Benzi (1656–1740).

After training in Rome, Foggini returned to Florence and the position of first sculptor at the grand-ducal court. As first sculptor, he

156 Claude Mellan, engraving of Duquesnoy's *Amor Attaching Wings to Mercury's Feet*. From *Galleria Giustiniana* (1631).

157 Giovanni Battista Foggini, *Time Ravishing Beauty*. Los Angeles County Museum of Art. Bronze. H. 54.6 cm.

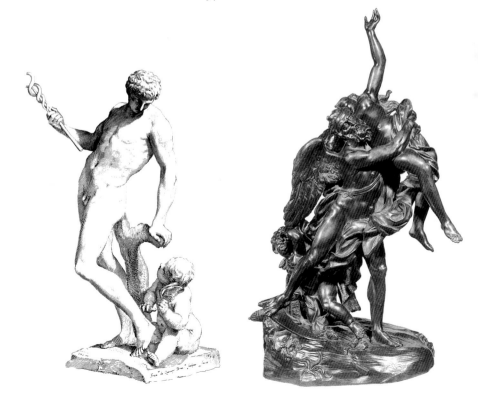

158, 159 Massimiliano Soldani Benzi. (*Left*) *Death of St Francis Xavier*, c. 1690. Bargello, Florence. Bronze. 98 × 32 cm. (*Right*) Front view of ewer with Amphitrite and a Nereid, c. 1710–15. Victoria and Albert Museum, London. Bronze. H. 79.7 m.

took over the foundry in Borgo Pinti originally run by Giambologna. A weak constitution compounded by illness encouraged him to concentrate on bronzes and small-scale works to conserve his strength. Many of these were created as diplomatic gifts to be sent abroad or presented to visitors at the court of Cosimo III. Almost exclusively Classical in subject matter, the best preserved still retain a reddish-brown patination and translucent lacquer; they display basic formulae derived from Giambologna and newly energized by the example of Bernini.

In contrast to Foggini, Soldani worked only in bronze, having been destined for service in the Florentine mint, which he directed for forty years from 1688. His training was typical of the new cosmopolitanism of the late Baroque: study at the Florentine Academy under Ferri and Ferrata brought him into contact with the circle of Queen Christina of Sweden and foreign artists such as his exact contemporary the Austrian architect, Johann Bernhard Fischer von Erlach (1656–1723). This was followed by a brief period of study of coinage in Paris where Soldani impressed the court with a medallion portrait of Louis XIV. Although Soldani returned to Florence for the rest of his long career, he maintained contacts abroad through numerous commissions for reliefs, decorative objects and replicas of antique sculptures. He brought the finesse of a medallist to all his works and created some of the most exquisitely modelled and chased bronzes of the period. Even a relatively early work like the *Death of St Francis* 158 *Xavier* reveals a perfect command of the High Baroque idiom in its adaptation of Cafà's *St Rose of Lima*, while his decorative ewers are peerless in their fusion of abstract and more naturalistic forms. Ewers of this sort had no practical function and were descended from the silver and gold vases displayed on sixteenth-century buffets. The shape of Soldani's ewers is dictated by a heady combination of naturalistic 159 forms, in this case Amphitrite with a Nereid, dolphins and other marine attendants (as well as some stray fauns). This figural profusion is matched by the exceptional delicacy of the surface finish which helped to create one of the supreme achievements of late Baroque decorative art.

Soldani's ewers were destined for princely collections, such as that of his patron, the young Prince Johann Adam Andreas von Lichtenstein. Princely magnificence required elaborately wrought works for display within palaces, and often, the original *raison d'être* of a functional object was lost through the premium placed on design and craftsmanship. Nowhere was this more evident than in ceremonial thrones, chairs, or state beds. The German artist and designer Johann Paul Schor was much in demand as a designer of such works in the Rome of Alexander VII; many of these can now only be appreciated in engravings and drawings. Few of his creations were more breathtaking than the state bed he created to mark the birth of a son to the Roman princely family of Colonna in 1663. Much of its impact derived from its extraordinary resemblance to a fountain, for the bed was conceived as an open shell, being pulled by four sea horses and resting on a wooden base resembling waves. Mermaids, painted to

160 Johann Paul Schor, engraving of a state bed for Principessa Maria Mancini Colonna, 1663. Kungliga Biblioteket, Stockholm.

appear golden, accompanied each horse, while little cupids seemed to pull back the gold brocade curtains. The bed was used only once when Maria Mancini Colonna received visitors forty days after her son's birth.

Mirrors and picture frames also lent themselves to elaborate carved decoration in silver, ivory, or wood. Bernini designed a renowned example for Queen Christina of Sweden, based upon the conceit of Time lifting a drapery to reveal the image of the beholder, a variation on his abandoned sculpture, *Truth Unveiled*. In this case, the folds of the drapery masked the joins necessitated by the mirror's construction from several small sheets of silvered glass. The Genoese sculptor Filippo Parodi, some of whose formative years were spent in Rome, created similar punning frames for his Genoese patrons, such as the elaborate mirror in the Villa Durazzo at Albisola in which the

162

161

polished surface becomes the water in which the Greek shepherd Narcissus first saw his own image. This conceit was all the more striking given that, in the seventeenth century, mirrors were still prized possessions for the privileged.

Parodi moved to Venice in 1678, enticed by the commission for a monument to the recently deceased patriarch, Giovanni Francesco Morosini. Shortly after his arrival, he acquired a promising young apprentice named Andrea Brustolon (1662–1732), who came from a family of artisan woodworkers in Belluno. This was a stroke of luck for the younger man because Parodi, being equally conversant with marble and woodcarving, would therefore expose Brustolon to a range of compositional ideas beyond his artisan background. His time in Parodi's workshop may have been supplemented by a trip to Rome, but Brustolon soon established himself in Venice and his native Belluno as the sovereign sculptor in wood. Today he is best known for the elaborate suites of furniture which he designed and carved for the

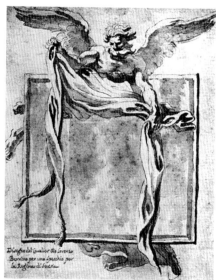

161 (*left*) Filippo Parodi, Mirror with myth of Narcissus, *c.* 1661. Villa Durazzo, Albisola, Genoa. Gilded wood.

162 (*above*) Gianlorenzo Bernini, design for a mirror for Queen Christina of Sweden, *c.* 1670. Royal Collection, Windsor Castle. Pen, ink and wash.

Venetian nobility. These were ceremonial pieces, items not intended for practical use but as a display of wealth, much like the state bed designed by Schor for Maria Mancini Colonna in Rome. The most impressive of Brustolon's works was a set of forty pieces, which he executed around 1700 for the palace of a Venetian nobleman, Pietro Venier. The chairs were made of boxwood, carved so that the supports resembled gnarled branches of trees, laced with vines and tendrils. The front supports included moors carrying the armrests on their shoulders and moorish putti sporting on the armrests themselves. The flesh of the moors was carved from ebony to convey a lustrous dark hue, and the backrests displayed embroidered allegories of vanity, fire and music, amongst others. There were also *guéridons* or small stands carved to look like moors supporting trays for candelabra, but the most extravagant piece was a large vase-stand of box and ebony. On this occasion, the ancient hero Hercules was called upon to perform another labour, for he appears between the multi-headed monster

163 Andrea Brustolon, Vase-stand with Hercules and moors, *c.* 1700. Museo del Settecento Veneziano, Cà Rezzonico, Venice. Boxwood and ebony. H. 2 m.

Hydra and the three-headed Cerberus, supporting a large platform with his club; two river-gods recline on either side of the platform between two Japanese vases while the centre is given over to an ebony group of three moors supporting a further vase. Such creations were prized for their novelty and craftsmanship, and they embody a taste not far removed from the bizarre iconographic programme of the Sansevero Chapel in Naples.

A French visitor, writing in 1739, observed the prodigious trappings of Venetian palaces but found the furniture lacking in taste and impossible to sit upon, owing to the delicacy of its sculptural decoration. He had rather missed the point, for although ostensibly furniture, such pieces were elevated to the realm of pure art by playing upon the same principles of mimicry which underlie so much Baroque sculpture. In this case, however, it is the paradox of arboreal forms simulated in boxwood and moors conjured up from ebony that makes Brustolon's work so piquant. The basic conception of the vase-stand has been compared to Bernini's *Fountain of the Four Rivers*, and the moors have sometimes been likened to the gigantic moorish captives by Melchior Barthel on the tomb of Doge Giovanni Pesaro, yet the association of ebony and African figures had also been popularized by French cabinet makers in the middle of the seventeenth century. Ebony was imported from the island of Madagascar, off the south-east coast of Africa, and from the East Indies, and its exotic associations formed the perfect foil for oriental blue-and-white porcelain which was then coming into fashion.

The plethora of associations found in Brustolon's work typifies trends in late Baroque sculpture: a Veneto craftsman, he trained under a Genoese follower of Bernini but was also open to influences from French decorative arts. Italy, and Rome in particular, became a meeting place for artists and patrons from all over Europe during the eighteenth century, and the effect of these new influences was to broaden and eventually bring about the demise of the Baroque.

From Late Baroque to Neoclassicism

Some time before his death in 1680, Bernini predicted a decline in esteem for his art. Judged superficially, his observation seems unexpected, given the perfect fusion of artistic gifts and spirituality that informs his mature religious works, the dominance he exercised over all major commissions in the Rome of his day, and the large number of assistants and collaborators who progressed through his workshop from the 1620s to the 1670s. But his judgment was accurate, for he outlived nearly all of his closest collaborators. His later style evolved in a direction that was intensely spiritual and highly personal, two factors which rendered his work literally inimitable. This change in Bernini's style was evident as early as his statue of Truth from the unfinished *Truth Unveiled*, with its uncanonical proportions and ecstatic expression; such features became even more pronounced in his later, chiefly religious commissions.

The distance between Bernini and his younger contemporaries can be gauged by one of his last major projects, the angels for the Ponte Sant'Angelo in Rome. Planned and executed between 1667 and 1669, the suite of eight, and subsequently ten, angels was designed by Bernini for Pope Clement IX as an embellishment to the ancient Roman Pons Aelius, which formed the principal link between the Vatican and the city. The major sculptors of the day were chosen to carve individual statues of the angels, each holding an instrument of the Passion of Christ, with two reserved for Bernini himself. The intention was to transform the bridge into a *via dolorosa* preparing pilgrims for the ultimate destination of their spiritual journey within Rome, the basilica of St Peter, and Bernini conceived the angels as grieving or reflecting upon the instruments they carry in order to instil a proper mood in the spectator. Although Bernini always insisted upon the authority of antique sculpture and even returned to the *Antinous* for the initial design of the *Angel with the Superscription*, the [164] finished work betrays little evidence of Classical inspiration. As executed, this angel and its companion, the *Angel with the Crown of* [165] *Thorns*, adopt complementary poses, with weight firmly on the left

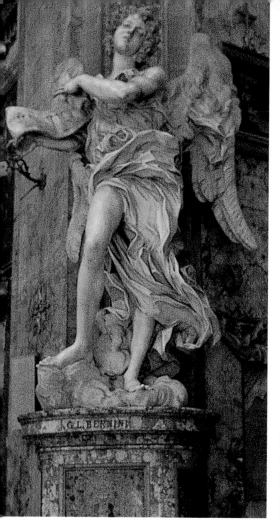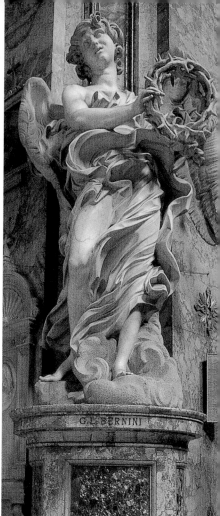

164, 165 Gianlorenzo Bernini. (*Left*) *Angel with the Superscription*, 1667–9.
(*Right*) *Angel with the Crown of Thorns*, 1667–9. Sant'Andrea delle Fratte, Rome.
Marble. Over life-size.

Page 197

166 (*left*) Cosimo Fancelli, *Angel with the Sudarium*, 1668–9. Ponte Sant'Angelo,
Rome. Marble. Over life-size.

167 (*right*) Antonio Raggi, *Angel with the Column*, 1668–9. Ponte Sant'Angelo,
Rome. Marble. Over life-size.

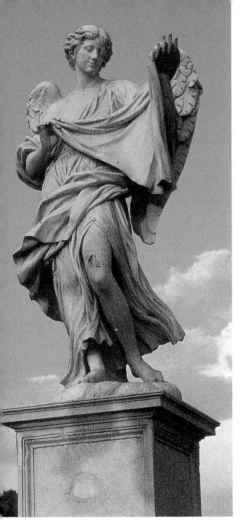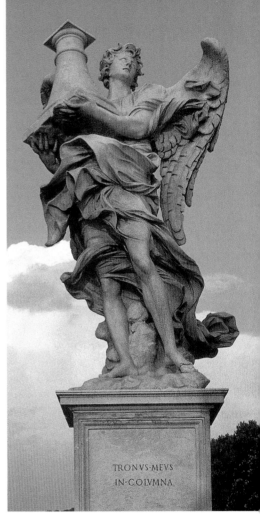

TRONVS·MEVS
IN·COLVMNA

leg and the right bent at the knee; both torsos are turned away from the front plane of the block of marble by the movement of their arms which display their attributes. Bernini also invested each angel with a different kind of emotional intensity: the *Angel with the Crown of Thorns* is more extrovert and outwardly directed, and the *Angel with the Superscription* seems more introverted. The drapery of the former billows up aggressively around the crown of thorns while that of the latter ebbs away into smaller, agitated patterns. In particular, its etiolated body and ineffable expression of grief endow the *Angel with the*

Superscription with an ethereal quality that sets it apart from the rest of Bernini's *œuvre*.

The rare qualities of these two marbles persuaded Clement IX to keep them inside; copies were placed upon the bridge. The degree to which Bernini's collaborators followed his intentions varied markedly, again a reflection of the distance between the ageing sculptor and his successors. Part of the disparity can be explained by his working method: Bernini did not follow his customary procedure of evolving designs through drawings and clay models but left it to studio draughtsmen to make copies of his initial sketches. This, in itself, meant that his collaborators were working at one remove from Bernini's original conception. Thus, the *Angel with the Sudarium* by Cosimo Fancelli (1620–1688) registers what must have been the essential pose established by Bernini. However, the proportions are more compact, the drapery patterns and the wings become more decorative than descriptive, and the angel's head points to the example of Algardi rather than Bernini. Antonio Giorgetti (*c.* 1635–1669) produced a more graceful work with the *Angel with the Sponge*, but again the emotional impact is diminished and whatever nuance Bernini might have conveyed was ironed out in a dutiful imitation.

166

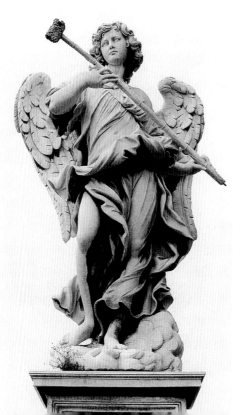

168 Antonio Giorgetti,
Angel with the Sponge, 1668–9.
Ponte Sant'Angelo, Rome.
Marble. Over life-size.

Much the same could be said of Antonio Raggi's suave but essentially ornamental rendering of the *Angel with the Column*.

With the exception of Domenico Guidi, all of Bernini's collaborators on the Ponte Sant'Angelo died before 1700; the most talented, Ferrata and Raggi, both died in 1686. A brilliant decorative sculptor, Raggi never evolved much beyond the role of Bernini's extra pair of hands while in his mature works, like *St Agnes on the Pyre*, Ferrata oscillates uncomfortably between the contrasting manners of Bernini and Algardi. Guidi, on the other hand, was different. He was a favoured assistant of Algardi and subsequently established an independent career that led to his being elected *principe* or governor of the Academy of St Luke and a rector of the recently established French Academy. Guidi's role at the latter institution also gave him some influence over the French sculptors then training in Rome, particularly Jean-Baptiste Théodon (1645–1713) and Pierre Legros the Younger. In his work, Guidi showed himself to be prolific if uninventive, content to follow the well established paths of Bernini and Algardi, but hardly a bridge between the age of Bernini and the eighteenth century.

The Ponte Sant'Angelo foreshadowed not only the end of Bernini's artistic dominance, but also the cornucopia of projects which had employed so many artists in seventeenth-century Rome. Clement IX's successors presided over a dwindling economic base and a changed moral climate which effectively terminated the largesse which had existed under Urban VIII or Alexander VII. Innocent XII actually issued a papal bull abolishing nepotism in 1692, and it was not until the reign of Clement XI (1700–1721) that papal patronage began to be revived. Some of the slack was taken up by the old papal families and private individuals, but the most conspicuous sculptural commissions of the late seventeenth century came from the Jesuits, who embarked upon the transformation of the Gesù and Sant'Ignazio in the full flood of triumphalism in the 1680s and 1690s. The stimulus came from a gifted Jesuit lay brother with a flair for illusionistic painting and design, Andrea Pozzo. In 1695, Pozzo obtained the commission for one of the most splendidly extravagant of Baroque altars, that of the Jesuits' founder, St Ignatius Loyola, in the church of the Gesù. Embracing the whole of the left transept, the altar assumes the form of an undulating aedicule which breaks open to reveal a statue of the saint (actually a stucco copy of the original, silver and gilded copper statue, destroyed in 1798) beneath a representation of the Trinity; this central group is surrounded by gilt-bronze and

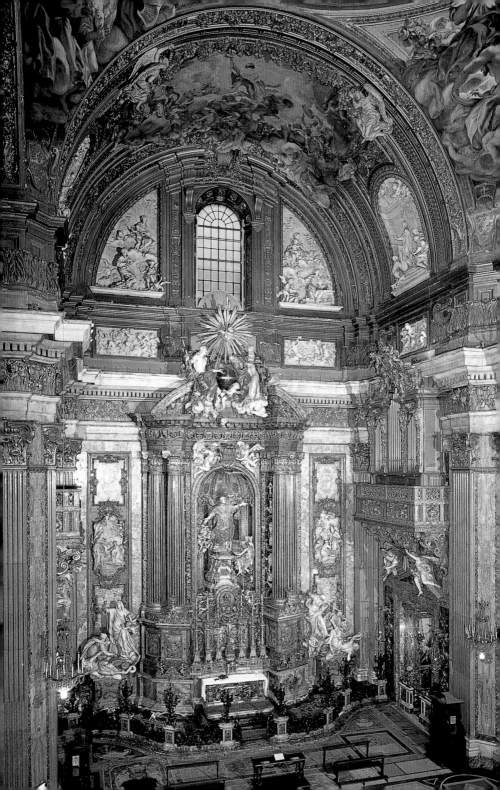

marble reliefs illustrating scenes from Loyola's ministry as well as large marble tableaux of the triumphs of Faith and Religion. The whole is further enriched by the profusion of rare marbles and lapis lazuli as well as gold and silver, all intended to evoke admiration and wonder.

Some one hundred artists and artisans worked on the altar of St Ignatius, and it was indicative of post-Berninian Rome that the most important commissions went to two Frenchmen, Théodon and Legros. Théodon executed the over-life-size marble group of the *Triumph of Faith over Idolatry* and Legros the *Religion Overthrowing Heresy and Hatred*, both archetypal images of the Church Triumphant. The initial conception for each sculpture would have been supplied by Pozzo, whose earlier fresco in Sant'Ignazio essayed similar themes, but the sculptors must have been given a fairly free hand in realizing such abstract ideas. In Legros' work, Religion hurls down thunderbolts upon an old woman representing Hatred while a male figure of Heresy writhes vanquished beneath; to reinforce the point, a putto cheerfully tears pages out of a volume by the Swiss reformer Zwingli, and a tome beneath the figure of Heresy bears Luther's name prominently on its spine.

169 (*left*) Altar of St Ignatius Loyola at the Gesù, Rome, designed by Andrea Pozzo, 1695–9.

170 Pierre Legros the Younger, *Religion Overthrowing Heresy and Hatred*, Altar of St Ignatius Loyola, 1695–9. Gesù, Rome. Marble. H. 3 m.

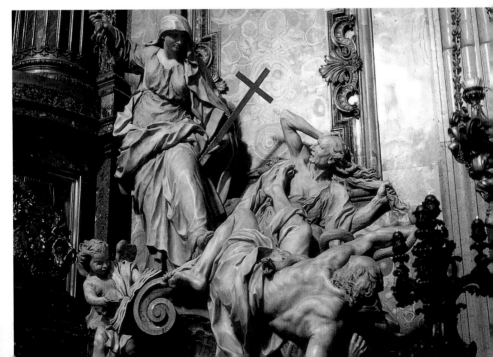

Like Théodon, Legros was among the first beneficiaries of the French Academy, which had been founded by Louis XIV's minister Jean-Baptiste Colbert in 1666. The son of a sculptor to the King, Legros trained in the atmosphere of Classicism fostered by the French court, but was also receptive to the High Baroque mode of Melchiorre Cafà, whose *Ecstasy of St Catherine of Siena* served as the model for his *St Aloysius Gonzaga in Glory*, one of several Jesuit commissions from the late 1690s. Legros' artistic make-up was such a successful synthesis of Italian and French elements that he never lacked work; his commissions, however, frequently embodied retardataire taste, none more so than the extraordinary multicoloured *St Stanislas Kostka on his Deathbed*. Here, too, Legros' work looks back to the tradition of ecstatic or dying saints created by Bernini and Cafà, but instead of a white marble figure set off by coloured marbles, colour forms an integral part of Legros' work: black touchstone for the Jesuit habit, Sicilian jasper and yellow marble for the bedding, and gilt bronze for the fringe. The saint's hands, feet and head are carved from white Carrara marble, with the hair left rough and unpolished and the nails and eyes delicately incised. The work's purpose was to shock visitors entering the room where the young man had once lived, by conveying the impression of someone actually dying, and the Jesuits resisted Legros' attempts to have the sculpture moved from their novitiate to the church of Sant'Andrea al Quirinale, largely because of its effectiveness in its intended setting.

The great Jesuit commissions proved more of a swansong than a new beginning in Italian Baroque sculpture. Obviously, a change in artistic taste did not occur overnight even though a striking departure from the High Baroque mode did emerge with the first major sculptural commission of the eighteenth century, the *Apostles* for St John Lateran. After a long and fallow period for the arts, Clement XI began his reign determined to instigate new competitions and to complete projects left unfinished by his predecessors. Among the latter was the decoration of the Lateran basilica, left suspended after the death of Innocent X in 1655. Twelve oval tabernacles had been created by Borromini during his remodelling of the interior, and Innocent had considered commissioning statues by Bernini and Algardi as well as a series of marble or bronze reliefs to line the walls above. Of these projects, only stucco reliefs by Algardi were actually carried out, and Clement established a committee to oversee the statues in 1703. Significantly, the artistic advisors employed were the architect Carlo Fontana (1634–1714) and the painter Carlo Maratti, but no sculptor.

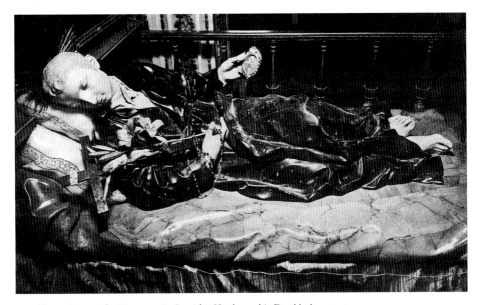

171 Pierre Legros the Younger, *St Stanislas Kostka on his Deathbed*, 1702–3.
Sant'Andrea al Quirinale, Rome. Coloured marbles. Life-size.

After Bernini's death, these two men advised on a variety of projects, including papal monuments. At the Lateran, Fontana's role was to consider the scale of the figures in the context of Borromini's tabernacles while Maratti would furnish preliminary designs from which the sculptors would prepare clay models. The purpose of this procedure was to ensure the kind of 'quality control' achieved by Bernini in the crossing of St Peter's or the *Cathedra Petri*; the results, however, were only partially successful. Fontana and Maratti clearly thought of the statues as essentially two-dimensional, overlooking the fact that their oval setting invited multiple viewpoints and a more substantial mass for each figure. And some of the chosen sculptors refused to work from Maratti's designs.

The Lateran project reveals the extent of Bernini's unpopularity by 1700. By then, most artists and connoisseurs took their cue from the writings of Giovan Pietro Bellori, whose *Lives of the Modern Painters, Sculptors and Architects*, first published in 1672, omitted to mention Bernini by name and noted, with some asperity, that 'down to our own time sculpture has lagged behind the ancients, given the small number of modern statues which deserve fame'. Bellori singled

out Duquesnoy and Algardi for the highest praise and tended to minimize the ways in which their two styles overlapped with that of Bernini. Maratti, who came to maturity in the latter half of the seventeenth century, based his paintings on the styles of those artists esteemed by his friend Bellori as epitomizing the best classicizing style: Carracci, Domenichino, Guido Reni and, above all, Raphael. Maratti's suave and restrained manner became all-pervasive in late Seicento Rome. His influence on the Lateran *Apostles* is palpable, most particularly on the great hero of the series, Camillo Rusconi, and less so on Pierre-Etienne Monnot (1657–1733) and Legros, both of whom ostentatiously avoided Maratti's models. Trained initially by the Milanese *caposcuola* Giuseppe Rusnati (d. 1713), Rusconi established a close friendship with Maratti after his arrival in Rome in around 1684, and their association proved more decisive on the sculptor's career than a brief period in the workshop of Ercole Ferrata. Among Rusconi's early independent works, the stucco series of virtues in Sant'Ignazio point unerringly to his study of analogous works by Algardi; he managed to preserve the best elements of that early Baroque style in his own heroic manner.

Rusconi's undoubted ability won him the lion's share of the Lateran *Apostles*, four as opposed to the two each awarded to his French rivals Monnot and Legros. His work here comes closest to that of Maratti and illustrates why even so hostile a critic of the Baroque as the painter Anton Raphael Mengs (1728–1779) could praise Rusconi as 'the last of the sculptors worthy of mention'. Rusconi's *St Andrew* and *St James the Great* reflect a close analysis of one of the few statues of the early Baroque which could guide him in the relatively uncharted waters of colossal statuary, Duquesnoy's *St Andrew*. Indeed, Rusconi's *St Andrew* is an obvious paraphrase of that much admired work, but that did him no disservice in the eyes of contemporary connoisseurs. As we have seen, copying the great works of the past was an accepted means of learning; it was felt that an artist's skill lay in the addition of something new to a familiar source. Here Rusconi has made his St Andrew a mirror image of Duquesnoy's while at the same time inclining the apostle's head in tragic resignation. Although he has purged his drapery patterns of the most obvious 'Baroque' excesses, Rusconi still could not resist a tremor of agitation in the cloth looped over the cross and above the left knee. The *St James the Great* similarly adapted the restraint of Duquesnoy's statue, reworking its upturned head and expansive gesture into an embodiment of inspired resolve. Here Rusconi did not

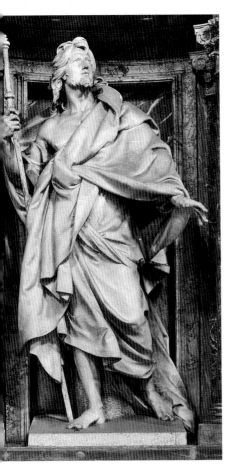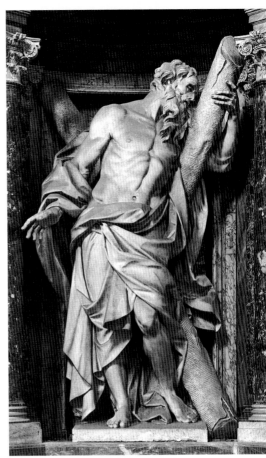

172, 173 Camillo Rusconi. (*Left*) *St James the Great*, 1715–18. (*Right*) *St Andrew*, 1708–9. St John Lateran, Rome. Marble. H. *c.* 4.25 m.

rely upon a design by his friend Maratti, but the result still demonstrates how close the two artists' styles had grown.

The work of Monnot and Legros follows a different path. Like his fellow countryman, Monnot was initially trained in France and then gravitated to Rome where he made copies after antique sculptures as well as after paintings by the Bolognese artists Francesco Albani and Domenichino. It was a sign of his eminence that he should be chosen for the statues of *St Peter* and *St Paul*. The former is one of the finest in the series, with the prince of the apostles presented as a Classical orator with a decisive gesture of the right hand and drapery that

174

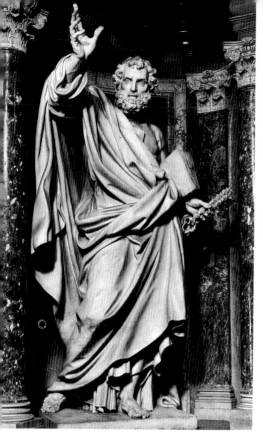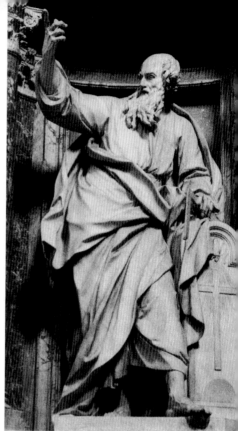

rigidly conforms to the lines of the body. Legros' *St Thomas* and *St Bartholomew* were underway concurrently and appear to have been designed to complement Monnot's work. In particular, the *St Thomas* shares the bold declamatory gesture and incisive characterization, although the swathes of drapery are more reminiscent of late Baroque than incipient classicizing tastes. If Rusconi and his French contemporaries represent the apogee of the Lateran cycle, then the work of the remaining sculptors could be described as veering between histrionics and frigidity; only one of this group, the *St Philip* by Giuseppe Mazzuoli (1644–1725), a sculptor of an older generation, displays a miscalculated commitment to the Berninesque style.

The move away from the High Baroque towards a more classicizing mode continued in the reigns of Clement's successors, notably the Florentine Pope Clement XII Corsini, who reigned from 1730 to

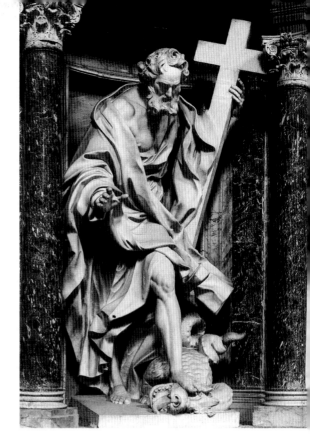

174 *(far left)* Pierre-Etienne Monnot, *St Peter*, 1708–13. St John Lateran, Rome. Marble. H. *c.* 4.25 m.

175 *(left)* Pierre Legros the Younger, *St Thomas, c.* 1705–11. St John Lateran, Rome. Marble. H. *c.* 4.25 m.

176 *(right)* Giuseppe Mazzuoli, *St Philip, c.* 1703–12. St John Lateran, Rome. Marble. H. *c.* 4.25 m.

1740. His family chapel at St John Lateran became a showcase of the new style under the family architect and protégé, Alessandro Galilei (1691–1737). Although much younger than the sculptors of the Lateran *Apostles*, Galilei subscribed to comparable principles of decorum and restraint in his architecture. He had an unusual training, which began with Foggini in his native Florence, was followed by the obligatory stay in Rome, and finally rounded off by a lengthy sojourn in England and Ireland just as the Palladian revival was gathering momentum. Galilei was impressed, as were his British contemporaries, by the writings of the third Earl of Shaftesbury, who argued for a return to the clarity and formal simplicity of Classical art. He put this into practice in the Corsini Chapel, the first papal chapel of its kind in more than a century. Clement XII had specifically requested that his family chapel be based on the Sistine and Pauline Chapels at

177

Santa Maria Maggiore, and the ground plan therefore adopted a Greek cross form. Similar, too, is the emphasis upon sculptural decoration and marble encrustation. Yet the total effect could hardly be more different: the colours are subdued, and the sculptural component is subordinated to the architectural scheme, much like the other great project of Clement's reign, the Trevi Fountain.

As with Salvi's Trevi design, the architectural vocabulary here is guided by a restrained version of sixteenth-century Roman architecture, notably Michelangelo's, rather than anything which could be restrospectively termed Neoclassical. The sculptural decoration, comprising memorials and allegorical statues, establishes a compromise between various currents in the late Baroque tradition. Giovan Battista Maini's memorial to Cardinal Neri Corsini pays homage to two great masters of the older generation: Legros' statue of Cardinal Casanate served as a model for the commemorative figures while Rusconi's Religion from the monument to Gregory XIII inspired the analagous virtue seen here in rapt contemplation of Clement XII's uncle. One of the most beautiful figures in the complex –

177 (*left*) The Corsini Chapel in St John Lateran, Rome, 1732–5, showing Giovan Battista Maini's Tomb of Cardinal Neri Corsini, 1733–4.

178 Filippo della Valle, *Temperance*, 1732–3. Corsini Chapel, St John Lateran, Rome. Marble. Over life-size.

indeed in eighteenth-century Rome – is Filippo della Valle's *Temperance*. Carved between 1732–3, the *Temperance* casts more than one glance back to a much admired statue of the early seventeenth century, Duquesnoy's *St Susanna*, but it is worth looking at the ways in which Della Valle departs from his model since they indicate a change in taste. A striking sinuosity dictates every aspect of the figure from her coiffure and spiralling pose to the syncopated folds of drapery and magnificent ewer at her feet. In all these aspects, Della Valle shows himself the pupil of Soldani, and the work could almost be described as a marble enlargement of a small-scale bronze. At the same time, Della Valle's *Temperance* displays a rather wistful air that aligns it with the work of his French contemporaries in Rome, Edmé Bouchardon (1698–1762) and René-Michel Slodtz (1705–1764), better known by his nickname Michelangelo Slodtz.

The influence of French artists on eighteenth-century Italian sculpture is clear, although difficult to quantify. It has been mentioned in our discussion of late Baroque portrait busts, such as Rusconi's bust of Giulia Albani degli Abati Olivieri, and can certainly be perceived in a work like Della Valle's *Temperance*, which is so imbued with charm and grace that it could almost be described as Rococo. But although the term Rococo is sometimes employed to describe Italian art of the early eighteenth century, it sits somewhat awkwardly on sculpture from a period which favoured public and monumental arenas rather than the intimate and amusing scope of much Rococo art.

Rome increasingly basked in its new role as an international school for artists and scholars alike. Both the French and Florentine Academies were based upon the proposition that young artists would benefit from exposure to great works of the past, and as the eighteenth century wore on, it was increasingly the antique as opposed to more modern works which were most influential. Training at the French Academy included life drawings but also drawings after Raphael and the antique. Classical sculptures were copied by most major sculptors for shipment abroad, and this clearly required a more academic approach to their study than would have been the case during most of the seventeenth century. This did not have as great an impact initially upon religious or secular sculpture as one might think. Two examples from one of the last great sculptural projects in St Peter's help to explain why.

Begun with the new century, the cycle of founders of the religious orders was intended to complete the sculptural decoration of the nave of St Peter's. Lack of funds and, at times, lack of interest meant that the series limped along, and despite great names like Rusconi and Maini, the results were highly uneven. The best, Slodtz's *St Bruno* and Della Valle's *St Teresa of Avila*, are technically competent and attractive but stylistically indebted to masters of the previous era, namely Legros and Rusconi. Slodtz's sculpture was carved in 1744, at the end of his Roman sojourn, and skilfully exploited the pathos of the Carthusian monk's renunciation of a bishop's mitre and crozier. Both gesture and drapery are simplified here even if the introduction of a putto is at variance with the high seriousness of the work as a whole. Della Valle's statue remains in thrall to the example of Rusconi, and its similarity to his master's Lateran statues is evident. More significant, however, is the sculptor's careful avoidance of any detail which could bring to mind Bernini's *Ecstasy of St Teresa*; even the angel with the fiery dart has been reduced to a harmless cherub with a token heart!

179 René-Michel Slodtz, *St Bruno*, 1744. St Peter's, Rome. Marble.

180 Filippo della Valle, *St Teresa of Avila*, 1754. St Peter's, Rome. Marble.

Many sculptures executed in Italy during the late Baroque betray an uncertainty of direction, a stalling of the creative engine. There was a general apprehension that the grandiloquence and ardour of Bernini's *St Longinus* or Algardi's *St Philip Neri* were indecorous, but it was difficult to determine what should replace them. Effectively, the tradition which connected Bernini and Rusconi had been successful in so many fields that it was difficult for their artistic heirs to see beyond it. So many works were either made in Rome or executed by artists trained there that it took a long time for the late Baroque to be

supplanted by the movement we now call Neoclassicism. Of course, no portcullis descends between one stylistic movement and another – life is too untidy for that. But the eighteenth century witnessed a gradual toning down of the exuberance of Baroque sculpture and a concomitant rise in the imitation of an antique style, at first Roman and then Greek as the distinctions between the two periods in Classical art were analysed and illustrated. This was manifest by the middle of the century, with major publications on architecture by the French abbé Marc-Antoine Laugier, and the Englishmen James Stuart and Nicholas Revett, not to mention the influential reassessment of Greek art found in the writings of Johann Joachim Winckelmann. Laugier advocated a return to the essence of architecture with a stress upon the trabeated temples of the Greeks. This matched Winckelmann's invocation of the 'noble simplicity and calm grandeur' of Greek sculpture as a guide for modern artists while Stuart and Revett enabled contemporaries to form a clearer image of the nature of Greek architecture through their painstaking series of volumes entitled *The Antiquities of Athens* (1762–1816). Together these writings changed the study and appreciation of art as much as they altered the modern understanding of the Classical world.

Characteristic of the transitional phase between the late Baroque and Neoclassicism is the work of the Collino brothers and their pro-tégés in Turin. Ignazio and Filippo Collino were the beneficiaries of Carlo Emanuele III of Savoy's decision to create an autonomous school of sculpture for the decoration of his royal palaces. Study with the Turin court painter, Claudio Francesco Beaumont, was followed by exposure to the workshop of Maini in Rome and the copying of ancient sculpture promoted by the discerning Cardinal Alessandro Albani, nephew of Clement XI and protector of Winckelmann. Over a period of decades, the brothers furnished allegorical and commem-orative statuary for the House of Savoy, first from their Roman work-shop and then in Turin. Their monument of 1788 to Carlo Emanuele III was discussed in Chapter Four, and close scrutiny reveals that its Classicism is superficial – the premises upon which it is based are those of the Roman Baroque. Much the same could be said of the graceful suite of marble figures executed by a pupil of the Collino brothers, Giovanni Battista Bernero (1736–1796), for the royal hunt-ing lodge at Stupinigi, between 1769 and 1772. They celebrate mythological figures associated with the hunt but, despite Bernero's best efforts, they could hardly be called Neoclassical. *Orion* typifies Bernero's independent stance towards the Classical models he studied

181 Giovanni Battista Bernero, *Orion*, c. 1770. Stupinigi, Turin. Marble. Life-size.

in Rome. While the torso and lineaments of the face share that quality of abstraction commonly associated with antique sculpture, the sense of movement and decorative detail betray Bernero's grounding in the painterly manner of the late Baroque. Indeed, the work's charm lies in a graceful sensuousness, far removed from the severity that often characterizes Neoclassical sculpture. This less than reverential approach was not exceptional among Italian artists, even in 1770.

Of course, Baroque sculpture continued to be produced throughout Italy and beyond well into the eighteenth century. Bronzes by Foggini and Soldani as well as garden statuary made by Bonazza in the Veneto and under Vanvitelli at Caserta fostered the style until the eve of the French Revolution. Even in Rome, a monument like Bracci's to Benedict XIV could be entertained as late as the 1760s, just as the strikingly gruesome *Dead Christ Lying in the Shroud* by Giuseppe Sanmartino seems unaffected by fashions in art after 1700 (although Canova, on a visit to Naples in 1783, preferred

182

Sanmartino's *Dead Christ* to Corradini's *Modesty*). But Rome, which had so encouraged the genesis of Baroque sculpture, also hastened its demise. Neither the Catholic Church nor even the earth was held to be at the centre of the universe by 1773, and Clement XIV's abolition of the Jesuits in that year was welcomed as the lancing of a boil by anti-clerical and enlightened critics of the Church. Baroque art, too, seemed tarred by association with superstition and deference to the *ancien régime* and came to seem discredited by comparison with the moral authority of antique art. Moreover, the stress upon the antique as the essential component in artistic education acquired new meaning as the *goût grec* and *style Étrusque* supplanted Roman and Hellenistic art as a focus of attention. Although Bernini and Bellori had stressed its importance, their conception of the antique was radically different from that of eighteenth-century scholars such as Winckelmann and others, who prepared the ground for the new art which painters such as Mengs and sculptors such as Canova embodied with such conviction. One of the first sculptures to reflect this new orientation was Jean-Antoine Houdon's *St Bruno*, a work commissioned by the Carthusian monks at Santa Maria degli Angeli in 1766. As a former pupil of Slodtz and at that time a *pensionnaire* of the French Academy, Houdon would have studied his master's *St Bruno* in St Peter's, but the differences between the two works are more significant than any similarities. No props are employed by Houdon and the drapery has been scaled down to a few synchronized folds; the work's power resides in its very concentration, the rapt gaze of the saint summing up much of the Carthusian ideal. Likewise, Canova's tomb of Clement XIV in SS Apostoli distanced itself from the flamboyant tradition of such memorials with the same disciplined

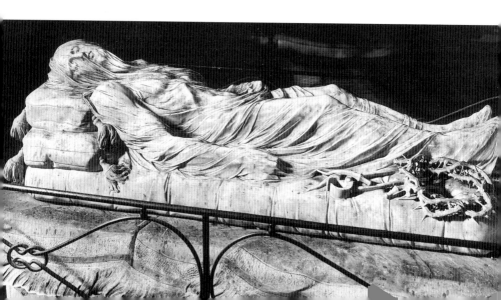

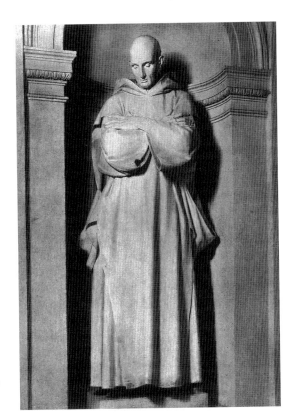

182 (*left*) Giuseppe Sanmartino,
Dead Christ Lying in the Shroud, 1753.
Santa Maria Pietà dei Sangro, Naples.
Marble. Life-size.

183 Jean-Antoine Houdon, *St Bruno*,
1766–7. Santa Maria degli Angeli,
Rome. Marble. H. 3.15 m.

rigour. The militant Neoclassical critic Francesco Milizia praised Canova's statues which 'appear to have been carved in the best period of Greek art, for composition, expression and draperies', adding that 'the accessories, the symbols and the architecture have the same regularity'. In singling out these aspects of Canova's work, Milizia recognized the extent of the sculptor's rejection of the illusionism and flamboyance of Bernini and his followers and his deliberate avoidance of effects like the *bel composto*. If ever a work represented an artistic volte-face, it was this.

We began this chapter with Bernini's prediction of the decline in the popularity of Baroque art. In more ways than one, the Baroque was the victim of its own success, for it evolved into the perfect medium for expressing many of the concerns of society in the seventeenth and eighteenth centuries, particularly the fostering of religious feeling and the evocation of mystical experiences. At its best, it conveyed the immediacy of dialogue between spectator and artefact, be it in

portraiture, fountains, or even tombs. Baroque artists strove to instil a sense of wonder and the unexpected, not only to draw the observer into a more active relationship with art, but also to instruct. In his *Passions of the Soul* of 1649, the French philosopher René Descartes stated that wonder was 'the first of all passions' and was beneficial if it induced a spirit of learning and enquiry; yet he added the caveat that too much wonder could 'prevent or pervert the use of reason'. Standing in the transept of Santa Maria della Vittoria, we can appreciate Descartes' distinction by comparing Bernini's Cornaro Chapel with its derivative pendant, Guidi's *Vision of St Joseph*. The same distinction can be drawn by a comparison of Bernini's *Cathedra Petri* with the many imitations created in Spanish churches, which the nineteenth-century traveller Richard Ford dubbed uncharitably but not inaccurately 'marble fricassees'.

Those critics who condemned Baroque art did so because its proponents did not conform to the standard of Classical artists; they were unable to make the mental leap necessary to enter into the minds of such men. In a world pursuing reason and rationality, there was little room for the Baroque; if our own age shows more tolerance, indeed, if we can now turn to Baroque sculptors for wonder and instruction, it is because we recognize something of ourselves in their attempts to confront the irrational side of human nature.

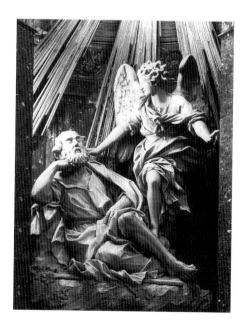

184 Domenico Guidi, *Vision of St Joseph, c.* 1694. Santa Maria della Vittoria, Rome. Marble.

Further Reading

GENERAL

The best concise introduction to the Italian Baroque remains that by R. Wittkower, *Art and Architecture in Italy, 1600–1750* (Pelican History of Art), 3rd ed., Harmondsworth, 1973; a new edition, edited by J. Montagu and J. Connors, is forthcoming. In Italian, two books by A. Nava Cellini, *La scultura del seicento* and *La scultura del settecento* (*Storia dell'arte in Italia*, ed. F. Bologna), Turin, 1982, provide excellent biographical information on sculptors in a region-by-region survey. Among individual volumes dedicated to Italian art of the period, the following are particularly useful for sculpture: E. Riccòmini, *Ordine e vaghezza*, Bologna, 1972, and *Vaghezza e furore*, Bologna, 1977; K. Lankheit, *Florentinische Barockplastik*, Munich, 1962; K. Lankheit and J. Montagu, 'Sculpture', *The Twilight of the Medici: Late Baroque Art in Florence, 1670–1743* (ex. cat.), ed. S. Rossen, Detroit, Mich., 1974, pp. 26–32; *Genova nell'età barocca* (ex. cat.), eds E. Gavazza and G. Rotondi Terminiello, Genoa, 1992; *La scultura a Genoa e in Liguria dal seicento al primo novecento*, eds E. Parma Armani and M. C. Galassi, Genoa, 1988; *Il seicento lombardo* (ex. cat.), Milan, 1973, 3 vols; O. Ferrari, 'I grandi momenti della scultura e della decorazione plastica', *Civiltà del seicento a Napoli* (ex. cat.), Naples, 1984, II, pp. 139–237; T. Fittipaldi, *Scultura napoletana del settecento*, Naples, 1980; A. Bacchi, *Scultura del '600 a Roma*, Milan, 1996 (plates); A. Blunt, *A Guide to Baroque Rome*, London, 1981; R. Enggass, *Early Eighteenth-Century Sculpture in Rome*, Univ. Park, Pa., 1976; S. Boscarino, *Sicilia barocca*, Rome, 1986; D. Maliguaggi, 'La Scultura della seconda metà del seicento e del settecento', in *Storia della Sicilia*, X, Palermo, 1981, pp. 73–117; L. Mallè, *Le arti figurative in Piemonte*, Turin, 1973, pp. 209–405; and C. Semenzato, *La scultura veneta del seicento e del settecento*, Venice, 1966. For individual sculptors, entries in *The Dictionary of Art*, ed. J. Turner, London and New York, 1996, are reliable and contain helpful bibliographical references; those in the *Dizionario biografico degli italiani*, Rome, 1960–, are more variable but more extensive.

INTRODUCTION

In Search of the Baroque

The classic treatment of the theme is H. Wölfflin, *Renaissance und Barock*, Munich, 1888 (English translation, London, 1965). Among more recent surveys, see especially J. R. Martin, *Baroque*, London, 1977; *Baroque and Rococo Architecture and Decoration*, ed. A. Blunt, London, 1978; and *The Age of the Marvellous* (ex. cat.), ed. J. Kenseth, Hanover, N.H., 1991. For primary sources, see R. Enggass and J. Brown, *Italy and Spain, 1600–1750: Sources and Documents*, Englewood Cliffs, N.J., 1970. On the etymology of 'Baroque', see the entry by G. Briganti in *The Encyclopedia of World Art*, New York and London, 1960, II, cols 257–63. The question of Mannerism lies outside the scope of this volume, but see the lucid introduction by E. Cropper to C. H. Smyth, *Mannerism and Maniera*, Vienna, 1992. For iconography, C. Ripa, *Iconologia*, Rome, 1603 (reprint, Hildesheim and New York, 1970), remains a valuable primary source; E. Mâle, *L'Art religieux . . . après le Concile de Trente*, Paris, 1932, is still essential reading, as is J. B. Knipping, *Iconography of the Counter-Reformation in the Netherlands*, Nieuwkoop and Leiden, 1974. On the particular case of the Sansevero Chapel, see M. Picone, *La Cappella Sansevero*, Naples, 1959; and B. Cogo, *Antonio Corradini, scultore veneziano*, Este, 1996, pp. 308–19, 325–36. Aldous Huxley's essay, 'Variations on a Baroque Tomb', is contained in his *Themes and Variations*, London, 1950, pp. 159–73.

CHAPTER ONE

The Origins of Italian Baroque Sculpture

On the major sculptural protagonists, see H. Hibbard, *Bernini*, Harmondsworth, 1965; R. Wittkower, *Gian Lorenzo Bernini: The Sculptor of the Roman Baroque*, 3rd ed., revised by H. Hibbard and M. Wittkower, Oxford, 1981; C. Avery, *Bernini: Genius of the Baroque*, London and Boston, Mass., 1997; and J. Montagu, *Alessandro Algardi*, New Haven, Conn., and London, 1985. For early biographies, F. Baldinucci, *The Life of Bernini*, translated by C. and R. Enggass, Univ. Park, Pa. and London, 1966, and G. P. Bellori, *Le vite de' pittori, scultori e architetti moderni*, ed. E. Borea, Turin, 1976, are fundamental. On Rome, see L. von Pastor, *History of the Popes . . .* , London, 1899–1953, especially vols XXI–XXXVIII (Sixtus V to Clement XIV); F. Haskell, *Patrons and Painters . . .* , New Haven, Conn., and London, 1980; T. Magnuson, *Rome in*

the *Age of Bernini*, Stockholm, 1982–6, 2 vols; and S. F. Ostrow, *Art and Spirituality in Counter-Reformation Rome*, Cambridge, 1996. Among more specific studies, the following are particularly recommended: J. Kenseth, 'Bernini's Borghese Sculptures: Another View', *Art Bulletin*, LXIII, 1981, pp. 191–210; I. Lavin, *Bernini and the Crossing of St Peter's*, New York, 1968; idem, 'Five New Youthful Sculptures by G. L. Bernini and a Revised Chronology of his Early Work', *Art Bulletin*, L, 1968, pp. 223–48; and R. Preimesberger, 'Themes from Art Theory in the Early Works of Bernini', *Gianlorenzo Bernini: New Aspects of His Art and Thought*, Univ. Park, Pa., 1985, pp. 1–18.

CHAPTER TWO

Portraiture

For general background, see I. Lavin, 'Bernini and the Art of Social Satire', *Drawings by Gianlorenzo Bernini* . . . (ex. cat.), ed. I. Lavin, Princeton, N.J., 1981, pp. 25–54; G. P. Lomazzo, *Trattato dell'arte della pittura, scoltura et architettura*, in *Scritti sulle arti*, ed. R. P. Ciardi, Florence, 1973–4, II, pp. 374–82; D. Mahon, 'Agucchi and the *Idea della bellezza*', *Studies in Seicento Art and Theory*, London, 1947, pp. 124–43; J. Montagu, 'The Portraits', in *Alessandro Algardi*, New Haven, Conn., and London, 1985, pp. 157–78; and G. Winter, *Zwischen Individualität und Idealität: Die Bildnisbüste*, Stuttgart, 1985 (Chapter VI). For some of the examples discussed here, see R. Enggass, 'L. Ottoni . . . ', *Storia dell'arte*, XV–XVI, 1972, pp. 315–42; I. Lavin, 'Duquesnoy's Nanni di Créqui and Two Busts by F. Mochi,' *Art Bulletin*, LII, 1970, pp. 132–49; V. Martinelli, 'Il Busto originale di Maria Barberini . . . di G. L. Bernini e Giuliano Finelli', *Antichità Viva*, XXVI, 1987, no. 3, pp. 27–36; J. Montagu, 'Some Small Sculptures by G. Piamontini', *Antichità Viva*, XIII, 1974, no. 3, pp. 3–21; idem, 'C. Rusconis Büste der Giulia Albani degli Abati Olivieri', *Jahrbuch der Kunsthistorischen Sammlungen in Wien*, Neue Folge, XXXV, 1975, pp. 311–27; A. Nava Cellini, *La scultura del seicento*, Turin, 1982, pp. 192–3 (Orazio Marinali); E. Riccòmini, *Mostra della scultura bolognese* (ex. cat.), Bologna, 1965, p. 92, no. 77 (Carlo Dotti); *The Twilight of the Medici: Late Baroque Art in Florence, 1670–1743* (ex. cat.), ed. S. Rossen, Detroit, Mich., 1974, p. 368, no. 208 (Torricelli's bust of Vittoria della Rovere); and H. H. Arnason, *The Sculpture of Houdon*, London, 1975, p. 13 (*Peasant Girl of Frascati*).

CHAPTER THREE

Fountains and Garden Sculpture

This is an understudied field, but the following are recommended for orientation: A. Colasanti, *Le fontane d'Italia*, Milan and Rome, 1926 (essentially plates); and C. d'Onofrio, *Le fontane di Roma*, Rome, 1967. On Renaissance fountains, see B. Wiles, *The Fountains of the Florentine Sculptors*, Cambridge, Mass., 1933; and S. ffolliott, *Civic Sculpture in the Renaissance: Montorsoli's Fountains at Messina*, Ann Arbor, Mich., 1984. J. A. Pinto, *The Trevi Fountain*, New Haven, Conn., and London, 1986, not only gives an excellent account of a famous landmark, but also sheds light on Roman Baroque fountain design. A useful résumé of Bernini's *Fountain of the Four Rivers* is found in *Drawings by G. L. Bernini*, 1981, pp. 108–17. On Caserta, see G. L. Hersey, *Architecture, Poetry, and Number in the Royal Palace at Caserta*, Cambridge, Mass., 1983, pp. 98–141. On Corradini's statuary in Dresden, see B. Cogo, *Antonio Corradini, scultore veneziano*, Este, 1996, pp. 52–6 and 240–60; on Bonazza, see A. Nava Cellini, *La scultura del settecento*, Turin, 1982, pp. 172–4.

CHAPTER FOUR

The Art of Dying Well

For general accounts of this theme in European culture, see E. Mâle, 'La Mort', *L'Art religieux . . . après le Concile de Trente*, Paris, 1932, pp. 203–27; P. Ariès, *The Hour of Our Death*, translated by H. Weaver, New York, 1981; M. Vovelle, *La Mort et l'Occident*, Paris, 1983; and J. McManners, *Death and the Enlightenment*, Oxford, 1981. Among more specialized studies, see E. Panofsky, *Tomb Sculpture . . .*, New York, 1964 (London, 1992), Chapter IV; J. Bernstock, 'Bernini's Memorials to I. Merenda and A. Valtrini', *Art Bulletin*, LXIII, 1981, pp. 210–32; 'The Tomb of Urban VIII', *Drawings by G. L. B.*, 1981, pp. 62–71; and A. Braham, *Funeral Decorations in Early Eighteenth-Century Rome* (Victoria and Albert Museum, brochure no. 7), London, 1975. On the Pesaro monument, see P. Rossi, 'I "marmi loquaci" del monumento Pesaro ai Frari', *Venezia Arti*, IV, 1990, pp. 84–93; on the Morosini monument, see R. Rotondi Briasco, *Filippo Parodi*, Genoa, 1962, pp. 44–5. For the Roman monuments of the late Baroque, see the catalogue entries in R. Enggass, *Early Eighteenth-Century Sculpture in Rome*, Univ. Park, Pa., 1976; also C. Gardara, *Pietro Bracci . . .* , Milan, 1921,

pp. 72–5; and U. Schlegel, 'B. Cametti', *Jahrbuch der Berliner Museen*, Neue Folge, V, 1963, pp. 54–60, 163–7. On Canova's tomb of Clement XIV see F. Licht, *Canova*, New York, 1983, pp. 53–60.

CHAPTER FIVE

The Bel Composto

The essential study of the Cornaro Chapel is I. Lavin, *Bernini and the Unity of the Visual Arts*, New York and London, 1980; see also the thoughtful review essay by R. Preimesberger, 'Berninis Cappella Cornaro', *Zeitschrift f. Kunstgeschichte*, XLIX, 1986, pp. 190–219. On Bernini's later use of the *bel composto*, see especially G. Careri, *Bernini: Flights of Love, the Art of Devotion*, Chicago, Ill., and London, 1995. Among other literature, see H. A. Millon, 'The Antamoro Chapel in San Girolamo della Carità in Rome . . . ', *Studies in Italian Art and Architecture, 15th through 18th Centuries* (American Academy in Rome), ed. H. A. Millon, Rome, 1980, pp. 261–80; E. Riccòmini, *Ordine e vaghezza*, Bologna, 1972, p. 96 (Corpus Domini, Bologna); C. Puglisi, 'The Cappella di San Domenico in SS Giovanni e Paolo, Venice', *Arte Veneta*, XL, 1986, pp. 190–219; and R. Pommer, *Eighteenth-Century Architecture in Piedmont*, New York, 1967, pp. 107–37 (Bernardo Vittone). For a background discussion to the issues raised here, consult A. Blunt, 'Bernini: Illusionism and Mysticism', *Art History*, I, 1978, pp. 67–89. V. Stoichita, *Visionary Experience in the Golden Age of Spanish Art*, London, 1995, is a complementary discussion of mysticism in Spanish art.

CHAPTER SIX

Reliefs and Sculptural Altarpieces

J. Montagu, 'The Reliefs', in *Alessandro Algardi*, New Haven, Conn., and London, 1985, pp. 135–56. On the important role of Cafà, see R. Preimesberger and M. Weil, 'The Pamphili Chapel in Sant' Agostino', *Römisches Jahrbuch f. Kunst-geschichte*, XV, 1975, pp. 183–98; J. Montagu, 'The Graphic Work of M. Cafà', *Paragone-Arte*, XXXV, no. 413, 1984, pp. 50–61; G. Schuster, *Das Hochaltarrelief der Kirche S. Caterina da Siena a Magnanapoli von M. Cafà* (MA Thesis, Friedrich-Alexander Universität), Erlangen and Nuremberg, 1988; see also G. Bissell, *Pierre Le Gros, 1666–1719*, Reading, 1997, pp. 44–6, no. 10 (*St Aloysius Gonzaga in Glory*). On the altars of Sant'Agnese, see G. Eimer, *La Fabbrica di S. Agnese in Navona . . .* (Stockholm Studies in History of Art,

nos 17–18), Stockholm, 1970–1, II, pp. 482–501; and R. H. Westin, 'Antonio Raggi's *Death of St Cecilia*', *Art Bulletin*, LVI, 1974, pp. 422–9. On De Corte and the Salute, see C. Semenzato, *La scultura veneta del seicento e del settecento*, Venice, 1966, pp. 20–3. On Genoese altars, see *Pierre Puget . . . un artista francese e la cultura barocca a Genova* (ex. cat., Palazzo Ducale, Genoa), Milan, 1995; and *La scultura a Genova e in Liguria dal seicento al primo novecento*, Genoa, 1988, pp. 143–65, for Parodi's career. An excellent account of the Corsini Chapel in Santa Maria del Carmine, Florence, can be found in *The Twilight of the Medici: Late Baroque Art in Florence, 1670–1743* (ex. cat.), ed. S. Rossen, Detroit, Mich., 1974, pp. 52–5, nos 15–17. On Cametti's reliefs for the Superga, see U. Schlegel, 'B. Cametti', *Jahrbuch der Berliner Museen*, Neue Folge, V, 1963, pp. 173–83. See also H. Honour, 'Filippo della Valle,' *The Connoisseur*, CXLIV, 1959, pp. 172–9; and J. Fleming, 'Giuseppe Mazza,' *The Connoisseur*, CXLVIII, 1961, pp. 206–15.

CHAPTER SEVEN

Ephemeral Decoration and Small Works of Art

The best general guide to ephemeral productions is M. Fagiolo dell'Arco and S. Carandini, *L'Effimero barocco . . .* , Rome, 1977–8, 2 vols; see also M. S. Weil, 'The Devotion of the Forty Hours and Baroque Illusionism', *Journal of the Warburg and Courtauld Institutes*, XXXVII, 1974, pp. 218–48; and J. Montagu, *Roman Baroque Sculpture: The Industry of Art*, New Haven, Conn., and London, 1989 (Chapter VIII). The *sacri monti* lie outside the scope of this book, but see the review article by W. Hood in *Art Bulletin*, LXVII, 1985, pp. 333–7. On Anton Maria Maragliano and his school, see the fascinating study by F. Franchini Guelfi, *Le Casacce . . .* , Genoa, 1973, pp. 85–137. On Naples, see F. Mancini, *Feste e apparati in Napoli*, Naples, 1968. Roman fireworks are discussed by J. A. Pinto, 'N. Michetti and Ephemeral Design in Eighteenth-Century Rome', *Studies in Italian Art and Architecture, 15th through 18th Centuries* (American Academy in Rome), ed. H. A. Millon, Rome, 1980, pp. 289–313. On the funeral decorations for Gian Gastone de' Medici, see *The Twilight of the Medici: Late Baroque Art in Florence, 1670–1743* (ex. cat.), ed. S. Rossen, Detroit, Mich., 1974, p. 484, no. 289. On stucco, see especially G. Beard, *Stucco and Decorative Plasterwork in Europe*, London, 1983; for papier-mâché and stucco statuary

in Naples, see V. Rizzo, 'Documenti su Solimena, Sanfelice, Sanmartino e i maestri cartapistari', *Napoli Nobilissima*, XX, 1981, fasc. v–vi, pp. 222–40; on Sicily, see D. Garstang, *G. Serpotta*, London, 1984. On sugar sculpture, see especially G. Masson, 'Food as a Fine Art in Seventeenth-Century Rome', *Apollo*, LXXXIII, 1966, pp. 338–41; and P. Bjurström, *Feast and Theatre in Queen Christina's Rome*, Stockholm, 1966. On J. P. Schor, see P. Werkner, 'J. P. Schor', *Alte und Moderne Kunst*, XXV, 1980, no. 169, pp. 20–8. On bronze sculpture, see A. Radcliffe, *The Robert H. Smith Collection: Bronzes, 1500–1650*, London, 1994; and J. Montagu, *Gold, Silver, and Bronze: Metal Sculpture of the Roman Baroque*, New Haven, Conn., and London, 1996. For a good account of Andrea Brustolon's furniture, see C. Alberici, *Il mobile veneto*, Milan, 1980, pp. 164–70.

CHAPTER EIGHT

From Late Baroque to Neoclassicism

On Bernini and his later collaborators, see especially M. S. Weil, *The History and Decoration of the Ponte Sant'Angelo*, Univ. Park, Pa., 1974. For historical background to this period, see H. Gross, *Rome in the Age of the Enlightenment*, Cambridge, 1990; and R. Enggass, *Early Eighteenth-Century Sculpture in Rome*, Univ. Park, Pa., 1976. Also worth consulting are:

M. Conforti, 'Pierre Legros and the Role of Sculptors as Designers in Late Baroque Rome', *Burlington Magazine*, CXIX, 1977, pp. 557–60; and *idem*, 'Planning the Lateran Apostles', *Studies in Italian Art and Architecture, 15th through 18th Centuries* (American Academy in Rome); ed. H. A. Millon, Rome, 1980, pp. 243–60. For studies of individual sculptors, see G. Bissell, *Pierre Le Gros, 1666–1719*; H. Honour, 'Filippo della Valle,' *The Connoisseur*, CXLIV, 1959; A. Nava Cellini, *Scultura del settecento*, Turin, 1982, pp. 214–16 (Giovanni Battista Bernero at Stupinigi); F. Souchal, *Les Slodtz . . .* , Paris, 1967, pp. 257–67 (*St Bruno*); and H. H. Arnason, *The Sculpture of Houdon*, London, 1975, p. 15 (*St Bruno*). For the overlap between late Baroque and Neoclassicism, see L. Eitner, *Neo-classicism and Romanticism, 1750–1850: Sources and Documents*, Englewood Cliffs, N.J., 1970; J. Fleming, *Robert Adam and his Circle . . .* , London, 1962; R. Rosenblum, *Transformations in Late Eighteenth Century Art*, Princeton, N.J., 1967; and H. Honour, *Neoclassicism*, Harmondsworth, 1968 (rev. ed., 1977). Finally, no account of the late Baroque can ignore J. J. Winckelmann's seminal writings, for which see *Winckelmann: Writings on Art*, ed. D. Irwin, London, 1972; A. Potts, *Flesh and the Ideal: Winckelmann and the Origins of Art History*, New Haven, Conn., and London, 1994, offers a stimulating and provocative new interpretation.

Photographic Credits

Photo: AKG/Hilbich 166, 167; Archivi Alinari 14, 16, 34, 37, 46, 65, 66, 72, 74, 80, 82, 84, 106, 111, 125, 131, 140, 152, 172, 173, 174, 176, 177, 179, 182; Photo Arte Fotografica 108; James Austin 184; Berlin, Staatliche Museen zu Berlin – Preussischer Kulturbesitz Kunstbibliothek 98; Paul Birnbaum 127; Gerhard Bissell, Reading 175; Osvaldo Böhm 110, 137, 163; Gabinetto Fotografico Soprintendenza Beni Artistici e Storici, Bologna 75; Bruce Boucher 17, 88, 90, 109, 124, 151, 164, 165; Mauro Buffoni, Genoa 71; Peter Cannon Brookes 101; Frederick Clarke, Genoa 95, 96, 138; The Conway Library, Courtauld Institute of Art, London 4, 43, 48, 49, 67, 73, 79, 81, 93, 112, 113, 136, 139, 142, 143, 178; Sächsische Landesbibliothek, Dresden. Abteilung Deutsche Fotothek/Möbius 92; Photo David Finn, New York 33, 39, 117; Kunsthistorisches Institut, Florence 77; © Christina Gascoigne 146, 170; Photo Heidi Grassley © Thames and Hudson Ltd 56, 130; © Raymond Gruaz 2; Martin Hurlimann 85; Index/L. Perugi 154; A. F. Kersting 100, 114; Museum der Bildenden Künste, Leipzig 122; Reproduced by courtesy of the Trustees, The National Gallery, London 35; By courtesy of the National Portrait Gallery, London 78; V&A Picture Library, London 10, 47, 52, 53, 87, 159; City Art Galleries, Manchester 60; after V. Martinelli 56; Jennifer Montagu 126; The Metropolitan Museum of Art, New York. All rights reserved, The Metropolitan Museum of Art 51 (Louise Eldridge McBurney Gift, 1953), 68 (Edith Perry Chapman Fund, 1957), 121, 127; Paris, © Photo R.M.N. 29; Enrico Polidori, Genoa 162; private collection 6; Bibliotheca Hertziana, Rome 165; Deutsches Archäologisches Institut, Rome 7; Gabinetto Fotografico Nazionale, Rome *Frontispiece*, 45, 61, 105, 120, 132; Istituto Centrale per il Catalogo e la Documentazione, Rome 23, 28, 50, 57, 62, 163, 135; Soprintendenza per i Beni Artistici e Storici, Rome 13; © Saskia 116, 180; Scala 12, 15, 20, 21, 22, 24, 25, 26, 30, 40, 102, 115, 118, 123, 150, 153, 169; Mrs I. Schneider-Lengyel 5; Schloss Museum, Schwerin 119; Rodolfo Soppo, Turin 181; The Royal Library, National Library of Stockholm 160; Nationalmuseum, Stockholm 155 ; Taylor & Dull Inc., New York 157; The Toledo Museum of Art, Ohio 55; Soprintendenza ai Monumenti, Turin 141; Foto Fabbrica di S. Pietro in Vaticano 41, 97, 104; Fondazione Scientifica Querini Stampalia, Venice 76; Azienda Promozione Turistica, Vicenza 94; Kunsthistorisches Museum, Vienna 31; The Royal Collection, Windsor. © Her Majesty Queen Elizabeth II 89, 103, 162; Archivio Federico Zeri 3, 18, 19, 27, 38, 42, 44, 58, 107, 133, 134

Index

Numbers in *italic* refer to illustrations